D1140095

182

CP044763

...isms

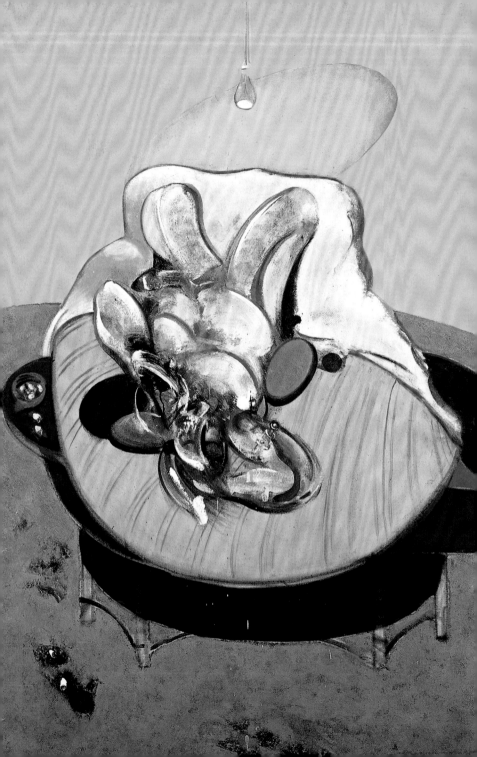

...isms

UNDERSTANDING MODERN ART

SAM PHILLIPS

BLOOMSBURY

LONDON • NEW DELHI • NEW YORK • SYDNEY

Contents

More than any other subject, modern art is structured by isms: movements, trends, styles or schools that act as categories for the practice of different artists. This book is an accessible guide to the most commonly used of these classifications.

In the late 19th and early 20th centuries, groups of artists coined isms in order to define themselves and wrote accompanying manifestos to clarify what set their work apart. Once their work had been classified its reception by the public and critics gained more momentum. Sometimes critics came up with these labels, with the benefit to the writer that if the art became famous they would forever be mentioned in the same breath. But some artists have distanced themselves from the isms with which they have been associated. This is because isms are, by their very nature, reductive: a three-letter suffix that helps condense complex artworks and artists into one word. Artists in the late 20th and early 21st centuries have tended not to use isms to describe their own work, in an effort to emphasise its uniqueness and multifaceted meanings.

Isms succumb to the ebb and flow of fashion. Vorticism, for example, was consigned to the past within a year or so, but publications and exhibitions in the 21st century have renewed interest in its incendiary ideas. Synthetism and Orphism were variations on Symbolism and Cubism respectively but, although art historically interesting, they have never enjoyed the same popular recognition. Isms tend to be formed in reaction to older isms – as an ism becomes more popular, those that conflict with it become less so. There are many isms coined by collectives and critics that have not made it into this book because they did not catch the *Zeitgeist* for artists. A recent example is 'Altermodernism', a term invented by French writer and curator Nicholas Bourriaud for art in the early 21st century.

The artists included in this book are necessarily representative of a particular ism. Some important practitioners are therefore excluded because they sat slightly outside an ism – for example, the famous Mexican painter Frida Kahlo, who was influenced by Surrealism, but did not epitomise the movement.

This publication is not an exhaustive summary – another book might choose other isms and other artists to represent those found here. Two isms included, Installationism and Sensationalism, are not terms used widely in the art world, but have been coined for this book to pithily sum up a type of art. The chronology of this book also comes with a caveat, as the start and end points of isms are open to interpretation. In some decades a wide variety of different modes emerged at around the same time, particularly the 1960s, so that their consecutive order can be questioned. It is also worth remembering that Impressionism and many older isms are still practised widely today. This publication focuses on the key period when an ism was most productive and influential.

THE FOUR TYPES OF ISM

1 TREND WITHIN THE VISUAL ARTS
eg Primitivism, Interventionism

These isms refer to broad tendencies within the visual arts. Interventionism, for example, classifies the trend of modifying pre-existing objects and structures. There is no collective who define themselves as 'the Interventionists', but a number of different artists whose work shows this tendency. These are overarching terms and can describe art across a wide range of decades.

2 BROAD CULTURAL TREND
eg Existentialism, Postmodernism

Not all isms in this book relate only to the visual arts. Some are relevant across different disciplines, such as architecture and film. One can therefore think of the visual artists in these isms as working as part of a broader cultural trend. Some of these trends are connected to an influential philosophical concept, like Existentialism, which was developed by French thinker Jean-Paul Sartre. Others such as Symbolism and Futurism had a specific application in literature before spreading to painting and sculpture.

3 ARTIST-DEFINED MOVEMENT
eg Rayonism, Abstract Expressionism

This is the most common type of ism in the book. It encompasses groups of avant-garde artists who either coined a term themselves to label their practice or had the word suggested at the time by a critic. These movements are generally the easiest to define, as they often have a manifesto or essay in which the artists' shared goals and processes are clarified. Some of the artists associated with a particular ism by critics might have rejected the label themselves, but it has remained in common use as a description of their work.

4 RETROSPECTIVELY APPLIED LABEL
eg Post-Impressionism, Precisionism

Although critics in the modern era have been quick to coin an ism at the first sign of its crystallisation, movements can sometimes only be clearly discerned in retrospect, when their key years are behind them and they can be seen in context. Post-Impressionism was used from 1910, even though artists associated with the ism, such as Vincent van Gogh, had already passed away by that time. They are useful art historical terms, but because they came into being after the event they are more likely to be disputed.

BCT Circular symbols next to the chapter headers differentiate between the four different types of ism described in the Introduction: a trend within the visual arts **TVA**, broad cultural trend **BCT**, artist-defined movement **ADT** or retrospectively applied label **RAL**. Some isms are arguably explained by more than one of these terms: in this case, this publication has used the most common type associated with the ism.

INTRODUCTION
Each chapter opens with a brief summary to explain the key features of the ism.

KEY ARTISTS
Up to five artists who epitomise each ism are listed in each chapter. The list could often be extended, but exploring the work of these five artists would give you a comprehensive understanding of the ism.

KEY WORDS
These are words taken from the main definition text that relate closely to the ism and are often repeatedly used in explanations of the affiliated artists' work.

MAIN DEFINITION
This describes in more depth the key ideas, methods and artists of each ism. It gives a brief history of the ism and its development, and how it can be distinguished from other modern art movements.

Fluxus **ADM**

Fluxus, meaning 'flow' in Latin, described a multidisciplinary group of international artists who collaborated on radical acts. They aimed to dissolve the boundary between art and life, and to create, in the words of their chief theorist George Maciunas, 'living art'.

DICK HIGGINS (1938–98); **ALISON KNOWLES** (1933–); **GEORGE MACIUNAS** (1931–78); **YOKO ONO** (1933–); **BEN VAUTIER** (1935–)

Fluxfests; intermedia; living art; multidisciplinary; performances

Maciunas coined the term Fluxus in 1961 to describe an international community of artists, designers, writers, musicians and activists who collaborated on experimental projects. Its wide range of affiliates included the Tokyo-born performance artist Yoko Ono, German

Conceptualist Joseph Beuys, Korean-American video art pioneer Nam June Paik, New York book artist Alison Knowles and her compatriots the avant-garde composers George Brecht and Dick Higgins, and poet Emmett Williams.

None of these figures restricted their work to one medium or discipline. The term Fluxus was chosen to reflect the way the members 'flowed' between different practices, as well as the ever-changing composition of the community. Higgins invented the word 'intermedia' to describe how Fluxus activities were in between classifications. Examples of these included Brecht's score/performance piece *Drip Music* (1962), which amplified the sound of water poured into vessels; actions by Ono that incorporated text and sound works; and Fluxus Editions, publications produced by many of the artists, into which art objects were assimilated.

The movement's heterogeneity reflected

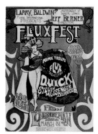

its central tenet: in Maciunas' words, 'anything can be art and anyone can do it'. Fluxus projects aimed not just to push the boundaries of what could be considered art, but to obliterate them altogether, so that art and life were one. Their pieces involved social critique and Maciunas had the aspiration that his message would 'be grasped by all peoples, not only critics, dilettantes and professionals'. To reach a broad audience, works had a 'do-it-yourself' simplicity and involved humour and fun.

Performances and sound pieces were presented at Fluxus festivals, known as Fluxfests or Fluxconcerts, organised in major European and American cities. Many of the actions and compositions were generated randomly, demonstrating the influence of Neo-Dadaist John Cage, who pioneered music that was left to chance. In their belief that art was life and not a commodity, some Fluxus artists refused to sell their works: for example, the Frenchmen Robert Filliou and

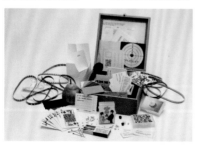

Fluxus

Ben Vautier pursued Mail Art, the free exchange of artist-made envelopes, stamps and postcards through the mail.

The collective is hard to categorise under any single item. Maciunas wrote in the early 1960s of its correlation with Neo-Dadaism, in the way it experimented with a wide range of media. But it blended the earlier movement with emergent Performance Art and Conceptualist practices, in both its anti-commercialism and redefinition of what an artwork could be. This radicalism meant it remained influential throughout and after the 1970s.

KEY WORKS in the Fogg Museum, Harvard Art Museums, Cambridge, Massachusetts

* *Fluxfest, 1967*, VARIOUS ARTISTS
Fluxfests were the group's most high-profile projects. The artists wished for wide participation and formed alliances outside the world of fine art. In the event advertised here – in a poster designed by Ida Griffin, partner of fellow psychedelic artist Rick Griffin – Fluxus joined forces with members of San Francisco's 1960s counter-culture.

* *Flux Year Box 2, c 1968*, VARIOUS ARTISTS
The contents of this limited-edition box demonstrate the diversity, playfulness and collaborative nature of Fluxus. Submitted by artists from across the collective, these objects are props for actions, from playing cards and matches to medicine and seeds.

OTHER WORKS in the Fogg Museum, Harvard Art Museums

Fluxkit, 1964, DICK HIGGINS
Bean Roll, 1964, ALISON KNOWLES
Fluxus 3 newspaper eVenTs for the pRicE of $1 No. 7 February1, 1966, 1964, GEORGE MACIUNAS
Grapefruit, 1964, YOKO ONO
The Postman's Choice, 1964, BEN VAUTIER

Futurism; Dadaism; Neo-Dadaism; Conceptualism; Performance Art

Impressionism; Neo-Impressionism; School of Paris; Abstract Expressionism; Kitchen Sink

KEY WORKS

Each chapter is illustrated with one or two works by the ism's Key Artists. These are selected each time from one of the world's major publicly accessible art collections. The illustrations are accompanied by captions that explain why the illustrated work exemplifies the particular ism.

OTHER WORKS

This is a supplementary list of works that are part of the same collection as the Key Works illustrated in the chapter. All are works by the ism's Key Artists and can be seen as part of a gallery visit or researched in catalogues, in print and online.

SEE ALSO

Isms often share characteristics with each other. This is a list of other isms explained in the book that relate to the ism under discussion, perhaps sharing a working process, stylistic tendency or concept.

DON'T SEE

These isms feature a key idea or process that contradicts the movement under discussion. Their assumptions might be antithetical, or aesthetically they might be very different.

Other resources included in this book

GLOSSARY OF ARTISTS

All the artists mentioned in the book are indexed alphabetically at the back. The ism, or isms, with which they are associated in the publication are noted, as well as their birth and death dates. Often artists are more famous than their isms: you can pick your favourite artist and then see which ism relates to them.

GLOSSARY OF USEFUL TERMS

This publication does not assume an in-depth knowledge of modern art. Any terms mentioned in its pages that are not commonly understood are listed in a glossary at the back of the book. Also included are words that are not used elsewhere in the publication, but that could be of help on a gallery visit or when undertaking further research.

CHRONOLOGY OF ISMS

This is a timeline of all the different isms explained in the book, from the advent of Impressionism in 1874 to the present-day ism of Internationalism. As explained in the Introduction to this book, the start and end points of isms can be debated – this timeline marks the period when the ism was most prevalent and had its greatest impact on the history of art. Russian artist Kasimir Malevich, for example, claimed that his first Suprematist work was in 1913, although the movement was officially launched with a manifesto and exhibition in 1915; the book therefore takes the latter date as its starting point. Some isms followed on from one another – for example, Neo-Impressionism, whose first public presentation in 1886 took the critical limelight away from Impressionism. Others coalesced at the same time, like Neo-Dadaism and New Realism, two similar movements on different sides of the Atlantic.

LIST OF MUSEUMS TO VISIT

A list of the museums and galleries whose collections include the Key Works and Other Works used to illustrate each chapter, organised by country.

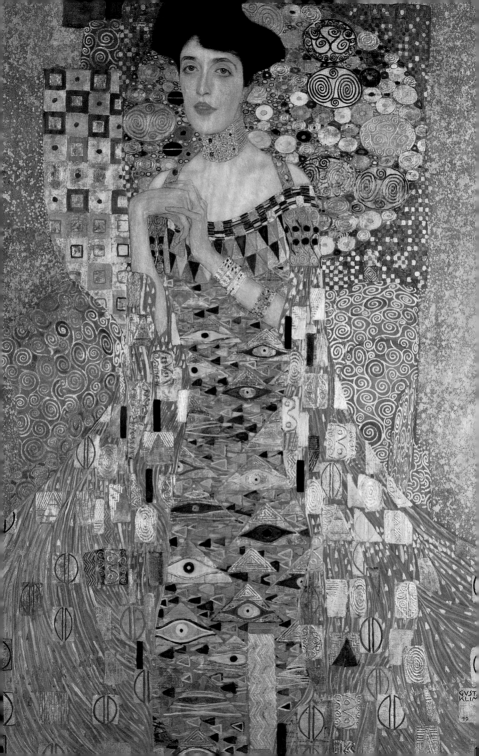

I

THE BIRTH OF MODERN ART

Impressionism began in the late 19th century with a group of French artists who rejected many of the traditional conventions taught in art academies. Instead of aiming for an objective depiction of the world, they focused on their subjective perceptions. Their style was characterised by rough-and-ready brush strokes and an experimental use of colour, and soon spread to other countries.

EDGAR DEGAS (1834–1917); ÉDOUARD MANET (1832–83); CLAUDE MONET (1840–1926); PIERRE-AUGUSTE RENOIR (1841–1919); ALFRED SISLEY (1839–99)

en plein air; play of light; unmixed pigment; sensory perceptions

The word Impressionism was first coined by critic Louis Leroy in a review of a group exhibition he visited in a Paris studio in April 1874. He derived the term from the title of a painting by Claude Monet, *Impression, Sunrise* (1873), that seemed to sum up many of the canvases on view: landscapes, cityscapes and portraits that appeared to be quick preliminary sketches rather than finished works.

But for the artists on show, whose number also included Paul Cézanne, Edgar Degas, Berthe Morisot, Camille Pissarro, Pierre-Auguste Renoir and Alfred Sisley, the whole point was the sense of spontaneity. They would paint landscapes *en plein air* (in the open air) and reflect their immediate sensory perceptions of the scene, capturing the blur of the first moment of seeing when forms are in movement and indefinite. They attempted to represent the play of light and would use unmixed pigment, allowing the colours to fuse in the eye of the viewer. If they did work in the studio, as did Degas, it would be to add to the impact of an initial impression, instead of replacing it with a classically realistic representation.

These techniques were profoundly at odds with the city's Academy, who favoured only artworks that, in the Classical and Renaissance manner, came as close as possible to a likeness of the natural world, with objects composed in proportion and perspective. The Impressionists' subject matter was also a marked departure from the allegorical and historical subjects preferred by the Academy; their canvases often featured incidental images of contemporary life. Another major shift was that they organised their own exhibitions, taking power out of the hands of the Academy's Salon show and encouraging others to present their work independently.

The path had been cleared by Édouard Manet, a friend of the group whose roughly painted and confrontational works had caused outrage in the 1860s. Japanese art was another influence in the way it offered alternative compositional techniques to the Western tradition. So was the new medium of photography, in which objects were sometimes spliced off at the canvas edge as if composed through a lens. And sculptor Auguste Rodin pioneered the same immediacy in three dimensions to international acclaim.

Variations of Impressionism spread to America, in the paintings of Mary Cassatt and Winslow Homer, and Britain, in the works of Walter Sickert and American expat James Abbott McNeill Whistler. But by the early 1880s the original French artists were working independently of each other and diversifying their techniques, which led to subsequent movements that either reacted against or further developed Impressionism.

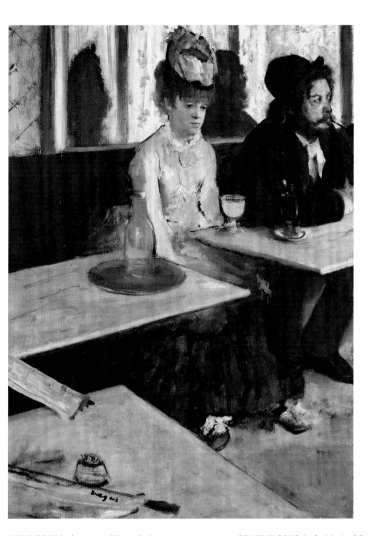

KEY WORKS in the Musée d'Orsay, Paris

In a Café (Absinthe), 1873, EDGAR DEGAS
Degas concentrated his gaze on the urban environment of Paris rather than the countryside. This painting of a drunken woman and man is composed as if a snapshot photograph from a nearby table; the woozy brush strokes, drained colour and desolate expressions are representative of the pair's intoxicated state.

OTHER WORKS in the Musée d'Orsay

Luncheon on the Grass, 1863, ÉDOUARD MANET
Villas at Bordighera, 1884, CLAUDE MONET
White Frost, 1873, CAMILLE PISSARRO
Snow at Louveciennes, 1878, ALFRED SISLEY

 Neo-Impressionism;
Post-Impressionism

 Suprematism; Pop Art;
Sensationalism

Poppies, 1873,
CLAUDE MONET
Monet evokes all the
atmosphere of a summer
stroll in the countryside of his
home in Argenteuil, a town
close to Paris. The figures are
faceless, props to accentuate
the diagonal of poppies
rendered by two unmixed
shades of red. Flicks of yellow,
beige, pink and blue highlight
the short strokes of the dark-
green field.

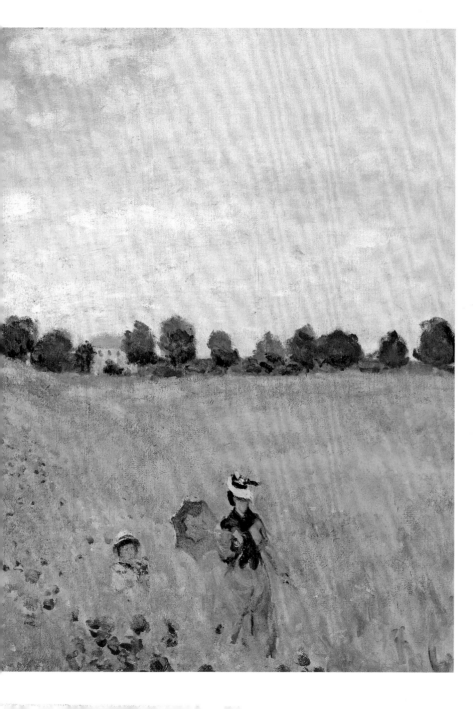

Neo-Impressionism was a brief but influential French movement that emerged in 1886. The Neo-Impressionists thought that Impressionism had gone too far in its emphasis on momentary experience. Developing new compositional and colour techniques, they attempted to paint people and landscapes with more solidity, so that they appeared substantial and timeless.

CAMILLE PISSARRO (1830–1903); **LUCIEN PISSARRO** (1863–1944); **GEORGES SEURAT** (1859–91); **PAUL SIGNAC** (1863–1935)

dots; colour theory; Divisionism; Pointillism; short brush strokes

In 1886, Camille Pissarro persuaded the group of Impressionist artists he associated with in Paris to allow his son Lucien, Georges Seurat and Paul Signac to exhibit in what was to be the last Impressionist exhibition. The four artists had recently begun working in a different style and their canvases were hung together in a separate room to assert their alternative aesthetic.

Their work was favourably received by the press and dubbed 'Neo-Impressionism' by the critic Félix Fénéon. While aiming for the same luminosity as the Impressionists, the Neo-Impressionists gave their scenes greater geometric structure, which imbued them with an atmosphere of permanence. Instead of intuitively laying down paint *en plein air* (in the open air), they put their faith in laborious techniques that involved numerous preparatory studies. Their method was the application of discrete dots or very short brush strokes of unmixed paint.

When the viewer stands back from a Neo-Impressionist canvas, these dots blend together to form the larger shapes that make up the picture. A contemporary comparison would be with a computer screen, where tiny pixels cohere to create the image projected. As the viewer attempts to 'join the dots', an optical effect is experienced in which the image becomes hazy and seems to float in front of them.

The colours of the painted dots were essential to Neo-Impressionist works, as in the absence of any linear marks it was the colour contrasts that organised each composition. Seurat and Signac codified how the colours could best be combined, borrowing ideas from books on colour theory and optics. The pair termed their theory Divisionism; Fénéon called their painting technique Pointillism, although the two terms and Neo-Impressionism are now often used interchangeably. The artists would often paint borders on the edges of their canvases in a Pointillist fashion, or even paint dots across the picture frames to further unify the visual experience. Seurat – the de facto leader of the group – was influenced by Charles Henry's writings on physiological responses to line and colour. He also experimented with the golden ratio, an ancient formula for arranging lines in space. Pointillist techniques briefly spread outside of France, to Belgium and the Netherlands.

The movement's real momentum ground to a halt following Seurat's untimely death in 1891. The Pissarros became disillusioned with the formulaic nature of Pointillism, but Signac continued to develop and write about Neo-Impressionism. His 1899 book *From Eugène Delacroix to Neo-Impressionism* inspired the colour experiments of younger artists, including those of the Fauve group, such as Henri Matisse.

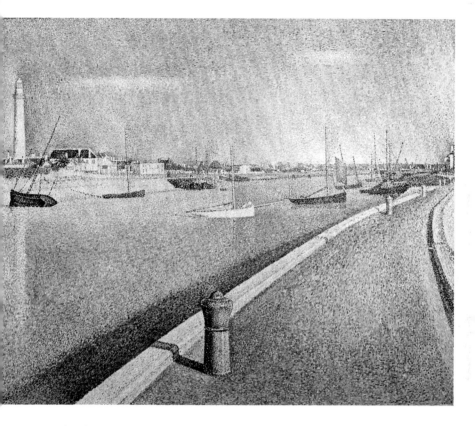

KEY WORK in the Indianapolis Museum of Art, Indiana

The Channel of Gravelines, Petit Fort Philippe,
1890, GEORGES SEURAT
The French painter employed all the methodical
techniques of Neo-Impressionism in this harmonious
harbour scene. He applied pigment in small, subtle dots
of modulating colour, the tonal combinations studied in
advance to ensure they produced a luminous visual
effect. The tranquil atmosphere is underpinned by a
pleasing sense of structure, enabled by the swooping
diagonal curve of the promenade and the row of boats
arranged evenly along the horizon.

OTHER WORKS in the Indianapolis Museum of Art

Woman Washing Her Feet in a Brook, 1894,
CAMILLE PISSARRO
Interior of the Studio, 1887, **LUCIEN PISSARRO**
*Le Dimanche parisien, from Revue Independent (Edition
de Luxe)*, 1887; *At Flushing*, 1895; *Entrance to the Port
of Honfleur*, 1899, **PAUL SIGNAC**

 Impressionism; Post-Impressionism;
Fauvism

 Constructivism; Dadaism; Arte
Povera; Minimalism; Installationism

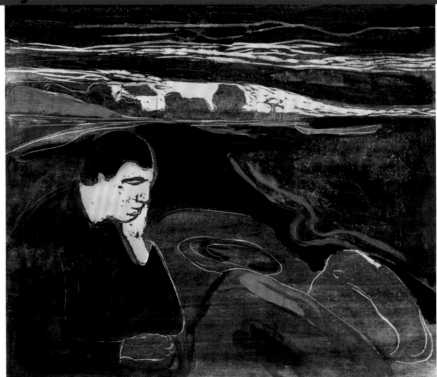

Symbolist artists aimed to express their moods and emotions rather than describe the world around them. This emphasis on psychology often led to disturbing works, the themes of which included anxiety, dreams and mysticism.

JAMES ENSOR (1860–1949); FERNAND KHNOPFF (1858–1921); EDVARD MUNCH (1863–1944); ODILON REDON (1840–1916); FÉLICIEN ROPS (1833–98)

anxiety; emotion; mood; mysticism; subjectivity

Symbolism was spearheaded by writers, in particular the Parisian poets Paul Verlaine, Stéphane Mallarmé and Arthur Rimbaud, who expressed their emotions and ideas instead of describing

the world of appearances. Poet Gustave Kahn wrote in 1886 that 'the essential aim of our art is to objectify the subjective', and in the same year his fellow French writer Jean Moréas published his Symbolist manifesto, announcing their goal to 'clothe the Ideal in a perceptible form'.

The Symbolists' rejection of the material world came with a distrust of both bourgeois society and science. In visual art, Realism and Naturalism were dismissed. Joris-Karl Huysman's famous Symbolist novel *A Rebours* (1884) featured a hero who retreats into his private reality, decorating his home with 'evocative works of art which would transport him to some unfamiliar world'. The painters of these works were the non-fictional French artists Gustave Moreau and Odilon Redon,

who are now considered pioneers of Symbolism.

Symbolist works eschewed traditional emblems and allegories for personal symbols that would connect to the artists' psychic states. Every subject of a Symbolist painting, however everyday it might seem, was descriptive of an emotional or spiritual realm rather than a physical reality. Artists would select their symbols by intuition rather than rationality. Individualism was encouraged, hence the diversity of styles defined as Symbolism. The range of Redon's output illustrates this variety. His early work was solely black-and-white drawings and prints, many of which featured nightmarish visions such as a spider with a human head, but from the 1890s he developed pastels and paintings in rich, hallucinatory colour.

Freed into subjectivity, Symbolist artists could indulge their anxieties and touch upon themes such as sex, disease, anguish and death. Perhaps the most iconic Symbolist work is *The Scream* (1893), an image of existential terror by the Norwegian artist Edvard Munch. Moreau, Frenchman Pierre Puvis de Chavannes and the English Pre-Raphaelite Edward Burne-Jones evoked more delicate moods in paintings characterised by a lyrical mysticism. Mythical subject matter was also a focus of the 'Salons de la Rose + Croix' Symbolist exhibitions in Paris, organised by the occult leader Joséphin Péladan.

Belgians James Ensor, Félicien Rops and Fernand Khnopff were significant Symbolist artists; the former, known for his macabre masked figures, was, like Munch, an inspiration for German Expressionism. The French painter Paul Gauguin's particular brand of Symbolism – Synthetism – was also to prove highly influential for subsequent artists, including the Surrealists.

KEY WORKS in the Cleveland Museum of Art, Ohio

← *Melancholy (Evening)*, **1896, EDVARD MUNCH**
The Norwegian artist's woodcuts are as powerful as his paintings and influenced later Expressionist artists. This example is a quintessential Symbolist landscape, the disjointed shapes and discordant colours of the beach and sea speaking of the mental disquiet of the image's introspective subject.

↙ *Orpheus, c* 1903–10, **ODILON REDON**
Redon illustrated the works of Symbolist writers and was also informed by myth and legend. The ancient Greek story of musician Orpheus, whose severed head sang as it floated down a river, inspired the poetic mood of this pastel; the psychedelic hues in purple and gold are characteristic of the artist.

OTHER WORKS in the Cleveland Museum of Art

The Seven Deadly Sins, 1904, **JAMES ENSOR**
The Sin, 1901, **EDVARD MUNCH**
The Temptation of St Anthony, 1888; *Symbolic Head*, 1890, **ODILON REDON**
The Hanging of Levallois-Perret, c 1880, **FÉLICIEN ROPS**

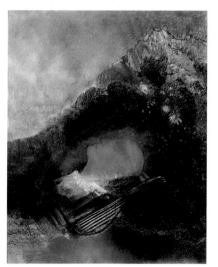

 Synthetism; Secessionism; Expressionism; Surrealism

 Cubism; Kineticism; Pop Art; Photorealism; Neo-Pop

Synthetism was a strand of Symbolism in France that surfaced from the late 1880s. It argued that artists should synthesise their observations of the world with both their emotions and aesthetic considerations. Paintings were particularly flat in appearance, often including large patches of bold colour.

ÉMILE BERNARD (1868–1941); **PIERRE BONNARD** (1867–1947); **MAURICE DENIS** (1870–1943); **PAUL GAUGUIN** (1848–1903); **ÉDOUARD VUILLARD** (1868–1940)

bold colour; flatness; harmony; outline; simplification

Synthetism has been largely forgotten as an avant-garde movement and has been subsumed within Symbolism. However, it can be seen as distinct in its simplification of forms, as well as its attempt to premeditate a successful work of art.

The term has been most closely associated with the work of Paul Gauguin, who is also labelled as a Symbolist and Post-Impressionist. The Paris-born painter exhibited with the Impressionists during the early 1880s, but became disillusioned with their emphasis on perceptions of nature: Gauguin wanted to represent his feelings. Later in the decade he left the capital to spend periods in the Breton village of Pont-Aven; the French countryside was a magnet for artists who hoped that isolation from the stresses and strains of urban life would benefit their practice. At Pont-Aven he met the younger artist Émile Bernard and his work soon underwent a significant shift in style.

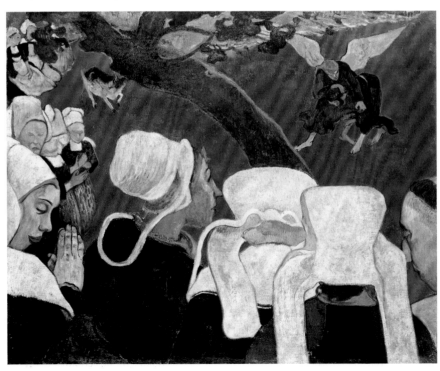

Bernard and Louis Anquetin had developed a style called Cloisonnism. This was characterised by simple shapes of flat, unnatural colour that were outlined in black, in the manner of cloisonné, the ceramic technique in which areas of coloured enamel would be separated from each other in metal compartments (*cloisons*, in French). Inspired by a particular painting of Breton women by Bernard, in 1888 Gauguin produced his groundbreaking work *Vision of the Sermon (Jacob Wrestling with the Angel)*. This featured areas of bright, unmodulated colour much like Bernard's canvas, but it was a much more powerful piece thanks to the dynamism of its composition and the way the chosen colours seemed to be in harmony with the spiritual subject matter.

This and subsequent works by those within Gauguin's circle carefully harmonised three critical elements: the objective world of appearances, the inner world of the artist, and the formal possibilities of line, shape and colour, which could be expressive in themselves. Critic Albert Aurier argued that this synthesis was crucial if Symbolist art was to communicate: art had to be 'synthetic, because it presents these forms, these signs, in such a way that they can be generally understood'.

The Nabis (meaning 'prophets' in Hebrew), a secret brotherhood of Paris art students unhappy with academic conventions, keenly followed Synthetism, inspired by its bold, simplified aesthetic. Like Gauguin and Bernard, the Nabis took influence from the pared-down styles of Japanese prints and medieval stained glass. The most productive members were Paul Sérusier, Maurice Denis, Pierre Bonnard and Édouard Vuillard; the latter two are the best known today, although their work in the 20th century was to depart from Synthetist art and draw more and more from domestic life.

KEY WORKS in the Scottish National Gallery, Edinburgh

Two Seamstresses in the Workroom, 1893,
↑ ÉDOUARD VUILLARD
Vuillard experimented with the Synthetist style in the early 1890s after he joined the Nabis. He used simplified shapes and bright colour in small oils on board, although an abiding interest in decorative pattern also emerged and was to become a hallmark of his work throughout his career.

← *Vision of the Sermon (Jacob Wrestling with the Angel),* 1888, PAUL GAUGUIN
The French painter portrays Breton women imagining the sermon they have heard: the story of Jacob, who wrestled with a mysterious angel. The diagonal branch separates the women from their vision, but the red ground unites them. The flatness of this red and the white headdresses in the foreground is characteristic of Synthetism.

OTHER WORKS in the Scottish National Gallery

Lane at Vernonnet, c 1912–14; *View of the River, Vernon,* 1923, PIERRE BONNARD
Martinique Landscape, 1887; *Three Tahitians,* 1899; PAUL GAUGUIN
The Chat, 1893, ÉDOUARD VUILLARD

 Symbolism; Post-Impressionism; Fauvism; Expressionism; Primitivism

 Neo-Plasticism; Bauhaus; Process Art; Postmodernism; Performance Art

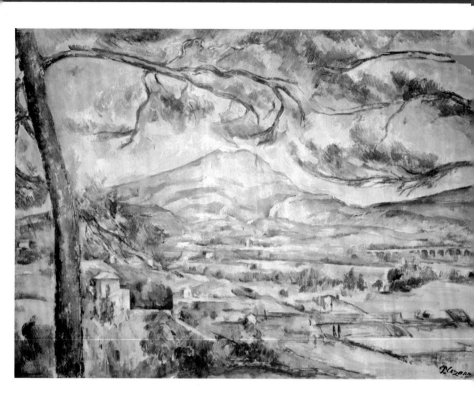

Post-Impressionism is a broad term that describes artistic developments in France from the mid-1880s to the first years of the 20th century, after the heyday of Impressionism. There is no style or manifesto of aims common to the artists, but one can see some trends, such as heightened colour and multiple perspectives, that anticipate the advances of art in the new century.

PAUL CÉZANNE (1839–1906); PAUL GAUGUIN (1848–1903); HENRI ROUSSEAU (1844–1910); HENRI DE TOULOUSE-LAUTREC (1864–1901); VINCENT VAN GOGH (1853–90)

candour; multiple perspectives; structure; transcendent; vivid colour

The English critic and painter Roger Fry first coined the term Post-Impressionism in 1910, for the 'Manet and the Post-Impressionists' exhibition he curated in London. This was the moment the British public was introduced to three decades of French avant-garde; the show presented a wide selection of figures, including Georges Seurat and Paul Gauguin, who had been known in Paris under labels such as Neo-Impressionism, Symbolism and Synthetism.

Many of the works in the exhibition were by influential painters who had passed away, and for that reason Post-Impressionism was very much a retrospective term rather than one with which young artists at the time would commonly identify. But it became a

useful word in identifying two practitioners in particular: Paul Cézanne and Vincent van Gogh, whose groundbreaking canvases pushed art in fertile new directions after Impressionism. Both painted vivid landscapes, but both rejected the Impressionist emphasis on capturing momentary perceptions of the natural world.

Cézanne had exhibited with the Impressionists in the mid-1870s before permanently settling in Aix-en-Provence and developing a range of time-consuming techniques that he declared would 'make of Impressionism something solid and enduring, like the art in museums'. The painter carefully reworked the outlines of forms to underscore their inherent geometric structure: still lifes of fruits would seem like arrangements of spheres and ellipsoids, landscapes fractured compositions of vertical, horizontal and diagonal planes. Cézanne abandoned classical perspective, in which all objects are foreshortened to a single vanishing point. Instead he rendered different elements from different perspectives, so that a representation appeared to contain the sum of viewpoints from which he had viewed a subject.

Van Gogh's canvases pushed the expressive possibilities of paint to the extreme. The Dutch artist's landscapes, portraits and still lifes reflect his overwrought disposition, which was prone to swing from religious euphoria to anxiety. His most transcendent works are full of swirling brush strokes in vivid colour and date to the last two years of his short life, before his suicide in 1890, which were spent in the south of France.

Other artists now bracketed as Post-Impressionist include Henri de Toulouse-Lautrec, whose paintings, poster art and prints depicted the nightlife of hedonistic Parisians with graphic verve, and fellow Frenchman Henri Rousseau, a self-taught painter in the Primitivist manner.

Post-Impressionism can now be seen as the bridge between late 19th-century and early 20th-century art. The work of Van Gogh was to prove an important influence on both Fauvism and German Expressionism, and Cézanne's structural experiments were taken to their logical conclusion in the Cubism pioneered by Pablo Picasso and Georges Braque.

KEY WORK in the Courtauld Gallery, London

Montagne Sainte-Victoire, c **1887, PAUL CÉZANNE**
The French painter kept returning to this peak in Aix-en-Provence throughout his career. The mountain and surrounding landscape is rendered as a patchwork of discrete shapes, a technique that typified the artist's mature work. The branches in the foreground follow the contours of the mountain range, making the summit seem close.

OTHER WORKS in the Courtauld Gallery

The Card Players, c 1892–5; *Still life with Plaster Cupid, c* 1894, **PAUL CÉZANNE**
Toll Gate, c 1890, **HENRI ROUSSEAU**
Jane Avril in the entrance to the Moulin Rouge, putting on her gloves, c 1892, **HENRI DE TOULOUSE-LAUTREC**
Peach Trees in Blossom, 1889, **VINCENT VAN GOGH**

 Symbolism; Secessionism; Fauvism; Expressionism; Cubism

 Minimalism; Postmodernism; Photorealism; Street Art

The withdrawal of artists from established academies and associations was a feature of the arts in Germany and Austria at the turn of the 20th century. They formed new independent groups called Secessions, and those of Munich, Berlin and, in particular, Vienna encouraged experimentation and collaboration between different disciplines.

LOVIS CORINTH (1858–1925); **GUSTAV KLIMT** (1862–1918); **OSKAR KOKOSCHKA** (1886–1980); **MAX LIEBERMANN** (1847–1935); **EGON SCHIELE** (1890–1918)

applied art; decorative; expressive; flat; independent

The first Secession was founded in Munich in 1892, when more than 100 wide-ranging artists from the city's professional association seceded to form their own society, following their dismay at bias and parochialism from the annual exhibition's selection committees.

The Munich Secession never really blazed a trail for the avant-garde, showing only work that was moderately progressive in the context of contemporary European art. But the example Munich set – the bravery to break away and set an independent agenda – was followed in many German-speaking cities, including Berlin, Vienna, Dresden, Karlsruhe, Düsseldorf, Leipzig and Weimar.

In Berlin in 1898, a group of artists seceded formally from the Prussian Academy of Arts. These included Lovis Corinth and the Secession's founding president Max Liebermann, who had a close affinity with the Impressionists in France. The Berlin Secession presented biannual shows that encouraged stylistic diversity and challenged the pre-eminence of the Academy's exhibitions, which continued to reflect the conservative tastes of Kaiser Wilhelm II.

Vienna was to prove the city synonymous with Secessionism. Already a centre for radical cultural, musical, philosophical and psychological theory through those such as Sigmund Freud, Vienna was ripe for an organisation that prioritised artistic experimentation. The Vienna Secession's first show in 1897 was a financial success and raised funds for a permanent exhibition hall, designed in a modern style – geometric and functional – by member Joseph Maria Olbrich; the Secession included architects and designers as well as fine artists. The society was keen to collapse the boundaries between disciplines, influenced from ideas across the English Channel from William Morris and his Arts and Crafts movement.

The venue was the first to present the European avant-garde to a Viennese public. The inscription over the doorway read 'To each age its art, to art its freedom', and the painters in the group, led by Gustav Klimt, were at liberty to go in their own aesthetic directions. However, much of their work shared a flat and decorative style, with Klimt notable for his use of gold and silver paint and fragments of jewellery and mother-of-pearl. His erotic depictions of women are among some of the most sumptuous pieces of turn-of-the-century art. Klimt intended ornamentation to be expressive of emotional states, and he championed young Expressionists like Oskar Kokoschka and Egon Schiele.

In 1905 there was a split in the Secession between a faction that wanted to concentrate on fine art (the Naturalists) and those, including Klimt, who wished for even closer connections with applied art and commerce (the Stylists). The latter formed a new group, the Klimtgruppe, and its members worked closely with the Wiener

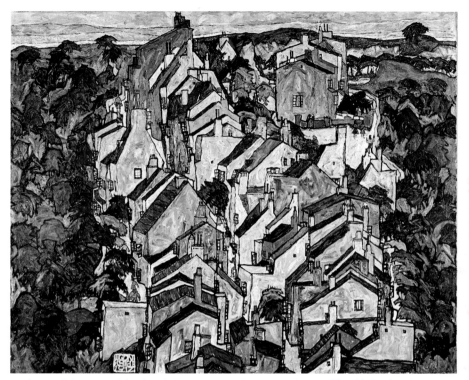

Werkstätte (Vienna Workshop), a design studio committed to producing jewellery, ceramics, furniture and textiles accessible to all. Through the workshop, the Secession further influenced the applied arts of Art Nouveau and Art Deco, and helped create the climate for Bauhaus and International Style design.

KEY WORKS in the Neue Galerie, New York

Adele Bloch-Bauer I, 1907, GUSTAV KLIMT *(see p10)*
Alongside *The Kiss*, which was painted in the same year, this portrait is at the zenith of the Austrian painter's more lavish output, a masterpiece encrusted from top to bottom in gold and silver geometric shapes and swirls. The Vienna Secession artist believed such decoration could express emotion as well attract the eye.

Town among Greenery (The Old City III), 1917, **EGON SCHIELE**
A protégé of Klimt, Schiele died young but left a large and hard-hitting body of work characterised by searing, semi-grotesque portraits and landscapes painted in twisted perspective, of which this is a fine example. His moody works mark a transition from Secessionism to German Expressionism.

OTHER WORKS in the Neue Galerie

Poster for the first Vienna Secession Exhibition, 1898; *Lucian's Dialogue's of the Courtesans,* 1907, **GUSTAV KLIMT**
Emil Löwenbach, 1914; *Self-Portrait Seen from Two-Sides as the Painter,* 1923, **OSKAR KOKOSCHKA**
Portrait (Head of a Young Man), 1917, **EGON SCHIELE**

 Symbolism; Post-Impressionism; Synthetism; Expressionism; Bauhaus

 Dadaism; Conceptualism; Arte Povera; Interventionism

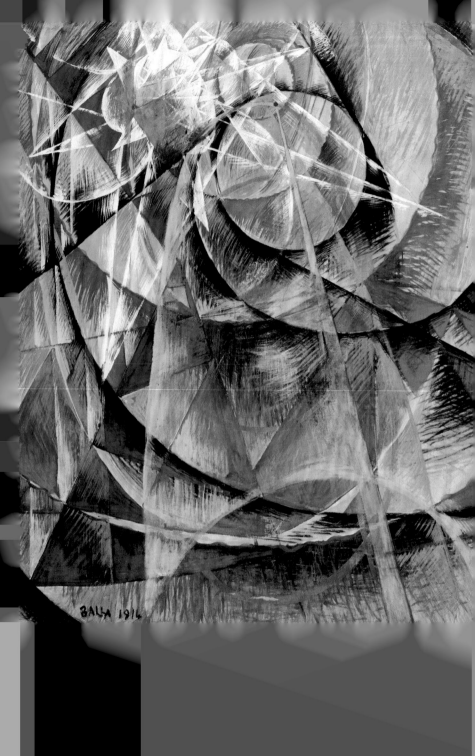

2

EARLY
20TH CENTURY

Modernism

This very broad term summed up the character of society, culture and thought in the modern era. In art it signified a departure from the classical traditions taught since the Renaissance, and is an umbrella term for many isms in this book. But exactly what Modernism meant, when it started, and if and whether it ended (see 'Postmodernism'), continues to be open to debate.

WASSILY KANDINSKY (1866–1944); **KASIMIR MALEVICH** (1878–1935); **HENRI MATISSE** (1869–1954); **LÁSZLÓ MOHOLY-NAGY** (1895–1946); **PABLO PICASSO** (1881–1973)

anti-establishment; experimentation; fundamental truth; new; progress

Modernism, in its broadest sense, was the character of the modern era. The task of trying to describe this character has been undertaken across a range of cultural fields and academic areas, including literary criticism, philosophy, sociology, linguistics, architecture, music and visual art, each discipline having defined and dated Modernism differently.

The key feature of Modernism in visual art, shared by all the isms in this book, was the intention to break with tradition and progress into new artistic territory. This began with the bravery of anti-establishment painters in the late 19th century, such as the Impressionists and Secessionists, who exhibited independently from the academies. The institutions' teachers and selectors for their exhibitions were conservative, dedicated to preserving the status quo, which was work that conformed to classical standards: realistic representations, in proportion and perspective, that would often be historical, religious or moral in theme.

'No more official beauty,' proclaimed the French poet Jules Laforgue in 1883, once the Impressionists had started to stage their own shows: 'The public, unaided, will learn to see for itself and will be attracted naturally to those painters whom they find modern and vital.' Instead of seeing their innovative work rejected by the establishment, artists could go straight to the public to attract collectors and make a living. They could choose their own artistic standards, codify them in manifestos and see whether people responded positively.

This experimentation with alternative ways to paint, sculpt and print became commonplace in the 20th century and moved in myriad different directions. As one can see in the following chapters, international Modernist movements were apt to contradict one another in their quest to be new. But common to all was a sense that with the right way forward, one could disclose fundamental truth, whether this truth was spiritual, ethical, rational or emotional. Some critics have argued that the move from Modernism to Postmodernism occurred in the late 20th century when it was acknowledged that this truth, in fact, could never be revealed.

Some quintessential Modernist artists discussed in more detail elsewhere in this book include Henri Matisse and Pablo Picasso, whose work did not stop respectively at Fauvism and Cubism and who embraced new forms of art throughout their careers; the Suprematist Kasimir Malevich and Expressionist Wassily Kandinsky, who both made the great leap forward into abstract art; and the Hungarian László Moholy-Nagy, who taught the foundation course at the first great Modernist art school, the Bauhaus.

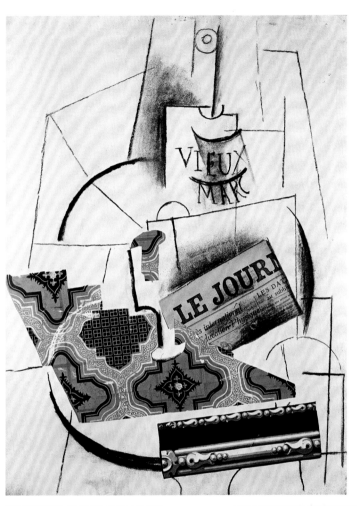

KEY WORKS in the Centre Pompidou, Paris

The Bottle of Vieux Marc, 1913, PABLO PICASSO
If Modernism is defined by the rejection of old modes for new, then Picasso's restless career sums up its spirit: his output progressed continually from ism to ism. This is an example of the Spanish artist's collage works that helped precipitate the transition from Analytic Cubism to Synthetic Cubism. The pasting of a newspaper into the piece is a particularly radical move: the newspaper represents itself, as if the artist dissolves the distinction between the artwork and the world outside.

OTHER WORKS in the Centre Pompidou

Impression V (Park), 1911, **WASSILY KANDINSKY**
Running Man, c 1932, **KASIMIR MALEVICH**
Sorrows of the King, 1952, **HENRI MATISSE**
Flower, c 1925–7, **LÁSZLÓ MOHOLY-NAGY**
Bust of a Woman, 1907, **PABLO PICASSO**

 Cubism; Suprematism; Surrealism; Neo-Plasticism; Abstract Expressionism

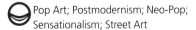 Pop Art; Postmodernism; Neo-Pop; Sensationalism; Street Art

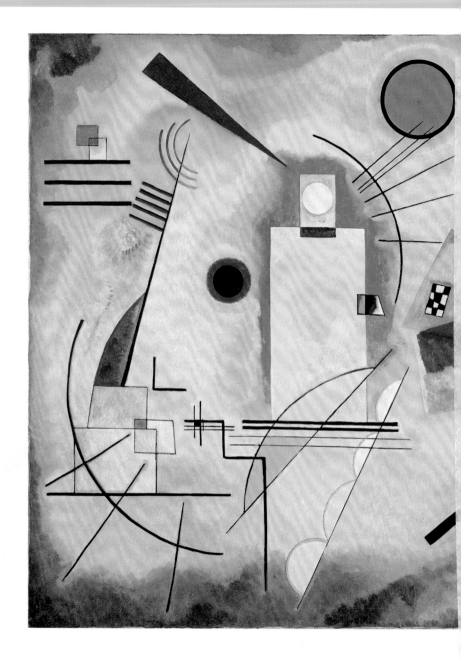

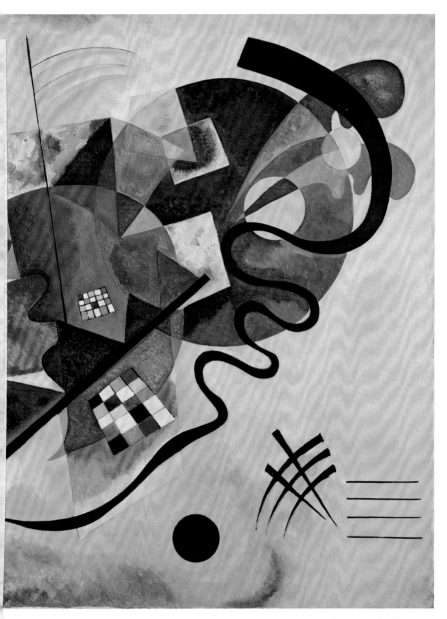

Yellow, Red, Blue, **1925, WASSILY KANDINSKY**
Modernism has often been associated with the clean lines and harmonious arrangements of shapes found in geometric abstraction. Kandinsky's works from the early 1920s are some of the most lyrical examples of this style, his colourful compositions of circles, triangles, squares, curved lines and acute angles musical in their synaesthesic sensibility.

The Fauves ('wild beasts', in French) were a group of Parisian painters who, between the years of about 1898 and 1906, applied intensely bright colour to their canvases in rough, instinctive brush strokes. Chroma corresponded to the artists' emotional states rather than the actual colour of what they were painting.

GEORGES BRAQUE (1882–1963); ANDRÉ DERAIN (1880–1954); HENRI MATISSE (1869–1954); KEES VAN DONGEN (1877–1968); MAURICE DE VLAMINCK (1876–1958)

flatness; instinctive brush strokes; intensity; non-natural colour; simplification

Fauvism caused shockwaves with its seemingly arbitrary use of kaleidoscopic and exceptionally vivid colour. There was sometimes no relation between a tone chosen for a subject and the colour of that subject in the real world: trees could be bright pink, grass blue and human skin orange, and the paint was applied roughly by an instinctive hand rather than by a calculating mind. Details of forms were excluded in favour of simplified scenes featuring flat areas of pigment.

Clashing colour seemed to be the opposite of good taste to more conservative eyes, and it was the consternation of one critic, Louis Vauxcelles, that gave the movement its name. The independent Salon d'Automne in Paris presented a selection of works in this brash style in 1905, by artists including Henri Matisse, André Derain, Kees van Dongen and Maurice de Vlaminck, alongside an Italianate bust; Vauxcelles proclaimed the sculpture was like '*Donatello parmi les fauves*' ('a Donatello among wild beasts'). The painters picked up with pride the pejorative term '*fauves*'. It was a perfect label for a modern art movement in many respects, as it highlighted how much their work departed from the traditional manner. It was not long before enlightened collectors of modern art began to buy the Fauves' work in bulk.

In many ways the Fauves built on foundations laid by artists before them. Matisse's claim that the 'chief aim of colour should be to serve expression as well as possible' sounds like something from the Symbolist manifesto from the previous century, which placed expression above realistic representation; indeed, the Symbolist Gustave Moreau taught Matisse – the central figure of the movement – as well as fellow Fauves Charles Camoin, Henri-Charles Manguin, Albert Marquet and Georges Rouault. When Paul Signac published his Neo-Impressionist treatise in 1899, Matisse was immediately attracted to the older artist's ideas about colour and composition; in 1904 the two spent time together in St Tropez where Signac had a studio. Matisse and Derain also studied the Synthetism of Paul Gauguin, and their works shared the latter's emphasis on broad areas of colour. Vlaminck's rough handling of paint was indebted to Vincent van Gogh, whose work he first saw in 1901.

Fauvism started to dissipate from 1906, with Cubism emerging in Paris as the new avant-garde, spearheaded by Pablo Picasso and Fauve Georges Braque, and followed by Derain. Vlaminck was hostile to Cubism and his work remained expressionistic, if increasingly concerned with structure. Matisse briefly experimented with Primitivist representations, before assuming a more decorative style and applying colour with greater consideration.

KEY WORK in the San Francisco Museum of Modern Art, California

Woman with a Hat, 1905, HENRI MATISSE
Included in the famous Fauve show at the Salon d'Automne in Paris in 1905, this portrait of his wife by Matisse caused a particular outcry, such was the violence of the brush strokes and the non-naturalism of the colour: bright red for her hair and green for her nose, for example. Such distortions had not been seen before in Western portraiture.

OTHER WORKS in the San Francisco Museum of Modern Art

Biblical Group, 1912, **ANDRÉ DERAIN**
Landscape: Broom, 1905; *The Girl with Green Eyes,* 1908, **HENRI MATISSE**
The Black Chemise, 1905–6, **KEES VAN DONGEN**

 Post-Impressionism; Modernism; Expressionism; Primitivism

 Precisionism; Minimalism; Photorealism; Interventionism

Expressionism

Expressionism generally describes art that privileges the display of emotions, and more categorically references art of this nature in Northern Europe, particularly Germany, from 1905 to 1920.

WASSILY KANDINSKY (1866–1944); **ERNST LUDWIG KIRCHNER** (1880–1938); **FRANZ MARC** (1880–1916); **GABRIELE MÜNTER** (1877–1962); **EMIL NOLDE** (1867–1956)

angular; emotion; semi-figurative; spiritual; woodcuts

German Expressionism was grounded in two artist groups: Die Brücke (The Bridge) and Der Blaue Reiter (The Blue Rider). The former was founded in Dresden in 1905 by four students – Fritz Bleyl, Erich Heckel, Ernst Ludwig Kirchner and Karl Schmidt-Rottluff – who declared in their manifesto: 'We want to free our lives and limbs from the long-established older powers. Anyone who renders his creative drive directly and genuinely is one of us.'

The group grew in number, with notable members including Emil Nolde, Max Pechstein and former Fauve Kees van Dongen. They believed that art could express the truth of the human condition.

Their stark aesthetic had a fierce expressive power, both in paintings – which, in palette, mirrored the bright non-naturalism of Fauvism in Paris – and two-tone woodcuts. These prints revived a German and Northern European woodcut tradition and were among the most affecting pieces the group produced. The emotion-laden graphic work of Edvard Munch was an important inspiration. One can see the clear influence on German Expressionism of Symbolists like Munch and Paul Gauguin, as well as the Post-Impressionist Vincent van Gogh. Die Brücke's most fertile period was after 1910, when members moved to Berlin. Their hard-edged aesthetic perfectly captured the intensity and alienation of city life.

Der Blaue Reiter, active in Munich from 1911, placed more emphasis on mysticism and created works in a more lyrical style. The key protagonists included the Germans Gabriele Münter and Franz Marc, Moscow-born Wassily Kandinsky and Swiss artist Paul Klee. Kandinsky believed openness to emotion could bring connection with the spiritual realm. He aimed to 'awaken the capacity to experience the spiritual in material and in abstract phenomena'. From 1909 he moved decisively towards abstraction when he started his series of 'Improvisations', the brilliant semi-figurative shapes and squiggles of which hardly depicted objects in any concrete way. During the following few years his work became more abstract. He asserted that colours and abstract shapes carried meaning in themselves, much like music.

In fact, Kandinsky heard music when he saw colour, as he benefited from the neurological condition synaesthesia, in which an individual finds that two usually separate senses are combined. The Russian artist explained in his inspiring tract *On the Spiritual in Art* (1911) that 'a light blue is like a flute, a darker blue a cello.'

Although Expressionism is most closely associated with visual art in Germany, two other great Expressionist painters were the Austrians Oskar Kokoschka and Egon Schiele. Both associated with the Vienna Secession (see 'Secessionism'), but their visceral works departed from the decorative.

Die Brücke disbanded in 1913 and the First World War took its toll on Der Blaue Reiter. However, once the war was over, Klee and Kandinsky were to teach at Weimar's influential Bauhaus school in the 1920s, and Expressionist ambitions were now on the agenda for many art movements to come.

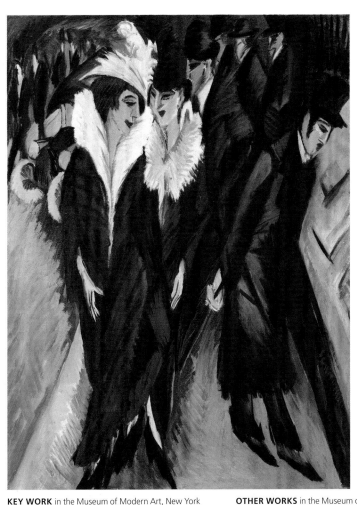

KEY WORK in the Museum of Modern Art, New York

Street, Berlin, **1913, ERNST LUDWIG KIRCHNER**
Kirchner's memorable scenes of men and women
strolling the streets of Berlin express the excitement and
emotional anxiety the artist felt once he moved to the
city from Dresden. In this piece, jagged diagonals deliver
a sense of movement and menace. The two women
surrounded by lurking men are prostitutes. Are they
under the control of the man with the cane, which
almost touches them?

OTHER WORKS in the Museum of Modern Art

Improvisation, c 1914, **WASSILY KANDINSKY**
Girl on a Divan, 1906, **ERNST LUDWIG KIRCHNER**
Blue Horse with Rainbow, 1913, **FRANZ MARC**
Interior, 1908, **GABRIELE MÜNTER**
Knight, 1906, **EMIL NOLDE**

Primitivism; Bauhaus; Neue
Sachlichkeit; Abstract Expressionism

Pop Art; Op Art; Postmodernism;
Photorealism; Neo-Pop

Primitivism

Primitivism described how Western artists assimilated styles of non-Western art and archaic art outside the Western academic tradition. It was an important ingredient in European art movements of the early 20th century, such as German Expressionism and Cubism, although it was often rooted in reductive ideas about other cultures.

MAX ERNST (1891–1976); **ERNST LUDWIG KIRCHNER** (1880–1938); **AMEDEO MODIGLIANI** (1884–1920); **HENRY MOORE** (1898–1986); **PABLO PICASSO** (1881–1973)

authenticity; colonial; human expression; reductive; vitality

European artists' infatuation with cultures they saw as 'exotic', especially those of the Middle East and Asia, found early expression in the Orientalist painting of the 19th century. These representations of foreign cultures could be highly stereotyped – with a focus on scenes of sensuality or barbarism – and academic in style, composed naturalistically in traditional perspective.

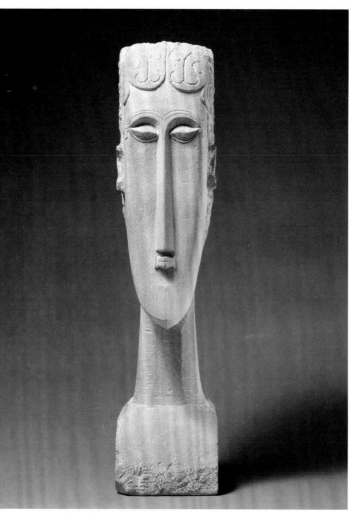

Primitivism in the 20th century was, however, less about depictions of 'strange lands' than a wish to learn formal lessons from non-Western artworks. In Pablo Picasso's monumental Primitivist work *Les Demoiselles d'Avignon* (1907), the Spanish painter's subject is a group of prostitutes from a Barcelona brothel, but the five women

shown are radically modelled in two dimensions much like a three-dimensional sculpture of African origin: their bodies are constructed from geometric shapes that directly mirror the pared-down forms of Dan, Fang and Songye masks and Kota reliquary figures that Picasso studied in the Musée d'Ethnographie du Trocadéro in Paris.

While non-Western art offered Picasso new avenues to explore structure, setting him off towards the formal experiments of Cubism, its emotional authenticity was the attraction for the many others who absorbed its aesthetic, such as the German Expressionists Emil Nolde and Ernst Ludwig Kirchner. Modern European sculptors were also inspired by non-Western art, as well as by archaic art that the academies ignored: the Italian Amedeo Modigliani mimicked the elongated shapes of Cycladic statuettes in his portraits in both two and three dimensions; Englishman Henry Moore used Pre-Columbian work from Central and South America as the starting point for his semi-figurative sculptures.

There was a sense that Western art from the Renaissance onwards had obscured real human expression with academic artifice. The uncorrupted 'primitive' from an alternative tradition could, in contrast, create art without such calculation, with a vigour and simplicity that had greater emotional or spiritual truth. This attitude can be seen earlier in the mystical Synthetist paintings Paul Gauguin produced in Tahiti in the 1890s. In the 1920s, Surrealists like Max Ernst and Joan Miró developed Primitivism in a new psychoanalytic direction, as they believed that African and Oceanic works were closer to their authors' unconscious.

But Primitivism should be seen as essentially reductive. The insinuation that non-Western artists were all instinct rather than intellect can be seen as an extension of the colonial mindset. The complex meanings that non-Western art objects had for their makers were commonly disregarded, and recent artworks were not always distinguished from objects decades and centuries older, as if the regions in which they were made had no cultural history. Primitivism also widened as a term to take in naive art, folk art and art produced by children, untrained people and those with mental illness (Outsider Art). The avant-garde may have praised these different arts for their vitality and clarity, but their conflation was lazy and disrespectful.

KEY WORK in the Metropolitan Museum of Art, New York

Woman's Head, 1912, **AMEDEO MODIGLIANI**
Modigliani's stylised heads in paint and stone have a clear connection to African sculpture, as well as that of ancient Egypt and the Bronze Age Cycladic civilisation. An American collector of African art acquired this bold example, which the Italian artist carved out of limestone.

OTHER WORKS in the Metropolitan Museum of Art

The Barbarians, 1937, **MAX ERNST**
Head of a Woman (Franzi), c 1910–15, **ERNST LUDWIG KIRCHNER**
Reclining Nude, 1917, **AMEDEO MODIGLIANI**
Gertrude Stein, 1905–6; *Bust of a Man*, 1908, **PABLO PICASSO**

 Synthetism; Fauvism; Expressionism; Cubism; Surrealism

 Constructivism; Social Realism; Pop Art; Postmodernism; Photorealism

Cubism

Cubist artists combined a large range of viewpoints in one picture or sculpture. Georges Braque and Pablo Picasso developed Cubism in Paris between 1909 and 1914.

GEORGES BRAQUE (1882–1963); **JUAN GRIS** (1887–1927); **FERNAND LÉGER** (1881–1955); **JACQUES LIPCHITZ** (1891–1973); **PABLO PICASSO** (1881–1973)

Analytic; facets; geometry; multi-perspectivism; Synthetic

The co-creators of Cubism were the Spanish titan of modern art, Pablo Picasso, and the French former Fauve Georges Braque: in Braque's words they 'were like two mountain climbers roped together'.

The two artists furthered the two techniques pioneered by Post-Impressionist Paul Cézanne. The French artist would emphasise the geometry of things and paint different objects in one work from slightly different perspectives; on occasion different parts of a single object would be rendered from a variety of viewpoints. The fractured forms of Picasso's Primitivist masterpiece *Les Demoiselles d'Avignon* (1907) showed the influence of Cézanne as well as African art. In 1908, Braque completed landscapes in the fishing village of L'Estaque that, in the words of a critic, reduced 'everything, landscape and figures and houses, to geometric patterns, to cubes'.

Once they started working together in Paris from 1909, the two artists' representations of the world became more geometric and less realistic. They began to fracture the objects into a large number of sharp-angled shapes (known as facets), all painted from different perspectives. The canvases were monochromatic – in variations of grey or beige – as the artists wanted to avoid the expressive qualities of colour. Their multi-perspectivism became radical – the facets were all drawn from different angles and, to make matters more complicated, they appeared to overlap. The result was a flat, fractured arrangement of geometric areas rather like a jigsaw puzzle with the pieces mixed up.

It was as if the Cubists wanted to combine in one work all the past and future views of their subject, to get to a more 'real' sense of it. This corresponded to the concept of 'simultaneity' articulated by French philosopher Henri Bergson at the time, in which past, present and future are in flux. Cubism's intellectual complexity saw it described as the first 'conceptual' movement in painting, and its first phase of development is known as Analytic Cubism.

From 1912 one can see a second stage take shape – Synthetic Cubism. Having deconstructed the world into a tessellation of unexpressive monochrome shapes, colour was injected into Cubist canvases, fewer facets were used and more attention was paid to the visual wit and rhythm of compositions. This new phase was related to the Cubists' discovery of collage techniques, which included *papiers collés* (cut-and-pasted papers) and the application of mixed-media elements such as cloth and newsprint.

Although Picasso and Braque showed their work rarely before the First World War, it filtered out and inspired other international artists. Spaniard Juan Gris, Frenchman Fernand Léger and the Mexican Diego Rivera became enthusiastic exponents of Synthetic Cubism. French artist Raymond Duchamp-Villon and Lithuanian Jacques Lipchitz followed up Picasso's Cubist experiments in three dimensions. Futurists, Orphists, Rayonists and Vorticists also quickly assimilated Cubist techniques.

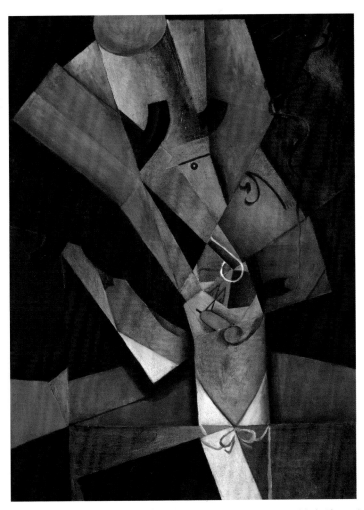

KEY WORK in the Thyssen-Bornemisza Museum, Madrid

The Smoker (Frank Haviland), **1913, JUAN GRIS**
After 1912, Cubism embraced colour in a stage known as Synthetic Cubism, and the work of Spanish artist Gris came to prominence at this time. The large green, blue, orange and red planes in this portrait are reminiscent of the paper collage pieces with which Picasso and other Cubists experimented.

OTHER WORKS in the Thyssen-Bornemisza Museum

The Park at Carrières-Saint-Denis, 1909,
GEORGES BRAQUE
The Disc, 1918; *The Staircase (Second State),* 1914,
FERNAND LÉGER
Man with a Clarinette, 1911–12, **PABLO PICASSO**

 Primitivism; Futurism; Orphism; Rayonism; Vorticism

 Surrealism; Social Realism; Abstract Expressionism; Postmodernism

Futurism

Futurism was an Italian movement that came to international prominence from 1909. It celebrated in painting and sculpture the dynamism of modern urban life, in particular new technology such as the motorcar.

GIACOMO BALLA (1871–1958); **UMBERTO BOCCIONI** (1882–1916); **CARLO CARRÀ** (1881–1966); **GINO SEVERINI** (1883–1966)

dynamism; lines of force; military aggression; speed; technology

Futurism was the brainchild of Italian poet Filippo Tommaso Marinetti, who published an article in a French newspaper in 1909 that, in extravagant and highly quotable rhetoric, set out a plan for cultural revolution. Marinetti eulogised elements he saw as vital to the modern age: industry, technology, military aggression, dynamism and speed, which was summed up by the motorcar. He proclaimed that 'a roaring motorcar which seems to run on machine-gun fire' was more beautiful than a well-known ancient Greek sculpture, and railed against academic tradition, as epitomised by the 'gangrene of professors, archeologists, antiquarians and rhetoricians'.

Marinetti went on to produce highly experimental works of literature, such as his artist book of his poem *Zang Tumb Tumb* (1914), which used onomatopoeia and radical typography to evoke the rhythms of a battle. But he was not just addressing writers with his Futurist manifesto, and by 1910 a group of painters had formed around him who issued two further manifestos, one of which claimed enmity 'against the supine admiration of old canvases, old statues and old objects, and against the enthusiasm for all that is worm-eaten, dirty and corroded by time'. The dominant style of their art, however, was not clarified until the

following year, once members Carlo Carrà, Umberto Boccioni, Luigi Russolo and Gino Severini had seen Cubist works in Paris.

The Futurists took the sharp geometric shapes of Cubism for their own canvases, concentrating not on still lifes and portraits, but instead on scenes such as crowds in city centres and cars and trains in flux. They extenuated a sense of rhythm and movement by using more varied marks and colour contrasts than their Cubist cousins; Futurist Giacomo Balla also studied photographic sequences of people in motion for this purpose. The Futurists wanted their art to have a visceral effect, the dynamism of their subject matter translating directly into the viewer's experience: they declared that their 'lines of force must envelop the spectator and carry him away'.

In 1912, a travelling exhibition of Futurist artworks captured the imagination of other artists in European capitals including Paris, Berlin and London. The English avant-garde Vorticism owed much to the Italians' experiments, as did Rayonism in Russia. Although Futurism as a visual art is closely associated with vibrant paintings, there were examples of sculpture on show, most notably pieces by Boccioni; his bronze *Unique Forms of Continuity in Space* (1913) showed a semi-figurative man striding forwards, his muscles bulging and blurring to evoke motion.

Marinetti and others in the group agitated for Italy to join the First World War. However, the conflict eventually took the wind out of the movement's sails: new machines did not seem so attractive once they had been used in what the Cubist Fernand Léger called 'the perfect orchestration of killing'. Futurism's finest moments had already passed and it continued only in a less transgressive, more lyrical vein until the end of the 1920s.

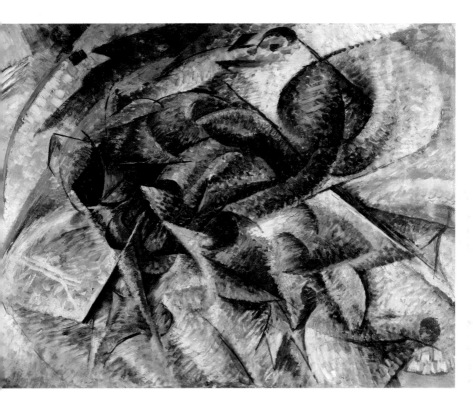

KEY WORKS in the Gianni Mattioli Collection at the Peggy Guggenheim Museum, Venice

Dynamism of a Cyclist, 1913, **UMBERTO BOCCIONI**
The racing cyclist was a symbol of dynamic movement ripe for Futurist representation. Boccioni paints choppy, curving shapes of colour to represent a cyclist hunched over the handlebars and speeding away in a blur. The artist's use of short brush strokes was inspired by Neo-Impressionist works.

Mercury Passing Before the Sun, 1914,
GIACOMO BALLA *(see p26)*
We look away from the city to the sky in Balla's depiction of a partial eclipse of the sun, which he witnessed through a telescope. The picture is completely energised by the contrast of the central spiral with the orange and blue triangles. The white triangular shapes and green cone may represent the optical traces Balla experienced on his retina.

OTHER WORKS in the Gianni Mattioli Collection at the Peggy Guggenheim Museum

Paths of Movement + Dynamic Sequences, 1913,
GIACOMO BALLA
Study for The City Rises, 1910, **UMBERTO BOCCIONI**
The Galleria in Milan, 1912; *Interventionist Demonstration,* 1914, **CARLO CARRÀ**
Blue Dancer, 1912, **GINO SEVERINI**

 Cubism; Rayonism; Vorticism; Constructionism; Precisionism

 Kitchen Sink; New Realism; Neo-Expressionism; Installationism

Orphism

Orphism – or Orphic Cubism – was a term concocted by the French poet and critic Guillaume Apollinaire in 1913 to define a trend of highly colourful, lyrical painting that emerged from Cubism in Paris, exemplified by the abstract compositions of Robert Delaunay.

ROBERT DELAUNAY (1885–1941); SONIA DELAUNAY (1885–1979); FRANTIŠEK KUPKA (1871–1957)

colour contrasts; kaleidoscopic; lyrical; musical; pure abstraction

In an essay in 1913, Apollinaire claimed that some Cubist painters had rejected representation. Their new style, heralded by the critic as Orphic Cubism, or Orphism (the terms were to be used interchangeably), was 'the art of painting new totalities with elements that the artist does not take from visual reality, but creates entirely by himself'. Orphism was non-representational, in Apollinaire's definition:

an exploration of colour and geometry that owed nothing to the actual form of objects.

The key proponent was Robert Delaunay, a French painter in whose Paris apartment Apollinaire stayed at the end of 1912. From 1909 Delaunay had represented buildings in the city in the Cubist fashion of fractured geometric facets. But the paintings Apollinaire saw in 1912 were more radically abstract, so that although one might recognise the outline of the Eiffel Tower in one area, most of a canvas was covered in simple shapes of alternating hues.

Delaunay had become particularly interested in the aesthetic effects of colour contrasts. He studied the colour theories of the Neo-Impressionists, as well as scientist Michel-Eugène Chevreul's theory of simultaneous colour contrasts, which tried to explain how different colours could be perceived at the same time. Two other Parisian artists working in the same mode as Delaunay by 1912 were his Russian wife Sonia and František Kupka, who was

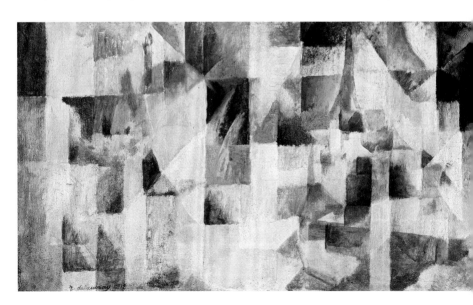

Orphism

born in Bohemia, later Czechoslovakia. Sonia Delaunay became well known for spreading the style to costume and textile design.

The word Orphism was derived by Apollinaire from the Greek myth of Orpheus, a lyre-playing poet whose significance was earlier suggested by Symbolist artists (see 'Symbolism', in particular the painting *Orpheus* by Odilon Redon). Legend had it that Orpheus could charm all things with his musical abilities, including mortals, gods and inanimate objects. Apollinaire labelled the Delaunays and Kupka Orphists – together with French artists including Fernand Léger, Francis Picabia, Marcel Duchamp, Albert Gleizes and Jean Metzinger – because he saw their abstract work as analogous to the musical power of Orpheus: transcendent, romantic, hypnotic, resonant of emotion and spirituality. The connection between music and visual art had become a popular point of discussion, and one pursued notably by Expressionist Wassily Kandinsky,

whose synaesthesia meant he could 'hear' colours as music.

But none of the practitioners were enamoured with the name Orphism; even Delaunay avoided it, preferring to discuss 'simultaneity' in the terms of Chevreul. A disagreement over the definition of the latter word caused a split between Apollinaire and Delaunay, and by 1914 the critic had turned his attention to Futurism, never discussing Orphism again. Indeed, the majority of artists championed as Orphists by Apollinaire – such as Léger and Gleizes – were better categorised as Cubists, as they represented objects and were hardly preoccupied with the correlation between music and painting.

Whether or not Orphism was a popular label in its day, the term helps bring attention to the often sublime works of the Delaunays and Kupka. These pioneered a form of pure abstraction at the same time as the more famous experimentations of Kandinsky and the Suprematist Kasimir Malevich.

KEY WORK in the Philadelphia Museum of Art, Pennsylvania

Three-Part Windows, 1912, ROBERT DELAUNAY
Orphism broke away from Cubism by ceasing to depict objects, instead concentrating only on the colour contrasts of abstract shapes. Delaunay's wide canvas demonstrates this new direction. There are traces of the Eiffel Tower, of which he used to paint Cubist representations, but nearly all the pictorial space is spread with non-descriptive polychromatic forms.

OTHER WORKS in the Philadelphia Museum of Art

Eiffel Tower, c 1909; *Eiffel Tower: No 2*, c 1910–11; *Study for 'The Cardiff Team'*, c 1912–13; *Eiffel Tower*, c 1925; *Untitled*, c 1925, **ROBERT DELAUNAY**

 Neo-Impressionism; Fauvism; Cubism; Futurism; Rayonism

 Neue Sachlichkeit; Surrealism; Social Realism; Pop Art; Photorealism

Rayonism

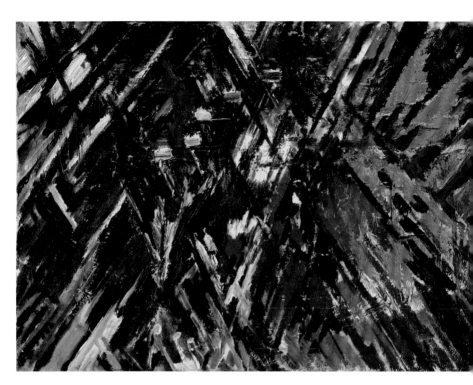

 Rayonism was a short-lived but significant strand of abstract painting that gained prominence in Russia between 1912 and 1914, pioneered by Mikhail Larionov and Natalia Goncharova. Their canvases captured the light rays that reflected from objects, rather than the objects themselves.

NATALIA GONCHAROVA (1881–1962);
MIKHAIL LARIONOV (1881–1964)

 fourth dimension; intersections; light rays; reflected; straight lines

Rayonism, or alternatively Rayism or Luchism ('ray' is English for the Russian word *luch*), was first presented to Moscow's public in March 1913 in an exhibition of avant-garde art entitled 'The Target'. Exhibited alongside Russian variants of Cubism, Futurism and Primitivism, some paintings by the artist Mikhail Larionov and his partner Natalia Goncharova inaugurated a new style characterised by the intersections of colourful straight lines and acute triangles. These represented non-visible rays of light rather than any static material objects.

Larionov took the lead in explaining their new mode, writing the Rayonist manifesto and a variety of associated texts. 'If we wish to paint literally what we see,' he claimed, 'we must paint the sum of rays reflecting from the objects.' A Rayonist reproduced in paint the paths of light rays as they bounced off objects and the 'intangible spatial forms' that were formed where these rays coalesced.

Rayonist works were on a spectrum between what Larionov described as Realistic Rayonism and Pneumo-Rayonism. In the former mode, some objects would remain identifiable in the pictorial space; in Larionov's still life *Rayist Sausage and Mackerel* (1912), the eponymous foodstuffs can still be recognised, although somewhat obscured by the rays of light that reflect from them. Pneumo-Rayonism saw the complete concealment of the object by rays, or the removal of the objective world altogether.

Without the visible world to anchor it, Pneumo-Rayonism assumed metaphysical associations for the artists. Larionov wrote that 'the ceaseless and intense drama of rays constitutes the unity of all things', which could be found in a 'fourth dimension' – a general concept much discussed by thinkers of the time, from mathematicians to mystics. Between 1912 and 1914, Larionov and Goncharova showed their work to the acclaim of avant-garde audiences in Paris, Munich, Rome and London. Their rhetoric about a 'fourth dimension' and their often-expressive use of colour allied them with abstract artists such as Wassily Kandinsky, who saw non-representational art as related to a spiritual realm.

Rayonism and Futurism tend to be mentioned in the same breath because of their dynamic linear marks, as well as the fact that Larionov's obsession with light rays was nurtured by an interest in science and technologies like the X-ray. But unlike the Futurists, both Larionov and Goncharova had a healthy respect for tradition. While they worked on their Rayonist paintings, they proceeded to develop Primitivist pieces that fused Cubist and Expressionist techniques with their native folk art (a style dubbed 'Neo-Primitivism' by the Russian painter and theorist Aleksandr Shevchenko).

The pair's Neo-Primitivism had won out against their Rayonism by 1915, when they started a series of folk-inspired costume and set designs for the Modernist ballet company the Ballets Russes. They had no Rayonist followers of note who could develop the movement. Rayonism, however, had burned brightly and exerted an influence on the subsequent Russian avant-gardes of Suprematism and Constructivism.

KEY WORK in the Museum of Modern Art, New York

Rayonist Composition: Domination of Red, **1912–13, MIKHAIL LARIONOV**
Rayonist works tended to include the name of the movement in their title, as does this exemplar of the style. This vibrant work shows that although Larionov studied science to learn about light rays, when it came to recreating them in oil paint the Russian artist could be bold and instinctive, marking the canvas forcefully with lines of brilliant colour.

OTHER WORKS in the Museum of Modern Art

Electricity, 1912; *Landscape, 47*, 1912, **NATALIA GONCHAROVA**
Rayonist Composition, c 1912–13; *Rayonist Composition: Heads*, c 1913; *Rayonist Composition: Number 8*, c 1913, **MIKHAIL LARIONOV**

 Cubism; Futurism; Vorticism; Suprematism; Constructivism

 Social Realism; Existentialism; Kitchen Sink; Neo-Pop; Interventionism

Vorticism was Britain's first indigenous 20th-century avant-garde, founded in 1914 by Wyndham Lewis. Its name was derived from the word 'vortex'. This short-lived movement has been seen as a variation on Futurism due to its hard-edged, machine-age aesthetic and vitriolic texts, although Lewis – in publications such as the journal *Blast* – distanced his group from the Italian movement.

DAVID BOMBERG (1890–1957); **JACOB EPSTEIN** (1880–1959); **HENRI GAUDIER-BRZESKA** (1891–1915); **WYNDHAM LEWIS** (1882–1957); **CRW NEVINSON** (1889–1946)

architectonic; machine-age aesthetic; maximum energy; vortex

The Bloomsbury Group was London's most influential intellectual circle in the first years of the 20th century: a clique of painters, writers and philosophers who gathered in the Bloomsbury area of the city. Artist and critic Roger Fry, part of the Bloomsbury set, had staged exhibitions of Post-Impressionism in London in 1910 and 1912 that presented avant-garde art from across the English Channel, and with fellow Bloomsbury painters Duncan Grant and Vanessa Bell practised experimental European styles, and created commercial products for Fry's design company, the Omega Workshops, founded in 1913.

However, the same year another Omega artist, Wyndham Lewis, fell out with Fry over a commission and together with three others quit the company and formed a new studio, the Rebel Art Centre, in 1914. The resignation letter criticised Omega for what Lewis perceived as old-fashioned taste: 'The Idol is still Prettiness, with its mid-Victorian languish of the neck… despite the Post-What-Not-fashionableness of its draperies.' He argued for a revolutionary art that would blow away the cobwebs of the conservative Victorian age.

Lewis embraced geometricism with aggressive intensity. He had worked in a semi-representational style similar to Synthetic Cubism, but soon ceased to compose recognisable objects. His works became collisions of irregular polygons, the quadrilaterals and pentagons jutting against one another from every possible angle. His shapes were often heavily outlined in black, so that their spatial integrity was kept intact; this marked a difference from Orphism, in which borders between shapes were more porous to allow their colours to blend in the eye.

Lewis published two issues of the periodical *Blast* in 1914 to publicise his art and ideas. The journal was subtitled *Review of the Great English Vortex* and was created in collaboration with the Modernist poet Ezra Pound. The writer declared in an essay that the vortex was 'the point of maximum energy'; the word also summed up the maelstroms of shapes that Lewis painted, and morphed into a name for his new art movement, Vorticism. The London exhibition of Vorticism was staged in 1915 and featured sculpture as well as paintings, thanks to the work of émigré artists Jacob Epstein and Henri Gaudier-Brzeska.

Blast's radical typography was influenced by publications by the Italian Futurist poet Filippo Tommaso Marinetti, and some of the overblown rhetoric of Vorticism is similar to that of Futurism, particularly that which extols the machine age. Painters affiliated with Vorticism, like David Bomberg and CRW Nevinson, kept some semblance of representation in their works and, like the Futurists, captured subjects in motion, such as horses, crowds and ships.

But Vorticism avoided the Italian movement's rhapsodic romanticism ('fuss

and hysterics', in Lewis'
words); it admired 'the
forms of machinery,
factories, new and vaster
buildings, bridges and
works', but in its optimism
for the future it
understood that these
forms could be impersonal
and harsh. Lewis'
architectonic works evoke
the spatial complexity of
urban environments;
Nevinson's paintings of his
experiences as an
ambulance driver in the
First World War had an
affecting graphic clarity.

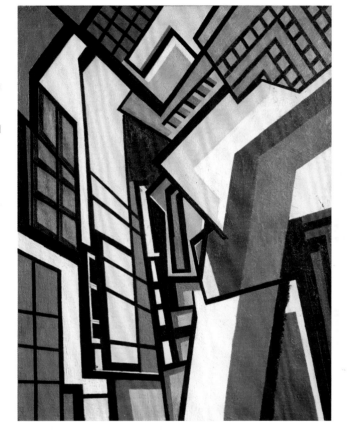

The war destroyed
Vorticism's momentum as
most of the artists went
on active service. Lewis
tried to revive the
movement after the war,
but by then the machine
age was perceived as
essentially destructive –
Gaudier-Brzeska was one
of the millions killed in
action. Vorticism was thus too brief a
movement to challenge Britain's generally
conservative attitude towards modern art.

KEY WORK in the Tate Collection, UK

Workshop, c 1914–15, **WYNDHAM LEWIS**
Vorticist leader Wyndham Lewis evokes the architecture
of the modern city in this characteristic canvas.
Quadrilaterals – echoing perhaps the windows of
buildings – are arranged in clusters on different planes
to give the perception of layers of space. The sharp
diagonal angles and discordant colours add a sense
of dynamism.

OTHER WORKS in the Tate Collection

The Mud Bath, 1914, **DAVID BOMBERG**
Composition, 1913; *The Crowd, c* 1915,
WYNDHAM LEWIS
Bursting Shell, 1915; *La Mitrailleuse*, 1915,
CRW NEVINSON

 Cubism; Futurism; Orphism;
Rayonism

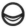 Impressionism; Surrealism; Social
Realism; Pop Art; Neo-Expressionism

Suprematism

A mode of abstract art formulated by Russian painter Kasimir Malevich that flourished from 1915. He reduced form to a minimum: just a small number of simple geometric shapes in solid colours on a white background. Malevich argued that these non-representational pictures could provide 'pure feeling'.

KSENIYA BOGUSLAVSKAYA (1892–1972); EL LISSITZKY (1890–1941); KASIMIR MALEVICH (1878–1935); IVAN PUNI (1894–1956); OLGA ROZANOVA (1886–1918)

non-representational; pure feeling; self-sufficient; simple geometric shapes; the infinite

Cubism and Futurism, from 1909 onwards, had stripped down pictorial space to arrangements of geometric shapes and intersecting lines. But this tendency was taken to an extreme in work by Kasimir Malevich revealed to the Russian public in a presentation of avant-garde art in Petrograd (now St Petersburg) in 1915. *Black Square* (1915) was simply a large black square of paint on a canvas, surrounded by a margin of white. A pamphlet signed by Malevich declared: '*Black Square* is the face of the new art. The Square is a living, royal infant. It is the first step in a pure creation of art.'

This new art was christened Suprematism. 'Before it, there were naive deformities and copies of nature,' the manifesto continued. Representation was the enemy of Malevich and the other pamphlet signatories, who included Kseniya Boguslavskaya, Ivan Puni and Olga Rozanova: 'Only with the disappearance of a habit of mind which sees in pictures little corners of nature … shall we witness a work of pure, living art.'

Unlike Cubism or Futurism, the pictorial forms of Suprematism were entirely self-sufficient and independent of the real world, the shape of the square chosen in particular because it did not manifest itself in nature. Other formally austere works by Malevich painted in 1915

featured just a black circle or a blue triangle intersecting with a black square.

Malevich said that Suprematism was 'the supremacy of pure feeling', but the artist did not mean by this emotional expression. 'Pure feeling' signified the purity of consciousness possible without the contemplation of the objective world. 'I have transformed myself into the nullity of forms and pulled myself out of the circle of things,' explained the artist. Malevich described this realm beyond as 'the infinite'. Although he hung *Black Square* at the corner of two walls in 1915, encouraging its comparison with the Russian icons that usually held that position, he used such words less in terms of religion than science, making reference to 'the infinite abyss' of space.

Between 1915 and 1917, Malevich's works became more dynamic, featuring a greater number of simple shapes that intersected at more points. The next year Malevich completed his series 'White on White', which re-embraced radical reduction by marking white forms with a faint outline on a white background. Suprematism was endorsed by the new regime after the Russian Revolution in 1917 and Malevich became director of the influential Vitebsk art school.

One of Malevich's keenest collaborators at Vitebsk, El Lissitzky, spread Russian abstract art's influence when he travelled to the West in 1922, forming links with the Neo-Plasticists in the Netherlands and the Bauhaus art school in Germany. In the early 1920s the movement was eclipsed at home by Constructivism and then, later in the decade, Social Realism. Its purity of form, however, was resuscitated later in the century with Post-Painterly Abstraction and Minimalism.

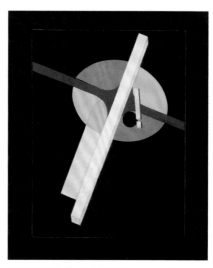

KEY WORKS in the Stedelijk Museum, Amsterdam

↑ *Study for Proun, c 1922,* **EL LISSITZKY**
El Lissitzky developed his own series of Suprematist paintings known as 'Proun' (pronounced 'pro-oon') under the influence of Malevich. These works have a three-dimensional quality, in contrast to Malevich's forms. Lissitzky's interest in architecture was to become more pronounced and align him with the Constructivist movement, which was inspired by real-world structures.

← *Suprematist Composition (With Eight Red Rectangles),* 1915, **KASIMIR MALEVICH**
The task Malevich set himself with Suprematism was to free his work of any possible reference to the objective world. This arrangement of red rectangles is typical in the way that neither the individual parts nor the whole remind the viewer of any specific subject. The colour is consistent across each of the squares, leaving no tonal nuance for the mind to consider.

OTHER WORKS in the Stedelijk Museum

Painterly Realism of a Football Player, 1915; *Suprematism: 18th Construction*, 1915; *Suprematism: Self-Portrait in Two Dimensions*, 1915; *Mystic Suprematism*, 1920–22, **KASIMIR MALEVICH**

 Rayonism; Constructivism; Post-Painterly Abstraction; Minimalism

 Impressionism; Surrealism; Social Realism; Neo-Expressionism

Constructivism

Constructivism debuted with Suprematism in the same exhibition in Petrograd, Russia, in 1915. Although both pursued geometric abstraction, Constructivism differed in its ideology; it was inspired by functional structures and technologies. Its emphasis on social purpose made it the favoured style of the Soviet state by the 1920s.

NAUM GABO (1890–1977); **LYUBOV POPOVA** (1889–1924); **ALEXANDER RODCHENKO** (1891–1956); **VARVARA STEPANOVA** (1895–1958); **VLADIMIR TATLIN** (1885–1953)

construction; geometric abstraction; modern materials; utilitarian; technological

Н. ПУНИН

Проект худ. В. Е. ТАТЛИНА

ПЕТЕРБУРГ
Издание Отдела Изобразительных Искусств Н. К. П.
1920 г.

Artists from different movements have often shown antagonism towards each other, but few have actually come to blows as did Kasimir Malevich and Vladimir Tatlin before a group exhibition in Petrograd in 1915 in which both participated. Their fist fight was sparked off by an ideological difference. While Malevich – the spearhead of Suprematism – believed abstract art should renounce the real world, Tatlin wanted to embrace it; he fabricated geometric reliefs and other sculptures using everyday materials like glass, metal and wood.

Tatlin and likeminded artists, who included Naum Gabo, Alexander Rodchenko and Varvara Stepanova, created constructions that resembled futuristic machinery or buildings such as bridges, towers and cranes. Two-dimensional pieces accompanied these sleek structures: paintings, drawings and prints of precise, simple shapes and smooth lines that seemed like the sketches of an architect or engineer. In their ordered composition, lacking any decorative elements, they captured the spirit of the technological age.

The movement at this time was known as Productivism; it was not until 1921 that the term 'Constructivism' was adopted. Their thinking was in tune with the revolutionaries who took power from 1917. The Communists saw the boundary between art and industry as bourgeois and encouraged artists to work

alongside scientists, architects and engineers to help society progress. Tatlin's work became increasingly Utopian in its ideals; he worked on visionary designs for a tower (the Monument to the Third International, planned from 1919) whose 1,312-foot (400-metre) high metal spiralling form would house rotating structures including a lecture hall and a news centre.

This unrealised project became an icon of Constructivism and was highly influential in the way it collapsed the distinction between sculpture and architecture. But Gabo declared: 'Such art is not pure constructive art but merely an imitation of the machine.' He and his brother Antoine Pevsner split from the group in 1920, unhappy that Tatlin had moved from being influenced by technology to designing technology itself; they believed art should not have a direct social application. Both left Russia by 1923 and helped popularise their less utilitarian form of Constructivism in the West.

The Constructivists who remained in Russia designed functional objects from furniture and ceramics to structural works such as street sales stands. Rodchenko excelled in photography and typography, and his photomontage works, posters and magazine designs are among the movement's finest achievements. Many factories were not progressive enough to produce Constructivist pieces on a large scale, although the textile works of Stepanova and Lyubov Popova enjoyed mass production in 1923 and 1924.

Stalin turned to Socialist Realism from 1928 in order to encourage economic advances, and Constructivism fell out of favour. However, the movement's emphasis on the social function of art and the way it broke boundaries between different disciplines echoed into the future, informing artists until the present day.

KEY WORKS in the Museum of Modern Art, New York

↑ *Spatial Construction No. 12*, c 1920, ALEXANDER RODCHENKO
Rodchenko produced this mesmeric sculpture by cutting concentric ellipses in a single sheet of aluminium-painted plywood and then expanding them into three dimensions. The work has a futuristic feel characteristic of Constructivist art – in a modern material it elegantly evokes the orbits of the planets.

← *Monument to the Third International*, 1920, VLADIMIR TATLIN
The cover of this publication by critic Nikolai Punin, stamped with letterpress, visualises the enormous iron tower Tatlin planned for the International Communist Congress to be held in Moscow in 1921. The artist claimed that it combined 'purely artistic forms with utilitarian goals': although the structure was never built, the functional aspirations it embodied came to define Constructivism over the next decade.

OTHER WORKS in the Museum of Modern Art

Head of a Woman, c 1917–20/1916, **NAUM GABO**
Construction, 1920; *Linear Construction*, 1920; *Line Construction*, 1920, **ALEXANDER RODCHENKO**
Figure, 1921, **VARVARA STEPANOVA**

 Cubism; Futurism; Rayonism; Suprematism; Interventionism

 Impressionism; Social Realism; Neo-Expressionism

Dadaism (also known more simply as Dada) was a multidisciplinary movement that sought to undermine social, political and cultural orthodoxies with works that were intentionally absurd and irrational. It solidified from 1916 as a scathing response to the values that had brought about the First World War. Dadaism was international in scope and provocative in its techniques.

JEAN ARP (1886–1966); **MARCEL DUCHAMP** (1887–1968); **FRANCIS PICABIA** (1879–1953); **MAN RAY** (1890–1976); **KURT SCHWITTERS** (1887–1948)

absurdity; chance; iconoclasm; irrational; readymades

Dadaism was less a pictorial style than a mindset. Taking shelter from the Great War in the neutral country of Switzerland, a group of writers, artists and performers began to rail against the

rationalism of Western society, a force that promised much but had delivered the senseless destruction seen in the conflict. The German poet Hugo Ball explained how the Dadaist could fight 'against the death-throws and death-drunkenness of his time': 'The Dadaist loves the extraordinary, the absurd … Every kind of mask is therefore welcome to him, every play at hide and seek in which there is an inherent power of deception.'

Ball and his wife Emmy Hennings founded the Cabaret Voltaire venue in 1916 in a seedy district of Zurich to present performances that revelled in chaos and irony. Tristan Tzara and Richard Huelsenbeck, French-Romanian and German respectively, recited texts simultaneously in three different languages; Ball himself read 'sound poems' of invented nonsense words. That year the term Dada was first used by the venue's

eponymous periodical and Ball wrote the first Dadaist manifesto. The babyish sound of the word 'Dada' appealed, as did the pluralism of its meaning: 'hobby horse' in French, 'goodbye' in German, 'yes, yes' in Romanian.

Huelsenbeck claimed Dada was chosen at random from a dictionary. This emphasis on chance – known as Automatism – characterised works by some visual artists affiliated with the movement. The French-German artist Jean Arp tore up pieces of paper, let them fall, and glued them in place where they lay, in the process rejecting the convention that an artist should carefully consider the arrangement of the forms he or she creates.

Frenchmen Marcel Duchamp and Francis Picabia travelled to New York to escape the war and, together with the Philadelphian-born artists Man Ray and Morton Livingston Schamberg, became the leading lights of American Dadaism. They were more interested in denouncing the art establishment than the war, and in Duchamp had the movement's most extreme *agent provocateur*.

In 1916 Duchamp exhibited his first 'readymades'. These were everyday industrially produced objects selected by Duchamp and exhibited without any significant alteration. The assertion that any object could be an artwork if an artist willed it caused major controversy and had a huge influence on future art practice. His most notorious readymade was *Fountain* (1917), a porcelain urinal – it is hard to imagine a more aggressive challenge to academic orthodoxies.

Dadaist groups grew in Germany after the war. Berlin-based artists John Heartfield and Hannah Höch excelled in political photomontage, Cologne Dadaist Max Ernst worked in collage and sculpture, and Kurt

Schwitters founded a one-man Dadaist movement in Hanover called Merz, using ephemera like waste paper in collages and constructions. Picabia, Tzara and French writer André Breton brought the movement to Paris, before it morphed in 1924 – under the leadership of Breton – into Surrealism, which related irrational activity to the expression of the unconscious mind. Dadaism's mixture of absurdity, anarchy, irony and iconoclasm was to return in the second half of the century with art movements including Neo-Dada and Conceptualism.

KEY WORK in the Tate Collection, UK

Fountain, 1917 (replica 1964), MARCEL DUCHAMP
When the French artist Duchamp submitted a urinal to a New York exhibition, he caused shockwaves in the art world that are still felt today. His radical rethinking of the art object helped define Dadaism. An art object could be chosen rather than created, and chosen from anywhere, even a lavatory. He signed the urinal with the pseudonym 'R. Mutt' to ironically assert its fine art credentials.

OTHER WORKS in the Tate Collection

The Bride Stripped Bare by her Bachelors, Even (The Large Glass) 1915–23 (reconstruction by Richard Hamilton, 1965–6); *Why Not Sneeze Rose Sélavy?,* 1921 (replica 1964), **MARCEL DUCHAMP**
Alarm Clock ,1919; *The Fig-Leaf*, 1922, **FRANCIS PICABIA**
Picture of Spatial Growths – Picture with Two Small Dogs, 1920–39, **KURT SCHWITTERS**

 Surrealism; Neo-Dadaism; Conceptualism; Performance Art; Sensationalism

 Impressionism; Neo-Impressionism; Synthetism; Social Realism; Kitchen Sink

Neo-Plasticism was a term coined by Dutch painter Piet Mondrian to describe the abstract mode of De Stijl ('The Style'), a coalition of artists, designers and architects that came together in the Netherlands in 1917. Mondrian's grids of thick black lines that enclosed flat areas of primary colour exemplified their radically reduced visual language.

PIET MONDRIAN (1872–1944); **GERRIT RIETVELD** (1888–1964); **BART VAN DER LECK** (1876–1958); **THEO VAN DOESBURG** (1883–1931); **GEORGE VANTONGERLOO** (1886–1965)

dynamic balance; geometric order; grids; primary colours

As Dadaism in Switzerland embraced absurdity as an outcry against the First World War, Dutch artist Theo van Doesburg brought together a group of artists, writers, architects and designers in the Netherlands to develop a very different response.

De Stijl argued that abstract art predicated on geometric order and spiritual harmony could produce peace and positivity in a European society blighted by suffering. The fine artists involved included Dutchman Bart van der Leck and Belgian artist George Vantongerloo. Van Doesburg and his compatriot Piet Mondrian were the movement's primary theorists, publicising their ideas in the group's eponymous journal, but it was the latter's style of painting in particular that came to epitomise De Stijl's aesthetic.

From 1913 Mondrian's representations evolved into purely abstract matrices of black horizontal and vertical lines. By 1917 these had become so ordered that they

formed precise right-angled grids on the canvas. The spaces in the grids were painted in flat areas of pigment, and from 1920 Mondrian restricted these to primary colours and black. Although this visual vocabulary was seemingly simple, the Dutch painter took pains to achieve a dynamic balance in his work.

Mondrian described the mode as 'Neo-Plasticism', explaining the term in an essay of 1920: 'Logic demands that art be the plastic expression of our whole being … it must also be the direct expression of the universal in us – which is the exact appearance of the universal outside us.' De Stijl saw art as a 'plastic equivalent' of the fundamental order of the universe rather than an expression of raw emotion.

Neo-Plasticism shared its metaphysics with Suprematism, although in Mondrian's work one finds a greater belief in harmony and contemplation than in that of Kasimir Malevich. Although it did not have the same obsession with technology as Constructivism, De Stijl shared the same wish that art should be absorbed into everyday life. The most influential De Stijl designer was the Dutchman Gerrit Rietveld; his buildings, structured in the same geometric manner as De Stijl paintings, formed an early foundation of the

International Style of architecture that held sway around Europe for more than three decades.

Van Doesburg worked with the Bauhaus art school in Germany in the 1920s. He also adopted diagonal lines in his work, to the consternation of Mondrian, who promptly resigned from the De Stijl group in 1924. Van Doesburg called his variation 'Elementarism' and continued to publish *De Stijl* until 1932, by which time he was spearheading a related style of geometric abstraction, Concrete Art. Mondrian developed links with Britain and America during the 1930s and moved to New York to escape the Second World War, his work influencing the city's postwar abstract painters.

KEY WORK in the Gemeentemuseum, The Hague

Contra-Composition of Dissonances XVI, 1925, THEO VAN DOESBURG
Van Doesburg's decision to incorporate diagonal lines in his work caused a split with his fellow Neo-Plasticist Piet Mondrian. This painting is an exemplar of the artist's new style, termed Elementarism. It incorporates a wider palette of colours than Mondrian's work; Van Doesburg became more playful and diverse over the decade, while his compatriot continued to work solely in primaries and right-angled grids.

OTHER WORKS in the Gemeentemuseum

Composition with Grid III: Lozenge Composition, 1918;
Tableau 1, with Red, Black, Blue and Yellow, 1921;
Victory Boogie Woogie, 1942–4, **PIET MONDRIAN**
The Card Players, 1917; *Composition IX,* 1917–18,
THEO VAN DOESBURG

 Suprematism; Constructivism; Bauhaus; Post-Painterly Abstraction; Minimalism

 Dadaism; Surrealism; Kitchen Sink; Photorealism; Neo-Expressionism

Bauhaus

The Bauhaus was a school established in Weimar, Germany, in 1919 that aimed to unify avant-garde visual art with design and architecture for the improvement of society. Its first influences included Arts and Crafts and Expressionism. From 1922, Constructivist ideas encouraged it to form a close relationship with industry.

HERBERT BAYER (1900–85); **JOHANNES ITTEN** (1888–1967); **WASSILY KANDINSKY** (1866–1944); **PAUL KLEE** (1879–1940); LÁSZLÓ MOHOLY-NAGY (1895–1946)

functional; geometric; high-tech; Utopian; workshops

Founding director Walter Gropius derived the name for the Bauhaus school from *bauen* – to build. The architect also intended an echo of *bauhütten*, Germany's medieval builders' guilds, as he hoped the school would have their same collegiate character. Practitioners from different disciplines would work together in a variety of media to form 'a new guild of craftsmen without class divisions' that would, according to Gropius' founding manifesto, 'create the new building of the future which will be all in one: architecture and sculpture and painting'.

This Utopian synthesis was a modern version of the *Gesamtkunstwerk* ('total work of art') discussed by Germans including composer Richard Wagner in the previous century, and it also owed an influence to the English Arts and Crafts movement. The Bauhaus teaching staff included leading lights of the 20th-century avant-garde. Expressionists were initially at the core. Swiss painter Johannes Itten developed a preliminary course to disabuse students of any old-fashioned preconceptions. Compatriot Paul Klee lectured on composition, and Russian painter Wassily

Kandinsky, pioneer of abstract art, taught ideas about form and colour. This fine art theory was put into practice in craft workshops, in which teacher and student would form the relationship of master and apprentice. Itten, for example, was master of metalworking, and Klee was in charge of glass painting and book binding.

After three years, however, the workshops were still making one-off works by hand. How would the school have its planned significance if they were not producing works on a large scale? Under the influence of Neo-Plasticist Theo van Doesburg and Russian abstractionist El Lissitzky, both visiting lecturers, Gropius inaugurated a new phase on principles similar to Constructivism.

Instead of artist-craftsmen, the school aimed to create designers and engineers whose prototypes would be mass-produced. László Moholy-Nagy, a practitioner of Constructivist-style art, replaced Itten. The geometric abstraction that had become a defining characteristic of the school became even more refined, and high-tech materials and machinery were embraced.

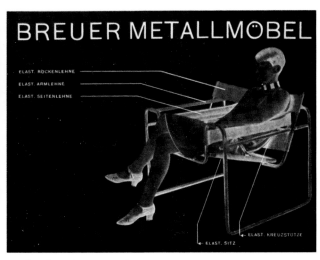

BREUER METALLMÖBEL

ELAST. RÜCKENLEHNE
ELAST. ARMLEHNE
ELAST. SEITENLEHNE

ELAST. KREUZSTÜTZE
ELAST. SITZ

KEY WORKS in the Victoria and Albert Museum, London

← *Advertisement for the Breuer Metallmöbel chair,* **1927, HERBERT BAYER**
This advertisement reminds us that from the mid-1920s the Bauhaus became more commercial, producing and publicising editions of furniture by designers like Marcel Breuer. The simple sans serif chosen by Bayer – the school's professor of advertising, layout and typography – mirrors the pared-down functional style of the chair.

After the right-wing Weimar government cancelled its grant, the socialist-leaning school moved to left-wing Dessau, where it was given resources to design new buildings. An architecture department under the Swiss Hans Meyer pioneered a functional, pared-down mode known as the International Style. Students trained at the school began to teach there, including German Josef Albers and Austrian Herbert Bayer, the latter's crisp typography proving highly influential. Under Meyer's directorship from 1928, the school became a commercial success, as Bauhaus furniture, wallpaper and textiles went into production.

Architect Ludwig Mies van der Rohe became director in 1930 before a new National Socialist administration withdrew funding in 1932. The Bauhaus briefly became a private institution in Berlin, but by 1933 it was closed down again by the Nazis. Affiliated artists emigrated to Britain and America. Across the Atlantic, Bauhaus ideals had a huge impact – particularly in architecture – and many of its former teachers became influential professors at American universities of art and design.

↖ *Bauhaus Verlag Bauhaus Bücher, c* 1924, **LÁSZLÓ MOHOLY-NAGY**
This brochure cover by Moholy-Nagy illustrates the geometric aesthetic of Bauhaus. Like the architecture and product design for which the school was famed, the composition makes a virtue out of minimal amounts of simple shapes and lines. The brochure advertises a series of books by Bauhaus teachers; they wished their lessons to be learnt on an international scale.

OTHER WORKS in the Victoria and Albert Museum

Abstract composition, c 1922–5,
WASSILY KANDINSKY
The Witch and the Comb, 1922, **PAUL KLEE**
Leda and the Swan, 1926; *Jealousy,* 1927; *Poster: 'Quickly away, thanks to Pneumatic Doors',* 1937,
LÁSZLÓ MOHOLY-NAGY

 Expressionism; Suprematism; Constructivism; Neo-Plasticism

 Social Realism; Photorealism; Neo-Expressionism; Street Art

Precisionism

Precisionism developed in American art during the 1920s. It was characterised by representations of modern machinery and architecture, subjects that were given a strong sense of monumentality. The style's emphasis on geometry showed the influence of Cubism, leading one critic to label it Cubist Realism.

RALSTON CRAWFORD (1906–78); CHARLES DEMUTH (1883–1935); LOUIS LOZOWICK (1892–1973); GEORGIA O'KEEFFE (1887–1986); CHARLES SHEELER (1883–1965)

American Dream; geometricism; industrial; monumentality; photography

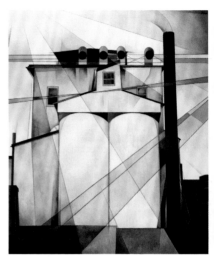

Precisionism refers to an aesthetic shared by painters rather than a collective of artists with a manifesto. The word has an uncertain provenance. The first full summation of the style was in a publication of 1947 by Wolfgang Born, but the critic claimed the term was in use during the 1920s, and it has been attributed elsewhere to the artist Charles Sheeler and the art historian Alfred H Barr in that decade.

The adjective 'precision' was certainly in use in the early 1920s to describe the work of artists such as Sheeler, Charles Demuth and Louis Lozowick, which depicted with clarity the machinery and structures of industrial America, from factory complexes to skyscrapers and suspension bridges. Precisionism shared its fascination with 20th-century urban forms with Futurism. But while the Italian movement stressed speed and dynamism, the American artists wanted to give subjects a sense of monumentality akin to the works of Post-Impressionist Paul Cézanne.

Simple geometric shapes and clear outlines defined sharply the structure of buildings and objects. This geometricism flattened subjects, much like the Cubist representations of Pablo Picasso and Georges Braque that Sheeler admired. However, the modern world did not shatter into fragments like Cubism; instead its forms became pronounced and gained gravitas. Chimney stacks were endowed with the solid, sculptural quality of ancient obelisks.

The surfaces of paintings were rendered with minimal detail and all the sheen of a newly waxed motorcar. While the First World War had caused a crisis of confidence in the mechanical age for Europeans, in America modern mass-produced machines still symbolised progress and, thanks to their widespread advertisement, glamour. Precisionism can thus be seen as a celebration of the American Dream, although humans were strangely absent from its cityscapes, as if their presence might taint the pure geometric forms. And some works, like those of younger painter Ralston Crawford, emitted a sense of alienation as well as optimism.

The sharp edges rendered on canvas gave images a focus that resembled

a photograph. The experimental camera work of Paul Strand and Alfred Stieglitz informed the paintings' unconventional viewpoints. Sheeler worked widely as a photographer and was commissioned by Ford Motor Company to document one of its factories. Georgia O'Keeffe, who married Stieglitz, linked herself with Precisionism with a series of skyscraper paintings; she borrowed techniques from photography for her famous flower pieces, framing out the perimeters of petals.

During the 1930s, the work of Sheeler and others had moved away from geometricism towards a greater realism, anticipating Photorealism later in the century. After 1945 the atomic age ushered in doubts about technology that undermined Precisionism. The movement's achievements, however, were to influence later developments in America such as the industrial Minimalism of Donald Judd and the Pop Art of Robert Indiana.

← *My Egypt,* 1927, CHARLES DEMUTH
The title of this work equates concrete grain elevators with the monuments of an ancient civilisation, in an indication of the way Precisionism idealised modern America's industrial landscape. The pristine surface of the painting is also typical of Demuth and likeminded American artists, who hid their brushworks from view; even the smoke bellowing from the chimney is a smooth geometric shape.

OTHER WORKS in the Whitney Museum of American Art

Steel Foundry, Coatesville, Pa, 1936–7, **RALSTON CRAWFORD**
New York, 1925; Corner of Steel Plant, 1929, **LOUIS LOZOWICK**
Flower Abstraction, 1924, **GEORGIA O'KEEFFE**
Office Interior, Whitney Studio Club, 10 West 8 Street, c 1928, **CHARLES SHEELER**

 Cubism; Futurism; Pop Art; Minimalism; Photorealism

 Suprematism; Neue Sachlichkeit; Surrealism; Installationism

KEY WORKS in the Whitney Museum of American Art, New York

River Rouge Plant, 1932, **CHARLES SHEELER**
The movement's close relationship with the medium of photography is demonstrated by this homage to a Ford Motor Company factory. Sheeler had photographed the building and worked from his prints to create this highly realistic painting, which shows a shift away from his more geometric work of the previous decade.

School of Paris

A broad term used now to describe the international community of artists working in the city between the world wars. It does not indicate a fixed style of artistic practice and is most often mentioned in relation to Parisian artists who do not otherwise fit any other interwar ism.

CONSTANTIN BRANCUSI (1876–1957); **MARC CHAGALL** (1887–1985); **JULIO GONZÁLEZ** (1876–1942); **AMEDEO MODIGLIANI** (1884–1920); **CHAÏM SOUTINE** (1893–1943)

art boom; bohemian; diversity; émigrés; Jewish

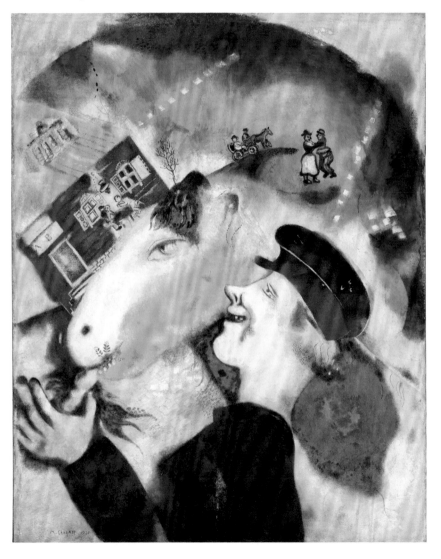

The French capital's status as the centre of the international art world was beyond doubt after the achievements and influence of Cubism. Artists from across Europe and America converged in greater numbers on Paris after the First World War to affiliate themselves with its avant-garde practice and take advantage of its art boom. Between the wars, the city had an estimated 20 significant Salon exhibitions and 130 art galleries, which attracted a large contingent of collectors and countless artists who aspired to the excellence of émigrés such as Spaniard Pablo Picasso. France's relative political stability sustained this situation until the Second World War.

The critic André Warnod coined the term School of Paris in the early 1920s to refer specifically to the non-French artists who had settled in the city, many of whom gravitated towards the bohemian melting pots of Montmartre or Montparnasse. Warnod praised the contributions of these international sculptors, painters and printmakers, but others resented what they saw as an invasion of foreigners.

Anti-Semitism fuelled this nationalism, as some of the most talented artists were of Jewish origin, such as the Russian painters of Belorussian birth, Marc Chagall and Chaïm Soutine, the Lithuanian sculptor Jacques Lipchitz and Italian Amedeo Modigliani. After the Second World War and the Holocaust, such sentiments were discredited and the label School of Paris was widened from that time to include all artists, both French and foreign, who worked in the capital.

The term allows for pronounced stylistic differences, encompassing work as various as the abstractions of the Romanian sculptor Constantin Brancusi, the idiosyncratic constructions of Barcelona-born Julio González (who collaborated with Picasso on groundbreaking wrought-metal works in the 1930s) and the erotic watercolours of Bulgarian Jules Pascin. One should note that the word 'school' in modern art is not always synonymous with such diversity. The schools of New York (see 'Abstract Expressionism') and London that came to prominence in the second half of the 20th century both had set aesthetic characteristics.

The term School of Paris has stuck most closely to artists such as Chagall and Soutine who did not easily fit an alternative category; a Parisian artist such as Spanish-born Juan Gris, for example, is more often discussed in terms of Cubism. The two Russians produced poetic figurative art that, while influenced by Expressionism, could not be grouped under that movement. Together with Modigliani's elongated portrait paintings, their pieces are perhaps the closest the School of Paris has to defining artworks.

KEY WORK in the Albright-Knox Art Gallery, Buffalo, New York

Peasant Life, 1925, MARC CHAGALL
This demonstrates the tendency of émigré artists to romanticise their homelands; Chagall spent much of his childhood visiting his grandfather's village in Belarus. The work has a dreamlike quality due to its strange spatial relationships and colour. This allies the painter with Surrealism, but Chagall was keen to be independent, thus his subsequent categorisation under the broad banner of the School of Paris.

OTHER WORKS in the Albright-Knox Art Gallery

Mademoiselle Pogany II, 1920, **CONSTANTIN BRANCUSI**
Small Seated Woman, c 1935–6, **JULIO GONZÁLEZ**
The Servant Girl, 1918; *Reclining Nude,* c 1919, **AMEDEO MODIGLIANI**
Page Boy at Maxim's, c 1927, **CHAÏM SOUTINE**

 Modernism; Expressionism; Cubism; Neue Sachlichkeit; Surrealism

 Abstract Expressionism; Land Art; New British Sculpture; Sensationalism

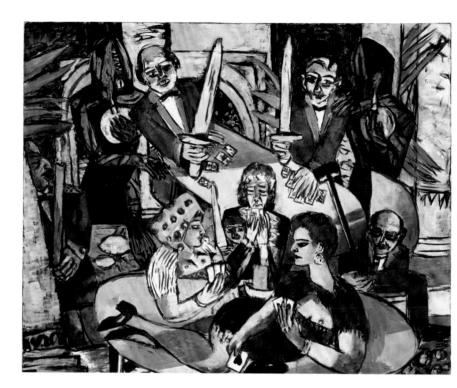

Neue Sachlichkeit (meaning 'New Objectivity') was coined in 1923 to describe a shift in German painting towards greater realism. The associated artists worked in a wide variety of styles, although they shared an engagement with social and political issues, attacking what they saw as decadence and decay in the country.

MAX BECKMANN (1884–1950); OTTO DIX (1891–1969); GEORGE GROSZ (1893–1959); KÄTHE KOLLWITZ (1867–1945); CHRISTIAN SCHAD (1894–1982)

anti-war; corruption; socially engaged; tangible reality; verists

The director of the Kunsthalle Mannheim, Gustav F Hartlaub, used the phrase 'Neue Sachlichkeit' in 1923 to define what he perceived as a strand of new objectivity in German art since the First World War.

This interest in the objective world was 'new' because it was much more than a simple reversion to 19th-century naturalism. A group of hard-hitting artists Hartlaub labelled as 'verists' now focused intently on the world around them not as an academic exercise, but to excoriate society's ills. Neue Sachlichkeit is synonymous with their socially engaged perspective.

Their attitude had been precipitated both by the war and the country's postwar condition; hopes for a left-wing revolution had been disappointed and the Weimar Republic, with its descent into hyperinflation and then a pact with American banks, was seen as morally and spiritually bankrupt.

Themes of the works by Neue Sachlichkeit artists included the horror of war, the despair of the country's poor, and the corruption of the middle and upper classes.

Its practitioners believed avant-garde movements such as Cubism had wasted time worrying over formal matters. Subject matter was everything – more important than style.

Frankfurt-based Max Beckmann painted pairs and groups of contorted figures in a diverse range of complex scenarios. He often alluded to performance, moral decay and death in works whose intensity mirrored those of Expressionism, although Beckmann said he wanted to avoid that movement's 'false, sentimental, inflated mysticism'.

Beckmann had a nervous breakdown during the war, when he served as a medic; artist Otto Dix, who moved between Dresden and Düsseldorf, was also deeply affected by the conflict, and continued to produce nightmarish depictions of the war after its conclusion. An older artist, Käthe Kollwitz, produced anti-war drawings and prints. Berliner George Grosz cultivated his Communist sympathies and cynicism towards the Republic with scenes sending up the bourgeoisie and big business.

Bavarian-born Christian Schad, in contrast, worked in a highly realistic style in portraits that emphasised the isolation of their sitters.

The National Socialists denounced Neue Sachlichkeit's critical stance and during the 1930s the associated artists lost their teaching jobs. In 1937, the Nazis mounted an infamous exhibition entitled 'Degenerate Art' that attempted to further defame Beckmann and scores of other avant-garde artists. Their work was confiscated and burned, and they were forbidden by the Nazis to paint or exhibit, which persuaded many artists to go into exile.

KEY WORKS in the Staatsgalerie, Stuttgart

Dream of Monte Carlo, 1939–43, **MAX BECKMANN**
This late work was completed in exile from Germany after Neue Sachlichkeit was damned as 'degenerate' by the Nazis. Beckmann characteristically transforms a scene of modern life – a Monte Carlo card table – into an allegory for death. The four suited men all wield weapons, while behind the two sword-bearing croupiers stand hooded figures bearing bombs.

The Match Seller, 1920, **OTTO DIX**
Neue Sachlichkeit's positions against war and poverty are combined here. The skewed perspective accentuates the veteran's face so that his sales pitch appears to be a cry of anguish. Dix aims his fire at the well-heeled passers-by who ignore him, just showing us their legs as if they cannot get away quick enough.

OTHER WORKS in the Staatsgalerie

Self-portrait with Red Scarf, 1917; *The Peruvian Soldier*, 1929, **MAX BECKMANN**
Small Self-portrait, 1913; *Portrait of Dr Paul Ferdinand Schmidt*, 1921, **OTTO DIX**
Dedication to Oskar Panizza, 1917–18, **GEORGE GROSZ**

 Dadaism; Surrealism; Social Realism; Existentialism; Kitchen Sink

 Futurism; Suprematism; Post-Painterly Abstraction; Cubism; Minimalism

Surrealism

Surrealism was an intellectual and artistic movement, founded in France in 1924 before spreading across the globe. Deeply influenced by psychoanalysis, writers and artists attempted to tap into the repressed realm of the unconscious mind in order to liberate culture from conscious logic and reason.

SALVADOR DALÍ (1904–89); **MAX ERNST** (1891–1976); **RENÉ MAGRITTE** (1898–1967); **ANDRÉ MASSON** (1896–1987); **JOAN MIRÓ** (1893–1983)

automatism; hallucinatory; juxtapositions; repressed; unconscious

Surrealism launched in 1924 before spreading across the globe with the publication of André Breton's *First Manifesto of Surrealism*. The Parisian poet defined it as 'psychic automatism in its pure state, by which it is intended to express … the true functioning of thought. Thought expressed in the absence of any control exerted by reason, and outside all moral and aesthetic considerations.'

The Austrian psychoanalyst Sigmund Freud argued that neuroses were caused by memories and desires that had been repressed from the conscious mind to the unconscious, and that techniques such as dream analysis and free association could release them. Breton had experimented with psychoanalysis as a medic during the First World War. As a leader of a new movement, he proposed that the unconscious had the creative potential to revive postwar culture.

Some Surrealist visual artists such as Jean Arp, Max Ernst and Man Ray had been affiliated with Dadaism. A key Dadaist practice had been to abandon decision-making in the creative process in favour of automatism. This method was adapted by Surrealism: the artwork was not a show of nihilism, but the product of the unconscious mind free of constraints. Frenchman André Masson poured sand on his canvases. Spanish artist Joan Miró painted bright biomorphic forms instinctively, declaring: 'As I paint, the picture begins to assert itself under my brush.'

Ernst, Belgian René Magritte and the older Italian artist Giorgio de Chirico concentrated on repressed memories and desires, painting works that blurred boundaries between fantasy and reality. Sexuality often appeared sinister in Surrealist paintings, and threatening motifs included masks, dolls and mannequins. Ernst also created collages and pioneered frottage pieces, laying paper sheets on textured surfaces and then rubbing them with a pencil.

The Catalan Salvador Dalí produced what he called 'hand-painted dream photographs': realistically rendered hallucinatory scenes full of unexpected juxtapositions. Dalí, Man Ray and the Swiss artists Méret Oppenheim and Alberto Giacometti combined disparate readymades in their sculptures, in order to highlight the uncanny character of those objects.

The poetic quality of Surrealist images proved highly popular. The movement had an impact on other disciplines from film to fashion, and spread to artistic circles as far as Egypt, Japan and Mexico. In England, painter Paul Nash and sculptor Henry Moore came under its influence; in America, Joseph Cornell – known for his assemblages in boxes – was an admirer. Although Surrealism's optimism about the unconscious became unfashionable in the heyday of Existentialism after the Second World War, automatism was reinterpreted productively by movements including Abstract Expressionism and New Realism.

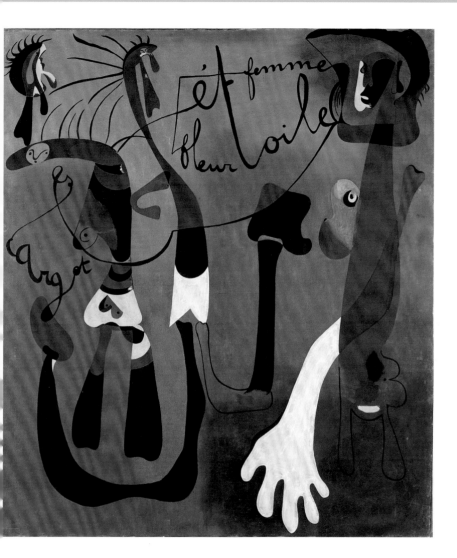

KEY WORKS in the Museo Centro de Arte Reina Sofía, Madrid

Escargot, Femme, Fleur, Étoile, 1934, JOAN MIRÓ
This work is characteristic of the movement in its freely painted fantastical shapes suggestive of living organisms. Its title is scrawled in a spirit of Freudian free association rather than as a description of the forms of the picture.

 Expressionism; Dadaism; Tachism; Abstract Expressionism; New Realism

 Impressionism; Bauhaus; Social Realism; Op Art; Minimalism

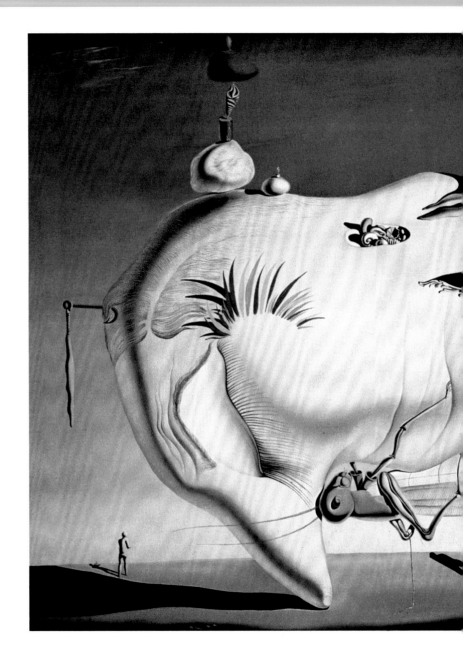

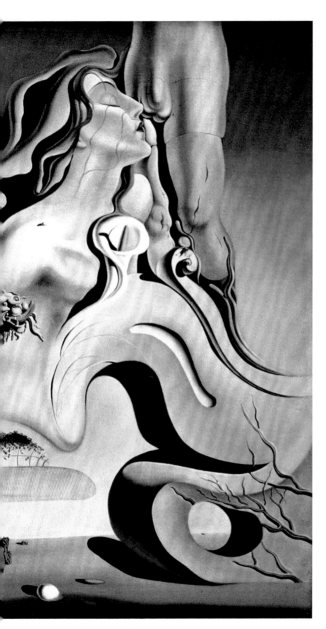

The Great Masturbator, 1929,
SALVADOR DALÍ
This painting explores the artist's
anxieties about sexual activities.
The large central form can be
read as a head in profile looking
downwards, representing the
mind of the artist. From this face
a fantasy of fellatio emerges, but
underneath its nose clings a
mechanical-looking locust, its
abdomen covered by a swarm
of ants.

OTHER WORKS in the Museo
Centro de Arte Reina Sofía

Memory of the Child-Woman,
1929, **SALVADOR DALÍ**
The German Beauty, 1934–5,
MAX ERNST
Man with a Pipe, 1925; *Untitled
(The Lovers at Night)*, 1934;
Portrait II, 1938, **JOAN MIRÓ**

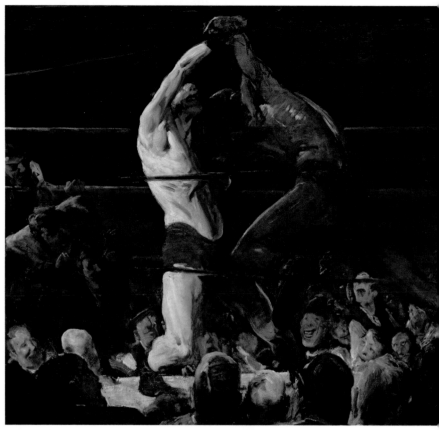

A general term attributed to art, photography and film, Social Realism prioritised social engagement before formal experiments. In depictions that were more naturalistic than those pursued by most modern artists, Social Realist painters drew attention to the everyday lives of the working classes and poor.

GEORGE BELLOWS (1882–1925); **ROBERT HENRI** (1865–1929); **EDWARD HOPPER** (1882–1967); **DIEGO RIVERA** (1886–1957); **BEN SHAHN** (1898–1969)

activist; gritty; reportage; social engagement; working classes

Social Realism has its origins before the 20th century; 19th-century French artists such as Gustave Courbet had already focused on the working classes without the same moralising message as earlier academic painters.

The Ashcan School in America was the first notable Social Realist circle of the century. It was spearheaded by Robert Henri, who had been encouraged towards realism by his former teacher, the painter Thomas Eakins, the verisimilitude of whose works was inspired by photography. Henri taught in New York from 1902 and his students included George Bellows and Edward

Hopper. Artists in Henri's circle produced gritty pictures of working-class life in the city; several had worked as illustrators for the press, so brought to painting their reportage skills. Some scenes showed social deprivation, following the example of photographers Lewis Hine and Jacob Riis who used the medium to encourage reform.

During the 1930s, as the Great Depression left a quarter of the American workforce unemployed, painters known as 'the urban realists' continued in this tradition, turning their gaze to the human tragedies unfolding. Lithuanian-born painter and photographer Ben Shahn was one of the most committed. At the same time three Mexican artists, Diego Rivera, David Alfaro Siqueiros and José Clemente Orozco, were gaining commissions in America to paint socially conscious mural works. In the previous decade they had produced hard-hitting murals and prints in their homeland in support of the Mexican Revolution.

Many artists sometimes described as Social Realists were less activist than painters like Shahn and Orozco. Hopper painted in a realist manner, but his work emphasised existential issues rather than those of social reform. Although they were Socialist in sympathy, the realist painters of the Euston Road School in London, such as William Coldstream, focused on portraiture.

Abstract Expressionism replaced Social Realism in America's affections after the Second World War. In Europe, however, it persisted in movements such as Kitchen Sink Realism in England, and it became a term commonly applied to films – notably in Italy and France – that rejected cinematic fantasy for the drama of everyday life.

Socialist Realism had an essential difference to Social Realism: the former mode, sanctioned by the Soviet state from the late 1920s, involved entirely idealised depictions of the country's circumstances, wiping out of history the political repression and enormous death toll that came with Joseph Stalin's policies.

KEY WORK in the National Gallery of Art, Washington DC

Both Members of This Club, 1909, **GEORGE BELLOWS**
Social Realists like Bellows spotlighted both the noble and the brutal aspects of working-class life. Public boxing matches were illegal in New York, so fights took place in the backrooms of private clubs. The boxing ring here becomes a metaphor for the savagery Bellows witnessed in wider society.

OTHER WORKS in the National Gallery of Art

Club Night, 1907, **GEORGE BELLOWS**
Volendam Street Scene, 1910, **ROBERT HENRI**
Haskell's House, 1924, **EDWARD HOPPER**
Viva Zapata, 1932, **DIEGO RIVERA**
Prenatal Clinic, 1941, **BEN SHAHN**

 Precisionism; Neue Sachlichkeit; Kitchen Sink; Photorealism; School of London;

 Suprematism; Cubism; Neo-Plasticism; Minimalism; Neo-Expressionism

Concrete Art

A term coined in 1930 to describe geometric works that avoided overt sentimentality, symbolism and spirituality. It soon came to define geometric abstraction in general. After the Second World War, Concrete Art acted as a counterpoint to the popularity of gestural abstract styles.

MAX BILL (1908–94); **BARBARA HEPWORTH** (1903–75); **RICHARD PAUL LOHSE** (1902–88); **KENNETH MARTIN** (1905–84); **BEN NICHOLSON** (1894–1982)

clarity; cold; geometric; precise; self-sufficiency

Neo-Plasticist painter Theo van Doesburg codified Concrete Art (or *Art Concret*) in a manifesto of April 1930. With the growing popularity of figurative art in the forms of Surrealism and Social Realism, the Dutch artist felt provoked to fight the corner for abstract art and specifically the geometric aesthetic seen previously in the works of De Stijl, Constructivism and Bauhaus.

But Van Doesburg used his manifesto to argue against some of the associations these earlier movements encouraged: 'The picture should be constructed entirely from purely plastic elements, that is to say planes and colours. A pictorial element has no other significance than "itself" and therefore the picture has no other significance than "itself".' He favoured works without symbolism and without Utopian or spiritualist aims. Instead of 'lyricism' and 'dramaticism', he asked artists to aim 'for absolute clarity'.

Former Bauhaus student Max Bill remained true to this premise. The Swiss artist's geometric paintings and sculptures were designed using mathematic and scientific concepts; for example, he produced a series of 'Endless Ribbon'

works that were sculptural versions of the Möbius strip. The grid paintings of his compatriots Karl Gerstner and Richard Paul Lohse also developed from equations, and the lack of emotion of these works led them to be described as Cold Art.

However, in practice, the phrase Concrete Art became synonymous with a wide range of geometric styles during the 1930s, many of which had resonances with the exterior world or a spiritual realm. French painter Jean Hélion, a signatory of the Concrete Art manifesto, helped to found the international group Abstraction-Création with Van Doesburg in 1931. This became a very broad group whose affiliates included older painters with spiritualist aims like Wassily Kandinsky and Piet Mondrian; Russian Constructivist exiles such as Naum Gabo and Antoine Pevsner; and English abstract artists like Ben Nicholson, Henry Moore and Barbara Hepworth who took inspiration from human figures and the natural world.

After the Second World War, Concrete Art remained a term with which geometric art could be classified. The word 'cold' became used more generically to describe abstract art that was cool and precise, in contrast to the 'hot' gestural practices of Tachism and Abstract Expressionism. Regional variations from the 1950s included a British movement known as

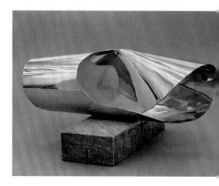

Constructionism, involving artists including Victor Pasmore and Kenneth and Mary Martin, and Neo-Concretism in Brazil. Concrete Art's interest in mathematics can be seen in Op Art, and its self-sufficiency in Post-Painterly Abstraction and Minimalism.

KEY WORKS in the Hirshhorn Museum and Sculpture Garden, Washington DC

Endless Ribbon From A Ring I, 1947–9, executed 1960, **MAX BILL**
Concrete Art's mathematical links are exemplified by Bill's 'Endless Ribbon' works, which were sculptures in the form of Möbius strips. These three-dimensional shapes formed by twisting two-dimensional planes fascinated mathematicians, who attempted to predict their structures through complex equations.

↑ *1937 (painting),* 1937, **BEN NICHOLSON**
Concrete Art in the broad sense encompassed all geometric abstract art. Nicholson's aesthetic owed much to Constructivism as well as to Neo-Plasticism: the influence of Piet Mondrian is clear in this rectilinear arrangement of primary colours, greys, black and white.

OTHER WORKS in the Hirshhorn Museum and Sculpture Garden

Four Complementary Color Groups, 1958; *Integration of Four Similar Color Pairs,* 1961, **MAX BILL**
Reclining Figure, 1933; *Pendour,* 1947–8, **BARBARA HEPWORTH**
1938 (white relief – large version), 1938, **BEN NICHOLSON**

 Constructivism; Neo-Plasticism; Bauhaus; Op Art; Minimalism

 Neue Sachlichkeit; Surrealism; Social Realism; Existentialism; Tachism

3

MID
20TH CENTURY

Existentialism

Existentialism was a philosophy elucidated by the French theorist Jean-Paul Sartre from the 1940s. It was based on the premise that the human condition was without any essential meaning. Although Existentialism was not an art movement as such, significant visual artists explored Existentialist ideas about meaninglessness, freedom, isolation and anxiety.

FRANCIS BACON (1909–92); **JEAN FAUTRIER** (1898–1964); **LUCIAN FREUD** (1922–2011); **ALBERTO GIACOMETTI** (1901–66); **GERMAINE RICHIER** (1902–59)

anxiety; freedom; human condition; isolation; meaninglessness

Sartre proposed in his 1943 book *Being and Nothingness* that 'existence precedes essence'. Our essence – the meaning of our life – is not at the heart of our existence, or preordained by religious or scientific truth. Meaning instead comes after the bare fact of our existence. It is assumed only through our individual choices; we are free to change these choices at any time. We must acknowledge that there is no fixed foundation to our character, or our interpretation of the world or ourselves.

Sartre owed much to the German philosopher Martin Heidegger, who had developed a complex theory of being two decades earlier. Writers such as

Albert Camus, Simone de Beauvoir and Samuel Beckett responded to Sartre's ideas and he popularised his difficult concepts via articles, novels, short stories and plays. The radical freedom *Being and Nothingness* proposed became represented in pessimistic terms: humans were seen as isolated in their choices and anxious at the meaninglessness of life.

The horrors of the Second World War gave these ideas a widespread resonance in the late 1940s and 1950s. Existentialism never became a coherent visual art movement like Abstract Expressionism, which shared some of its concerns; instead it gave an intellectual impetus to a broad range of painters and sculptors.

Alberto Giacometti progressed from his Surrealist sculpture to vertically stretched, super-thin bronze figures of humans: their solitariness in space appeared a metaphor for man's Existentialist isolation. The French sculptor Germaine Richier dismembered and distorted her large-scale figures and gave the bronzes a rough texture which, like that of Giacometti's, suggested flayed skin or decomposition.

British artist Henry Moore gained acclaim for haunting drawings of Londoners sheltering from German bombing raids; the spectral figures summed up the dehumanising effects of war. Frenchman Jean Fautrier painted the series 'Hostages' following his imprisonment by the Germans. The abstract forms in the series equate to human heads and bodies, and

the thick impasto paint is layered and scored like lacerated flesh. British painter Francis Bacon similarly mutilated the subjects in his claustrophobic canvases, turning their bodies inside out so that bloody innards morphed into external muscle and features. His fellow Londoner Lucian Freud was, in the words of one critic, 'the Ingres of Existentialism', for his early realist portraits that probed the anxiety of his sitters.

Existentialist themes remained part of these artists' works beyond the 1950s, but by the 1960s younger artists were producing Pop Art that was more concerned with commercial culture than with the human condition.

KEY WORKS in the Fondation Beyeler, Basle

The Cage (First Version), 1950, **ALBERTO GIACOMETTI**
The cage is a common Existentialist motif. Humans were perceived as trapped by their own freedom, as every possible decision lacked any essential meaning. The elongated standing figure here appears almost part of the cage that confines it, its arms horizontal like bars and its body as thin as the enclosure's vertical struts.

 Lying Figure, 1969, **FRANCIS BACON**
Bacon focused on the agony of human existence. The subject here may be only lying in bed, but its disintegrated head evokes Existentialist inner turmoil. The paint has been smudged in different directions to evoke antagonism in the subject's thoughts. The body's flesh is made pink to appear like that of a carcass.

OTHER WORKS in the Fondation Beyeler

Portrait of George Dyer Riding a Bicycle, 1966;
In Memory of George Dyer, 1971, **FRANCIS BACON**
Seated Woman, 1946; *Man Walking in the Rain*, 1948;
Woman of Venice VIII, 1956, **ALBERTO GIACOMETTI**

 Expressionism; Neue Sachlichkeit; Tachism; Abstract Expressionism; Kitchen Sink

Constructivism; Neo-Plasticism; Bauhaus; Precisionism; Pop Art

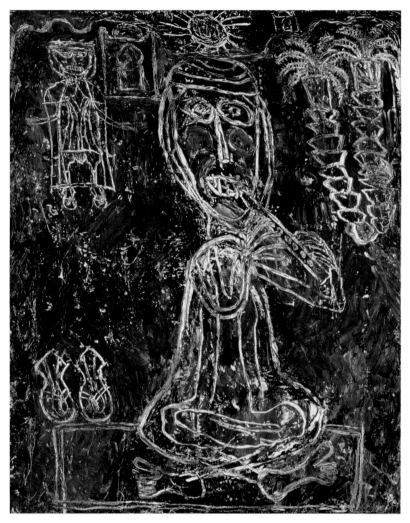

Tachism was derived from the French word *tâche*, meaning blot or stain. Critics used the term from the early 1950s to describe a type of European art characterised by spontaneous, gestural mark-making. It is interchangeable with the term Art Informel and movements such as Art Brut and CoBrA can be considered under its banner.

ALBERTO BURRI (1915–95); **JEAN DUBUFFET** (1901–85); **HANS HARTUNG** (1904–89); **ANTONI TÀPIES** (1923–2012); **WOLS** (ALFRED OTTO WOLFGANG SCHULZE) (1913–51)

gestural; Outsider Art; mixed-media; raw; spontaneous

The first use of Tachism has been attributed variously to Pierre Gueguen,

Michel Tapié and Charles Estienne in either 1951 or 1952. These French critics were just a few of the diverse voices defining a new strain of painting in postwar Europe; other terms used included Art Informel (Art Without Form), Art Autre (Other Art), Lyrical Abstraction and Matter Painting.

Canvases were haphazardly covered in splotches of colour. Sometimes the paint was spontaneously smudged by hand or scratched with a sharp implement. The artist's gestures were not hidden behind a smooth finish; instead they seemed the very subject of these paintings.

This emphasis on gesture had a precedent in the semi-figurative Expressionist works of Wassily Kandinsky from around 1910, although the Russian painter soon assumed a geometric vocabulary. Surrealism's belief in the unconscious also had an influence. Tachist artists were found across Europe, working independently or in small groups. They were brought together in exhibitions and publications, sometimes with Abstract Expressionists such as Jackson Pollock with whom they shared an affinity. All rejected realism and geometric abstraction for a raw form of art that could express their anger and anxiety in a postwar world.

Early works in this style were by French artist Jean Fautrier (see 'Existentialism') and German painters Hans Hartung and Wols (Alfred Otto Wolfgang Schulze). The latter applied paint in thick layers before scratching away the surface to expose the substrata. Pierre Soulages, Henri Michaux and Georges Mathieu from France, and Patrick Heron, Roger Hilton and Peter Lanyon from England (part of the famous artistic community in St Ives) pioneered other styles of gestural abstraction.

Frenchman Jean Dubuffet collected Art Brut ('Raw Art', or Outsider Art), which was work made by untrained artists including children, prisoners and the mentally ill. He perceived a direct expressiveness in these pieces created outside the conventions of the art world. Dubuffet's own work, in turn, featured childishly drawn figures. The group CoBrA (whose name was formed by the capital cities of members' different nations: Copenhagen, Brussels and Amsterdam) also drew inspiration from children's drawings.

Tachism's interest in materials was demonstrated in the mixed-media works of Italian Alberto Burri and Catalan Antoni Tàpies, which were comprised of pumice, tar, burlap, burnt plastic, clay, paper, string and rags as well as acrylic and oil paint. These pieces laid the foundation for later movements such as Fluxus, Process Art and Arte Povera that embraced unorthodox processes and substances.

KEY WORK in the Hamburger Kunsthalle, Hamburg

Composition, 1947, WOLS *(see p72)*
The German artist dripped, splashed and dabbed on the canvas layers of paint in a visceral manner that epitomised Tachism. Sometimes a figurative form like a face, as in this picture, would be suggested by the violent scratch marks and smudges the painter would make as he completed the piece.

← *He has Taken off his Sandals,* 1947, JEAN DUBUFFET
Dubuffet's work shows the influence of children's artwork. The artist visited Algeria prior to its independence; the form of a cross-legged figure is a knowingly naive depiction of an Algerian, scratched out of oil paint as if by a child's fingers. Dubuffet also took inspiration from ancient cave paintings discovered in France that decade.

OTHER WORKS in the Hamburger Kunsthalle

Blossoming Earth, 1959; *Declension of the Beard,* 1959, JEAN DUBUFFET
Composition T 55–17, 1955, HANS HARTUNG
Composition LXIV, 1957, ANTONI TÀPIES
Untitled, c 1941–2, WOLS

 Expressionism; Surrealism; Abstract Expressionism; Arte Povera

 Impressionism; Suprematism; Social Realism; Pop Art; Minimalism

Abstract Expressionism

This was applied to American painters who, during the 1940s and 1950s, aimed to convey emotion through abstraction. Although it comprised a diverse range of individual styles, the movement can be divided into those interested in the potential of gesture (Action Painters) and those who emphasised colour (Colour Field Painters).

FRANZ KLINE (1910– 62); **WILLEM DE KOONING** (1904–97); **BARNETT NEWMAN** (1905–70); **JACKSON POLLOCK** (1912–56); **MARK ROTHKO** (1903–70)

action; colour field; crisis of faith; emotional effect; gesture

Abstract Expressionism was a term coined by the New York critic Robert Coates in 1946 to describe American painters who invented new idioms of abstract art to communicate their deepest feelings. Like Tachism in Europe, the movement rejected the Utopian geometric abstraction that had predominated before the Second World War. Instead the artists worked with an attitude more in tune with the crisis of faith that had been stimulated by the conflict.

The majority of the painters worked in New York, leading the group to be known as the New York School. They were influenced by the emotional engagement of Expressionism as well as Surrealist émigrés such as Max Ernst and André Masson. These artists pursued automatism, the attempt to let their unconscious memories and desires flow without constraints. While Surrealism was optimistic that neurological equilibrium could be achieved, Abstract Expressionism's worldview was shaped by Existentialism: the artist's condition was seen as one of isolation and anxiety.

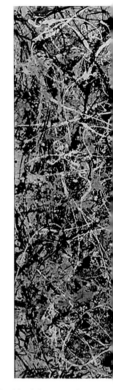

Jackson Pollock laid unstretched canvases on the floor and dripped house paint across them directly from the can. Rhythmically projecting swirls of paint from all angles, he was described variously as a dancer, a shaman in a trance or a saxophonist improvising freely. Pollock explained his paintings as 'energy and motion made visible'. Critic Harold Rosenberg christened him an Action Painter, alongside gestural painters including Willem de Kooning, whose grotesque figures were rendered with violent marks, and Franz Kline, whose sweeping black brush strokes resembled Japanese calligraphy.

Colour Field Painters, in contrast, formed large areas of unbroken colour on their canvases. In the case of the works of Mark Rothko, these soft-edged expanses glowed in front of the eyes to poignant emotional effect. Although they appeared contentless, Rothko, Adolph Gottlieb and Barnett Newman argued in a letter to the *New York Times* in 1943 that such works had subject matter that was 'tragic and timeless'. Newman produced 'zip' paintings, so called because of the vertical line that separated colour fields – this line had the association of a boundary between different metaphysical realms.

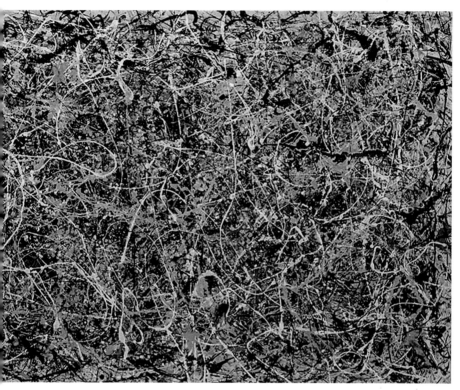

Philip Guston's abstracts were characterised by short pink and red brush strokes, and those of Clyfford Still by jagged forms. David Smith's rusted works in steel and iron are the movement's most famous sculptures. But the emotionalism of Abstract Expressionism was deemed too overwrought for a younger generation of American artists. By the 1960s the less anguished movements of Post-Painterly Abstraction and Pop Art had taken its place.

KEY WORK in the Museum of Contemporary Art, Los Angeles, California

Number 1, 1949, 1949, JACKSON POLLOCK
This work exemplifies the strand of Abstract Expressionism known as Action Painting. Pollock dripped paint from above as he moved continually around the canvas; the work therefore acts as a map of the artist's movement, an expression of his physical actions. The painting appears both chaotic and structured, like the jazz to which the artist liked to listen.

OTHER WORKS in the Museum of Contemporary Art

Monitor, 1956, **FRANZ KLINE**
Two Women with Still Life, 1952, **WILLEM DE KOONING**
Untitled (The Cry), 1946, **BARNETT NEWMAN**
Number 15, 1951, **JACKSON POLLOCK**
No. 61 (Rust and Blue) [Brown Blue, Brown on Blue], 1953, **MARK ROTHKO**

 Expressionism; Tachism; Existentialism; Surrealism; Post-Painterly Abstraction

 Suprematism; Constructivism; Precisionism; Social Realism; Postmodernism

Kitchen Sink Realism

A term given to a group of realist British painters working in the 1950s whose deliberately drab works borrowed the imagery of domestic life, from kitchen sinks and tables to toilets and back yards. Their works captured the austerity and anxiety that prevailed in the country after the Second World War.

JOHN BRATBY (1928–92); **DERRICK GREAVES** (1927–); **EDWARD MIDDLEDITCH** (1923–87); **JACK SMITH** (1928–2011)

austerity; everyday; figuration; mundane; working class

David Sylvester coined the term Kitchen Sink in an article in 1954 in which he described the work of four young artists: John Bratby, Derrick Greaves, Edward Middleditch and Jack Smith. In his words, their work included 'every kind of food and drink, every utensil and implement, the usual plain furniture and even the babies' nappies on the line. Everything but the kitchen sink? The kitchen sink too.'

The painters had trained at London's Royal College of Art and were also known as the Beaux Arts Quartet because of their affiliation to the city's gallery of that name. Their interior scenes and still lifes of commonplace objects emphasised the banality of everyday lives, particularly those of the working classes. When the artists moved beyond interiors they painted the terraced housing, tenements and industrial buildings in cities such as Sheffield, where Greaves and Smith had grown up.

This allied them to the older English artist LS Lowry, who painted industrial districts in Northern England, and it mirrored American Social Realism's focus on the less advantaged. It gained them the approval of influential Marxist critic John Berger, although the Kitchen Sink painters were not social reformers. Instead their mundane subject matter echoed with Existentialism; the detritus of a kitchen table or a toilet's interior spoke of the meaninglessness of life, a postwar society blighted by austerity and the lack of hope in a nuclear age.

The four artists lacked a common ideology and painted in different figurative styles from each other. Bratby, for example, used less muted colours than the other three artists, and his handling tended to be more free and expressive.

Kitchen Sink's popularity came at the same time in Britain as the ascendency of the Angry Young Men, a group of working- and middle-class writers whose realist output was exemplified by John Osborne's play *Look Back in Anger* (1956). The Swinging Sixties saw Pop Art eclipse Kitchen Sink Realism, but there continued to be a strong strand of figuration in the country's art scene, evidenced by the prominence of the School of London. That group of artists included Frank Auerbach and Leon Kossoff whose cityscapes bore a resemblance to those of the Kitchen Sink painters.

KEY WORK in the Tate Collection, UK

Still Life with Chip Frier, 1954, JOHN BRATBY
The odd perspective and colour palettes in Bratby's kitchen-table still lifes evoked the artist's ambivalence towards the objects that clutter modern life. This particular picture illustrated the article in which David Sylvester defined Kitchen Sink in 1954.

OTHER WORKS in the Tate Collection

Elm Park Gardens, 1955; *The Toilet*, 1955; *Susan Ballam*, 1956, **JOHN BRATBY**
Dead Chicken in a Stream, 1955, **EDWARD MIDDLEDITCH**
Bottles in Light and Shadow, 1959, **JACK SMITH**

Impressionism; Neue Sachlichkeit; Social Realism; School of London

Dadaism; Bauhaus; Abstract Expressionism; Pop Art; Minimalism

This classifies artworks that move or appear to move. The movement is not an additional quality, but integral to the form and purpose of the works. Although moving artworks were seen in Dadaism and Constructivism early in the century, Kineticism only coalesced into a distinct art movement in the 1950s.

POL BURY (1922–2005); ALEXANDER CALDER (1898–1976); MARCEL DUCHAMP (1887–1968); NAUM GABO (1890–1977); JEAN TINGUELY (1925–91)

energy; motorised; movement; rhythm; spectacle

Kineticism, a term interchangeable with Kinetic Art, became an established movement after the Second World War. The seminal exhibition 'Le Mouvement' (1955) at Galerie Denise René in Paris brought together artists of all generations who made moving artworks, inaugurating an ism that had its roots in Dadaism and Constructivism.

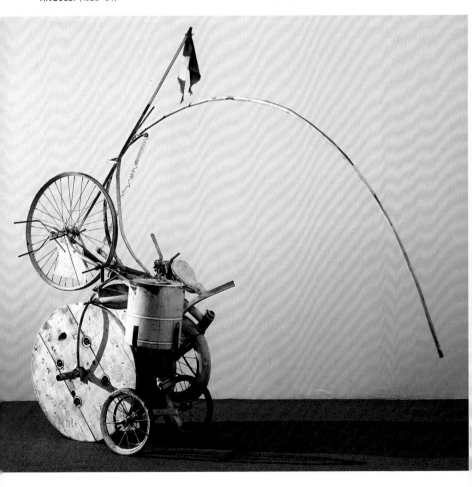

Kineticism

Marcel Duchamp's *Bicycle Wheel* (1913) is considered to be the first kinetic sculpture. It comprised a readymade bicycle wheel, mounted on a stool, which could be spun by hand – a characteristically comic Dadaist gesture. This playfulness can also be seen in the works of Alexander Calder, an American artist influenced by Dadaism's successor Surrealism. *Circus* (1926) was a menagerie of wood and wire creatures that Calder operated by hand. From 1932 he suspended 'mobiles' that moved by air currents and hand cranks, or were motorised. Their abstract shapes resembled the forms painted on canvas by the Surrealist Joan Miró.

In contrast to this playfulness, Naum Gabo made a serious attempt to absorb kinetic works into Constructivist theory, eulogising their energy and rhythm. His sculpture *Kinetic Construction (Standing Wave)* (1919–20) was a strip of twisted metal that appeared to take up a larger three-dimensional space when it oscillated. The Russian argued that such works had time and space as their basic elements; they could only be considered art when in motion. Fellow Constructivist László Moholy-Nagy established the importance of light for Kineticism with *Light-Space Modulator* (1930), a structure of glass and metal discs that projected a light show when animated.

The high-tech of Constructivism met with Surrealism in the constructions of Swiss New Realist Jean Tinguely. During the 1950s he produced 'meta-mechanical' devices: small-scale works made from scrap metal and other found materials in which geometric shapes rotated at different speeds. By the mid-1960s Tinguely had become popular for monumental, rickety structures that were unpredictable and could self-destruct – these undercut with irony any optimism about technology.

Other participants in Kineticism's postwar golden age included Belgian Pol Bury, whose arrangements of balls, cubes and cylinders moved very slowly, sometimes imperceptibly; Athenian Vassilakis Takis, who explored magnetism and sound in his sculptures; and American collectives such as Experiments in Art and Technology, and USCO (which stands for The Company of Us), who created audio-visual environments with innovative engineering and electronics. Kineticist exhibitions from the 1950s also included static pieces that appeared to move, such as the two-dimensional Op Art of Hungarian-French artist Victor Vasarely or the interactive sculptures of Venezuelan Jesús Soto.

By the 1980s Kineticism as a movement had subsided, but its emphasis on dynamic states and spectacle influenced Conceptualist movements from Performance Art and Fluxus to New British Sculpture and Sensationalism.

KEY WORK in the Museum of Modern Art, New York

Fragment from Homage to New York, 1960, JEAN TINGUELY
A piece from one of the most famous works in the Kineticist canon: an enormous machine formed from found materials that self-destructed in a spectacle of smoke and smashed glass – an ode to the energy of the American city and an ironic take on the machine age.

OTHER WORKS in the Museum of Modern Art

Untitled from 'X Cinetizations', 1966, POL BURY
A Universe, 1934; *Spider*, 1939, ALEXANDER CALDER
Bicycle Wheel, 1913 (replica 1951), MARCEL DUCHAMP
Sketch for Homage to New York, 1960, JEAN TINGUELY

 Constructivism; Surrealism; Fluxus; Process Art; Sensationalism

 Neo-Impressionism; Social Realism; Photorealism; Neo-Expressionism

Neo-Dadaism

Neo-Dadaism describes a group of American artists who from the mid-1950s incorporated images and materials from everyday life in their work. While retaining expressionistic brushwork, they rejected Abstract Expressionism's emotional intensity and embraced an irreverence that had echoes of Dadaism.

JOHN CAGE (1912–92); **JIM DINE** (1935–); **JASPER JOHNS** (1930–); **ROBERT RAUSCHENBERG** (1925–2008); **LARRY RIVERS** (1923–2002)

ambiguity; Happenings; irreverence; readymades; signs

Art historian Robert Rosenblum coined Neo-Dada (which can be used interchangeably with the term Neo-Dadaism) in 1957 in a review of an exhibition at New York's Leo Castelli Gallery. The artists on show included Robert Rauschenberg and Jasper Johns, the two leading protagonists of the movement.

Critics used the term more keenly than artists. There had been a revival of art-historical interest in Dadaism after painter Robert Motherwell published an anthology on the earlier movement in 1951. But Rauschenberg and his contemporaries were not attempting a reinterpretation of an older style: instead, they borrowed some Dadaist techniques in order to move away from the dominant mode of American art, Abstract Expressionism.

These techniques included the appropriation of commonplace materials, the use of readymades and a tendency towards visual wit. Rauschenberg's *Bed* (1955) consisted of a quilt and pillow in a box frame, covered in paint and mounted on the wall. Although this work was seen as a prank, the artist used readymades not as an anti-art gesture, but to create an art closer

to life – one that could connect powerfully to everyday experience by incorporating ordinary objects. This series of mixed-media works were known as 'combines' because they combined elements of painting and sculpture.

Johns painted serial representations of signs and symbols from contemporary life, such as flags, maps, stencilled words, targets and numbers. These conventional images were rendered with sensuous surfaces using complex techniques, such as the spreading of encaustic (pigmented wax) over collage. They both combined and raised questions about popular culture and painterliness: were these everyday images more ambiguous then they seemed, and was expressive painting itself becoming familiarly conventional?

Larry Rivers interpreted with similar ambiguity the work of masters such as Neoclassical painter Jean-Auguste-Dominique Ingres and Impressionist Édouard Manet, making vulgar copies of their great works. Jim Dine produced mixed-media assemblages from discarded clothing, bedsprings and other objects, as well as designing makeshift environments for 'Happenings', the collective Performance Art events orchestrated by artists like Allan Kaprow and the composer John Cage who – in an echo of Dadaism – attempted to incorporate chance in his music.

Social occasions such as 'Happenings' contrasted with the Existentialist and Abstract Expressionist idea of the artist as an individual. Neo-Dadaism can be seen as a bridge between these forms and Pop Art; many of the artists were later categorised under the label of the latter movement. Neo-Dadaism's penchant for paradoxes and ambiguities also laid the groundwork for Conceptualism and Postmodernism.

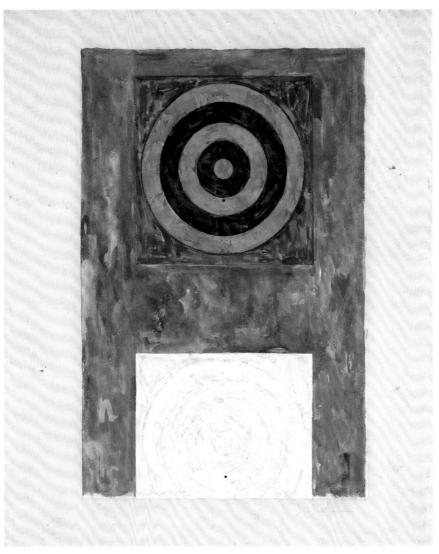

KEY WORKS in the Moderna Museet, Stockholm

Targets, 1966, JASPER JOHNS
Neo-Dadaism reintroduced subject matter to painting at
a time when abstract art predominated. But rather than
paint a figurative scene, Johns repeatedly represented an
abstract form from everyday life: the target. This symbol
seems to act as a metaphor for the way eyes are aimed
during the act of viewing art.

 Dadaism; Surrealism; New Realism;
Pop Art; Postmodernism

 Suprematism; Bauhaus; Social
Realism; Neo-Plasticism; Concrete Art

Neo-Dadaism

Monogram, 1955–9, ROBERT RAUSCHENBERG
One of the most famous of the artist's 'combines', which
mixed paint with readymade sculptural objects;
components here include a stuffed angora goat, a tyre, a
broken sign and a shirt sleeve. These ironic works
positioned Neo-Dadaism as an antidote to Abstract
Expressionist angst.

OTHER WORKS in the Moderna Museet

Black Tools in a Landscape, 1962, **JIM DINE**
Slow Field, 1962; *Figure 4,* 1968, **JASPER JOHNS**
One Question, One Answer (What? Look), 1962; *Prize,*
1964, **ROBERT RAUSCHENBERG**

The New Realists were a loose affiliation of European artists who in the late 1950s and early 1960s attempted 'new perceptive approaches to the real', in the words of French critic Pierre Restany. Artworks were often created out of commonplace materials in order to better mirror social realities.

ARMAN (ARMAND FERNANDEZ) (1928–2005); **RAYMOND HAINS** (1926–2005); **YVES KLEIN** (1928–62); **NIKI DE SAINT PHALLE** (1930–2002); **JEAN TINGUELY** (1925–91)

collective; mass media; salvaged objects; satire; sociological reality

New Realism (*Nouveau Réalisme* in French) rejected Tachism in the same way that, across the Atlantic, Neo-Dadaism renounced Abstract Expressionism. Both replaced individual painterly gesture with a collective visual language of everyday materials, objects and images. The New Realists were predominantly French and based in Paris. Restany clarified in 1960 the type of realism that was their focus: 'It is sociological reality in its entirety, the common good of all human activity, the great republic of our social exchanges, or our commerce in society.' At a time of growing affluence, a decade after the war,

consumption and the mass media defined society more readily than anxiety and austerity.

The *affiches lacérées* (torn posters) of Frenchmen Raymond Hains, Jacques de la Villeglé and François Dufrêne, and Italian artist Mimmo Rotella, comprised advertisements found on the street and subway, in which the top layers of print would be worn away to reveal previous layers. As well as their formal beauty, these pieces would gain an added resonance via unexpected juxtapositions of words and image.

French-born Arman (who changed his name from Armand Fernandez in accordance with a printing error) grouped together salvaged objects in transparent boxes. The objects ranged from items of all the same type – such as scrap water jugs or gas masks – to the miscellaneous refuse he found in a friend's rubbish bin. Swiss artist Jean Tinguely made eccentric machines from junk (see 'Kineticism'), and French sculptor César (César Baldaccini by birth) echoed Arman's critique of waste in his 'Compressions' series: cubes of compressed scrap metal, mainly sourced from automobiles.

Niki de Saint Phalle parodied the painterly pretensions of Tachism in her series of 'Shooting Paintings'. White plaster reliefs were filled with pockets of coloured paint before the artist or an exhibition visitor shot the reliefs with a gun, releasing the paint haphazardly over the plaster. Yves Klein, the leading New Realist, was similarly fond of satire. He patented an ultramarine shade of paint, IKB (International Klein Blue), and sold identical canvases covered by it for different prices.

In Klein's 'Anthropométries' series, nude women smeared in IKB pressed their bodies against paper, canvas and fabric, a radical gesture that anticipated Performance Art. The momentum of New Realism as a movement was cut short with Klein's untimely death in 1962, but its experimental works would help shape Pop Art, Conceptualism and Process Art.

KEY WORK in the Walker Art Center, Minneapolis, Minnesota

Mondo Cane Shroud, 1961, YVES KLEIN
New Realism's subversion of painting traditions is exemplified by Klein's 'Anthropométries' series, of which this is a representative example. Nude bodies imprinted the paint, replacing the brush, and Klein's status as the artwork's individual creator was undermined by the fact that the marks were made conjointly by several models.

OTHER WORKS in the Walker Art Center

Accumulation of Teapots, 1964, **ARMAN (ARMAND FERNANDEZ)**
Dimanche, 1960; *Untitled,* 1961, **YVES KLEIN**
Untitled from Edition MAT 64, 1964, **NIKI DE SAINT PHALLE**
Tinguely: Meta II, 1965, **JEAN TINGUELY**

 Pop Art; Conceptualism; Process Art; Neo-Dadaism; Performance Art

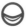 Impressionism; Suprematism; Concrete Art; Tachism; Abstract Expressionism

Pop Art

From the 1950s in Britain, and the 1960s in America, young artists produced works that took their inspiration from popular culture. Christened Pop Art, this new form of fine art appropriated the 'low art' images found in mass-media sources, from consumer advertisements and comic strips to magazine photo-shoots and movies.

PETER BLAKE (1932–); **RICHARD HAMILTON** (1922–2011); **ROY LICHTENSTEIN** (1923–97); **EDUARDO PAOLOZZI** (1924–2005); **ANDY WARHOL** (1928–87)

advertisements; mass media; popular culture; Swinging Sixties

English critic Lawrence Alloway coined the phrase Pop Art in an article in 1958, although a circle of British artists, designers and writers – the Independent Group, who met at London's Institute of Contemporary Arts (ICA) – had been focusing on popular culture and the mass media since the early 1950s.

The group included Eduardo Paolozzi, who in 1952 presented at the ICA a slideshow of pictures pulled out from comics and magazines, such as pin-up girls, celebrities, cartoon characters and consumer advertisements. Paolozzi's assortment of low-brow images, arranged in a series of collages known as 'Bunk' (1947–52), were the foundation stone of British Pop Art.

Fellow Independent Group member Richard Hamilton summed up the movement with the flair of an advertising copywriter: 'Popular (designed for a mass audience); Transient (short-term solution); Expendable (easily forgotten); Low Cost; Mass Produced; Young (aimed at Youth); Witty; Sexy; Gimmicky; Glamorous; and Big Business.' The ironic tone in Hamilton's pronouncement persisted in his work. By spotlighting consumer images in the context of collages and paintings, he brought out their hidden connotations, some of them sinister.

In contrast, Peter Blake's Pop Art had an unashamed admiration for popular culture – the artist collected contemporary ephemera such as illustrations and toys, and assembled these with love in constructions and collages. A group of artists who graduated from the Royal College of Art (RCA) later than Blake, in the early 1960s, developed Pop Art in confident new directions. David Hockney, for example, summed up the freedom of the Swinging Sixties with a series of paintings of swimming pools, and Allen Jones produced fibreglass sculptures of sexualised females, their treatment aping pornographic magazines.

Pop Art in America developed from Neo-Dadaism in the early 1960s and, like Hamilton's work, it had a more ambiguous position towards its subject matter than most British Pop Art. Andy Warhol's silkscreen paintings, in which he would repeatedly superimpose a found image from print or film on paint, blended banality, glamour and pathos. Roy Lichtenstein copied single images from comic strips in large paintings; once these simple, speech-bubbled pictures were blown up in scale, their banal content became strangely aggrandised. James Rosenquist produced artworks with the look of billboards, in which commercial images of products and celebrities would be juxtaposed in unsettling ways.

By 1962, Pop Art had replaced Abstract Expressionism in the affection of America's critics and curators, although it faced competition from Post-Painterly Abstraction. The movement spread internationally until the 1970s, the decade of Minimalism and Conceptualism, and was then revived in the 1980s through Neo-Pop.

KEY WORK in the Tate Collection, UK

I was a Rich Man's Plaything, 1947, from 'Ten Collages from Bunk' (1947–52), EDUARDO PAOLOZZI

Paolozzi's Pop Art collages mounted on card, of which this is a very early example, feature the type of commercial images that would come to represent the movement, like Coca-Cola advertisements and pictures of pin-up girls. These collages parodied the way people were increasingly bombarded with such images via the mass media after the war.

OTHER WORKS in the Tate Collection

The Toy Shop, 1962, **PETER BLAKE**
Whaam!, 1963, **ROY LICHTENSTEIN**
Interior, 1964–5; *Swingeing London 67 (f),* 1968–9, **RICHARD HAMILTON**
Black Bean from 'Soup Can Series I', 1968, **ANDY WARHOL**

 Neo-Dadaism; New Realism; Neo-Pop; Postmodernism; Sensationalism

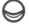 Suprematism; Neo-Plasticism; Concrete Art; Neo-Expressionism

Op Art

An abbreviation of Optical Art, this term describes works that precipitate unexpected optical effects in viewers, such as the illusion of movement, depth or vibration. Op Art more specifically refers to a group of painters who gained acclaim for geometric works of this type from the 1960s.

RICHARD ANUSZKIEWICZ (1930–); MICHAEL KIDNER (1917–2009); LARRY POONS (1937–); BRIDGET RILEY (1931–); VICTOR VASARELY

(1906–97)
after-images; illusion; movement; optical effects; perceptual abstractionists

Op Art as a modern art movement crystallised with the exhibition 'The Responsive Eye' at New York's Museum of Modern Art (MoMA) in 1965. The show featured a wide array of abstract artists, but the painters who received the most press were those called 'perceptual

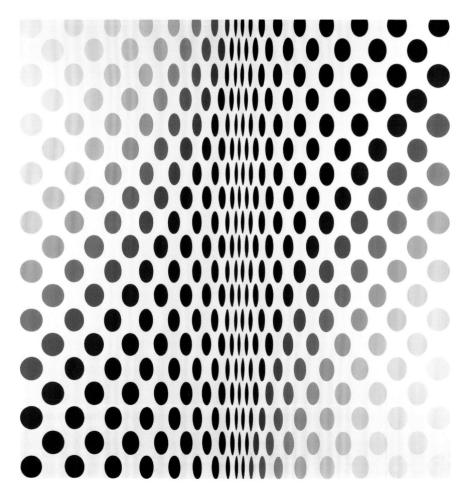

abstractionists' – a group of international artists, working independently, whose works attempted to confound the perceptual expectations of the viewer. They included British painters Bridget Riley and Michael Kidner, the Hungarian-French artist Victor Vasarely and the Americans Larry Poons and Richard Anuszkiewicz.

Visual trickery, however, was not a new phenomenon. The history of art is full of examples of tromp l'oeil (meaning 'trick the eye'), in particular two-dimensional works of such radical perspective that viewers believed they had real three-dimensional depth. Modern art movements before Op Art had shown interest in the science of optics; the Pointillist technique in Neo-Impressionism, for instance, relied on the illusion whereby discrete dots of paint merge into one in the eyes of the viewer.

The Op Art movement in the 1960s was typified by geometric abstract paintings in which optical effects were, in essence, the work's subjects. Riley progressed from figurative Pointillism to black-and-white patterns of lines or shapes that seemed to recess and bulge, or vibrate and move, at certain points. Some of these early works' effects were not pleasurable: they could make the viewer dizzy or leave after-images on the eye. From 1967 Riley began to complete canvases in full colour and her paintings produced more subtle sensations through chromatic combinations.

Vasarely also played at first with black and white, in series such as 'Zebras' (1937–52), in which the two-toned animals would merge either into one another or a black-and-white background. He then developed a visual language of matrices, first in monotone and then in bright colour, in which variations would elicit unexpected effects of depth or dazzle. The Parisian painter had Utopian ambitions for his Op

Art; he codified his visual language into what he called a 'Plastic Alphabet', so that his designs could be created by machines and integrated into future architecture and urban planning.

Although popular with audiences, Op Art was seen as gimmicky by some critics and went quickly out of fashion by the late 1960s. It had a lasting worth, however, in questioning the nature of perception and suggesting the illusory nature of both art and reality.

KEY WORK in the Centro de Arte Moderna, Lisbon

Metamorphosis, **1964**, **BRIDGET RILEY**
This painting illustrates the way Op Art achieved dramatic visual effects through methodical processes. Riley painted the horizontal axes of her black ellipses ever shorter in order to give the impression that they were receding into the distance.

OTHER WORKS in the Centro de Arte Moderna

Shuttle, 1964, **BRIDGET RILEY**
Mansa, 1979, **VICTOR VASARELY**
Red Counter Pink, 1961; *Orange, Blue and Green*, 1964; *Brown, Blue and Violet No.2*, 1964, **MICHAEL KIDNER**

 Neo-Impressionism; Bauhaus; Concrete Art; Kineticism; Post-Painterly Abstraction

 Expressionism; Neue Sachlichkeit; Social Realism; Kitchen Sink; Photorealism

Post-Painterly Abstraction

This term encompasses a range of abstract painting styles that emerged in America in the late 1950s and early 1960s. They were united in their rejection of the emotionalism of Abstract Expressionism and were characterised by linear clarity, pure colour and brushwork that lacked any individuality in its application.

HELEN FRANKENTHALER (1928–2011); **ELLSWORTH KELLY** (1923–); **MORRIS LOUIS** (1912 –62); **KENNETH NOLAND** (1924–2010); **FRANK STELLA** (1936–)

anonymous; flatness; inexpressive; self-sufficient; shaped canvas

The critic Clement Greenberg coined the title Post-Painterly Abstraction for an exhibition he curated in 1964 at the Los Angeles County Museum of Art (LACMA). He perceived that the painters included had progressed from the 'Painterly Abstraction' of Abstract Expressionism. The exhibitors replaced gestural mark-making with anonymous application of paint; spontaneous marks with premeditated design; thick tactility with thin surface; a sense of depth with flatness; and expression of emotion with an emphasis on the painting as a purely visual object.

Their diverse styles included Hard-Edged Painting by Ellsworth Kelly and Frank Stella, characterised by abrupt transitions between different colour spaces; Stain Painting by Helen Frankenthaler, in which diluted paint would soak into the canvas; and inexpressive forms of Colour Field Painting, practised by artists such as Morris Louis and Kenneth Noland, who were later known as part of the Washington Colour School.

Stella's 'Black Paintings' (1959) are often seen as the starting point for the departures of Post-Painterly Abstraction. This series of canvases are covered in stripes of unmodulated black enamel paint, separated by thin white lines of canvas. The artist was not interested in imbuing these works with associations, whether symbolic or spiritual, and said in relation to one of the paintings that 'What you see is what you see'.

This attitude countered the transcendental aspirations of Abstract Expressionism, as well as the Utopian social inclinations of earlier forms of abstraction

paintings' formal qualities as objects.

Post-Painterly Abstraction can be seen to merge with Minimalism in the monochrome works of Stella, Robert Ryman and Agnes Martin. The two movements were popular until the late 1970s and early 1980s, when less restrained styles of painting emerged in movements such as Postmodernism and Neo-Expressionism.

KEY WORK in the Los Angeles County Museum of Art

Unfurled Series: Beta Ro, 1959–60, **MORRIS LOUIS**

The dripping of paint, pioneered by Action Painters like Jackson Pollock, was appropriated by Post-Painterly Abstraction. Louis poured streams of paint diagonally across the corners of this canvas, not to accentuate gesture, but to remove it; the paint does the work rather than the human, leaving an attractive but impersonal arrangement of colours.

such as Neo-Plasticism and Bauhaus. Concrete Art's manifesto in 1930 had encouraged self-sufficient art with 'no other significance than "itself"', but this aim had gone unfulfilled as the movement focused on mathematics and came to include all geometric non-figurative art.

The painters also often used unmixed commercial acrylics, which Stella described as 'straight out of the can; it can't get better than that'. Colours tended to remain distinct in the eye of the viewer rather than coalescing towards a visual harmony.

Another notable innovation was the shaped canvas: instead of being squares or rectangles, paintings would have curved forms or jagged perimeters. This stressed the

OTHER WORKS in the Los Angeles County Museum of Art

Winter Hunt, 1958, **HELEN FRANKENTHALER**
Blue on Blue, 1963, **ELLSWORTH KELLY**
Gemini, 1962, **MORRIS LOUIS**
Chocorua 1, 1965–6; *Bampur*, 1966, **FRANK STELLA**

 Concrete Art; Neo-Dadaism; Op Art; Minimalism; Conceptualism

 Impressionism; Cubism; Precisionism; Postmodernism' Neo-Expressionism

Minimalism

The adjective 'minimalist' generally signifies any form that is simplified or pared-down. It is also an art-historical category that refers to American artists who from the mid-1960s presented serial geometric structures made from industrial materials. These works were self-sufficient, without reference to other forms or themes.

CARL ANDRE (1935–); **DAN FLAVIN** (1933–96); **EVA HESSE** (1936–70); **DONALD JUDD** (1928–94); **ROBERT MORRIS** (1931–)

geometric; industrial materials; neutral; self-sufficient; serial

Minimalism as an art movement never had a manifesto and its associated artists worked independently. But the essay 'Specific Objects', written in 1965 by one of its practitioners, Donald Judd, became the closest it had to a canonical text.

In this overview of a range of artists, including fellow Minimalists Dan Flavin and Robert Morris, Judd explained: 'It isn't necessary for a work to have a lot of things to look at, to compare, to analyse one by one, to contemplate. The thing as a whole, its quality as a whole, is what is interesting … shape, image, color and surface are single and not partial and scattered. There aren't any neutral or moderate areas or parts, any connections or transitional areas.'

Judd developed a visual language that conformed to these ideas. He created

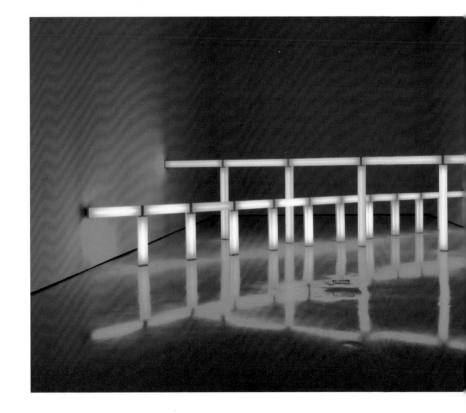

structures to be appreciated as objects in themselves, without 'connections' to anything else. He presented series of monochrome metal boxes that had been prefabricated in a factory for a perfect finish and to avoid individualities of shape or texture. Judd attached these units to the wall at equal intervals, forming what were called 'stacks'. He labelled these 'specific objects' as he did not want to classify them in terms of painting or sculpture.

Morris produced similarly pared-down geometric forms, such as metre-high cubes with mirrored surfaces that were arranged equidistantly from each other on the gallery floor. Carl Andre also created configurations of units on the floor, comprising common

building materials such as bricks and metal plates.

These works' lack of mimetic, symbolic or expressive function led to the label Minimalism, although this was used more often by critics than artists, who disliked the connotation that their work was without content for the viewer. Morris claimed that: 'Simplicity of space does not necessarily equate with simplicity of experience.' His cubes enabled complex encounters for viewers, whose reflections would move on the

mirrored surfaces as they walked around the works. Flavin's arrangements of neon light tubes encouraged a rich visitor experience due to the way they illuminated the gallery space in spectacular ways.

Minimalism continued its influence throughout the 1970s. Frank Stella and other Post-Painterly Abstractionists were described as Minimalist painters, as they also attempted to create objects without references. Conceptualism – in which the artwork became condensed to an idea – was also seen in connection with Minimalism. Artists like Robert Morris, Eva Hesse and Richard Serra explored process in their adaptations of Minimalist practices in the late 1960s: these adaptations were known as Process Art and also described as Post-Minimalist.

KEY WORK in the Solomon R Guggenheim Museum, New York

***Greens crossing greens (to Piet Mondrian who lacked green),* 1966, DAN FLAVIN**
Minimalist artists considered their works' relationship to the gallery space and the viewer. In this installation, Flavin prohibited movement around the gallery by forming barriers from fluorescent lights. He connected his practice to art history by acknowledging the influence of Neo-Plasticist Mondrian in the work's title.

OTHER WORKS in the Solomon R Guggenheim Museum

10 x 10 Altstadt Copper Square, 1967, **CARL ANDRE**
the nominal three (to William of Ockham), 1963, **DAN FLAVIN**
Untitled, 1968; *Untitled,* 1970, **DONALD JUDD**
Untitled (Corner Piece), 1964, **ROBERT MORRIS**

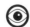 Suprematism; Constructivism; Concrete Art; Post-Painterly Abstraction; Conceptualism

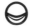 Symbolism; Expressionism; Surrealism; Pop Art; Postmodernism

Conceptualism

Conceptualists asserted that their artworks were essentially ideas rather than items – material objects were no more than conduits for concepts. The movement had a widespread international reach and influence from the late 1960s, and contemporary artists and critics continue to describe theory-orientated practice as Conceptualist.

JOSEPH BEUYS (1921–86); **MARCEL BROODTHAERS** (1924–76); **JOSEPH KOSUTH** (1945–); **SOL LEWITT** (1928–2007); **LAWRENCE WEINER** (1942–)

dematerialisation; ideas; linguistics; questions; receivers

Conceptualism (or Conceptual Art) radically redefined the artwork. The objects presented by Conceptualists were assessed in terms of how successfully they communicated ideas rather than by any aesthetic considerations.

Typographic work emerged as a new medium in the late 1960s and the 1970s. Produced by artists such as Joseph Kosuth and Lawrence Weiner in New York, and the collective Art & Language in Britain, these pieces explored linguistics and how words could represent ideas within the context of visual art. Weiner produced short descriptions of works in artist books and on walls. Most of the works did not exist as finished objects, as it was the ideas behind them that were essential, rather than their execution or completion. Weiner claimed these ideas were subjective to those who comprehended them, who he called 'receivers' rather than 'viewers'.

Sol LeWitt wrote instructions for wall drawings to be completed by assistants. The instructions, which comprised text, a diagram and a certificate signed by the artist, assumed as much significance as the

actual drawings. LeWitt argued that 'The idea becomes the machine that makes the art': the ability and identity of the maker was less important than the concept.

This 'dematerialisation of the art object' (in the words of critic Lucy Lippard) posed challenging questions for both public and private galleries. For example, if the material work was no longer the prime piece, then how could art be sold, collected and valued? Could the old hierarchy of critics, curators and gallerists be circumvented? The French artist Daniel Buren exhibited vertical stripes outside gallery spaces, on walls, floors and even on sandwich boards attached to people, explaining: 'The museum/gallery instantly promotes to "art" status whatever it exhibits with conviction, ie, habit, thus diverting in advance any attempt to question the foundations of art.' Belgian Marcel Broodthaers mocked museum display with baffling installations of objects, images and texts.

German Fluxus artist Joseph Beuys and New York-based Adrian Piper were two of the many Conceptualists to emphasise social change, communicating ideas about the environment and identity respectively in some of their works. Younger artists from the late 1970s, known occasionally as Neo-Conceptualists, explored other concepts

Conceptualism

ranging from gender (Jenny Holzer and Barbara Kruger) to capitalism (Neo-Pop artists Jeff Koons and Richard Prince).

Conceptualism has become a broad label to represent all movements concerned with theoretical questions, from the Dadaism of Marcel Duchamp to Performance Art, Fluxus, Sensationalism and Interventionism. There has also been a backlash against Conceptualism's influence by art lovers and groups, such as the Stuckists in Britain, who disdain how it ranks theory above aesthetic experience.

KEY WORKS in the Hamburger Bahnhof, Museum for Contemporary Art, Berlin

Directive forces (Of a new society), 1974–7, **JOSEPH BEUYS**
An example of what the artist termed 'social sculpture', this installation of 100 chalk-scribbled blackboards illustrates how Conceptualism turned to unexpected objects to sum up complex ideas. Beuys uses these symbols of education to raise questions about self-improvement and the development of society.

← *It was it No. 5,* 1986, **JOSEPH KOSUTH**
This work exemplifies Conceptualism's interest in language's ability – and impotence – when it comes to conveying ideas. The background text discusses an actor making an error in speech. Kosuth superimposes two texts in neon: the top clause evokes the vagueness of verbal language, the bottom the correspondence of one word to another.

OTHER WORKS in the Hamburger Bahnhof, Museum for Contemporary Art

Unschlitt/Tallow, 1977; *Untitled (from PLIGHT),* 1985, **JOSEPH BEUYS**
A Winter Garden, 1974, **MARCEL BROODTHAERS**
Open Cube/Corner Piece, 1965, **SOL LEWITT**
Left Here Put There for a Limited Time, 1976, **LAWRENCE WEINER**

 Performance Art; Fluxus; Neo-Pop; Sensationalism; Interventionism

 Impressionism; Neo-Impressionism; Secessionism; Fauvism; Precisionism

Performance Art (or Live Art) became a key art practice from the 1960s. The artist's body and its performance became the artwork. In contrast to those on stage and screen, art performances tended to be highly experimental in format, transgressive in character and Conceptualist in their aim to communicate complex ideas.

MARINA ABRAMOVIC (1946–); **VITO ACCONCI** (1940–); **CHRIS BURDEN** (1946–); **BRUCE NAUMAN** (1941–); **CAROLEE SCHNEEMANN** (1939–)

actions; the body; documentation; taboos; transgression

In the late 1950s, Neo-Dadaists participated in events known as 'Happenings', antecedents to Performance Art. They combined elements ranging from poetry readings and academic lectures to painting exhibitions and dance pieces. Their activities had a precedent in Futurist and Dadaist events, which integrated spoken word, such as poems and political rhetoric, with theatre and live music.

Performance Art matured from these unruly social events from 1960. New Realism that year integrated performance into the making of artwork; audiences watched on as Yves Klein's models marked canvases with their paint-covered bodies. The first Fluxus events from 1961 promoted 'living art', the idea that human actions could be considered artworks in themselves.

Premeditated performance pieces (called 'actions') articulated complex ideas and tore up social taboos. Themes included animalism, brought to life in Carolee Schneemann's *Meat Joy* (1964), an erotic reverie with raw meat; the violation of women, examined in *Cut Piece* (1964), in which a Japanese audience cut off the clothes of Fluxus artist Yoko Ono; and narcissism, explored in *Seedbed* (1971), in which Brooklyn-based Vito Acconci masturbated under a ramp in a gallery space as his fantasies about those above him were amplified. Sadomasochistic works by the Serbian Marina Abramovic and Boston-born Chris Burden, as well as the sacrificial rites of a group known as the Vienna Actionists, exemplified this tendency towards transgression.

These works came out of the same intellectual climate as Conceptualism. Performances had the advantage that they could convey concepts without leaving behind an art object to be assessed in terms of aesthetics and traded. If there was an object involved, it was the body – leading to the term Body Art. Artists like the American Bruce Nauman and British pair Gilbert & George photographed themselves as if they were living sculptures.

The viewer became a voyeur in many of these works, although not all performances were spectacular or presented to an audience. Taiwan-born Tehching Hsieh investigated the nature of time in a series of 'One Year Performances': in the first (1978–9), he endured solitary confinement for a year in a wooden cage, forbidding himself to talk, read, write, listen to a radio or watch TV. A friend visited daily to deliver food, remove waste and take a photograph.

Although for Hsieh these photographs were documentation and not artworks, they have since been exhibited in galleries. Indeed in the 1980s and 1990s, Performance Art became integrated into the mainstream art world, as institutions acquired film and photographic records as well as objects associated with past performances, and began to present live pieces themselves.

KEY WORK at Electronic Arts Intermix, New York

Pinchneck, 1969, **BRUCE NAUMAN**
Performance Art posited that the body is an artistic medium and explored all its nuances and gestures. A series of films, of which this is an example, shows Nauman as he distorts the flesh of his neck, cheek and mouth to bring attention to the malleability of the human form.

OTHER WORKS at Electronic Arts Intermix

Performance Anthology, 1975–80, **MARINA ABRAMOVIC**
Trappings, 1971, **VITO ACCONCI**
Documentation of Selected Works, 1971–4, **CHRIS BURDEN**
Dance or Exercise on the Perimeter of a Square (Square Dance), 1967–8, **BRUCE NAUMAN**
Up To and Including Her Limits, 1976, **CAROLEE SCHNEEMANN**

 Dadaism; Neo-Dadaism; New Realism; Conceptualism; Fluxus

 Impressionism; Post-Impressionism; School of London; Photorealism

Fluxus

Fluxus, meaning 'flow' in Latin, described a multidisciplinary group of international artists who collaborated on radical acts. They aimed to dissolve the boundary between art and life, and to create, in the words of their chief theorist George Maciunas, 'living art'.

DICK HIGGINS (1938–98); **ALISON KNOWLES** (1933–); **GEORGE MACIUNAS** (1931–78); **YOKO ONO** (1933–); **BEN VAUTIER** (1935–)

Fluxfests; intermedia; living art; multidisciplinary; performances

Maciunas coined the term Fluxus in 1961 to describe an international community of artists, designers, writers, musicians and activists who collaborated on experimental projects. Its wide range of affiliates included the Tokyo-born performance artist Yoko Ono, German Conceptualist Joseph Beuys, Korean-American video art pioneer Nam June Paik, New York book artist Alison Knowles and her compatriots the avant-garde composers George Brecht and Dick Higgins, and poet Emmett Williams.

None of these figures restricted their work to one medium or discipline. The term Fluxus was chosen to reflect the way the members 'flowed' between different practices, as well as the ever-changing composition of the community. Higgins invented the word 'intermedia' to describe how Fluxus activities were in between classifications. Examples of these included Brecht's score/performance piece *Drip Music* (1962), which amplified the sound of water poured into vessels; actions by Ono that incorporated text and sound works; and Fluxus Editions, publications produced by many of the artists, into which art objects were assimilated.

The movement's heterogeneity reflected

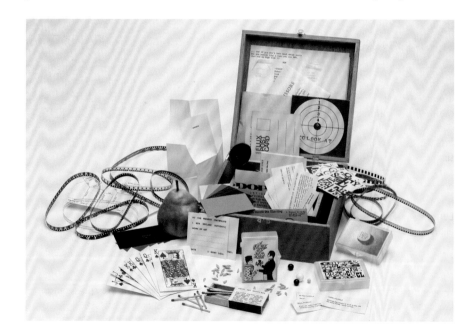

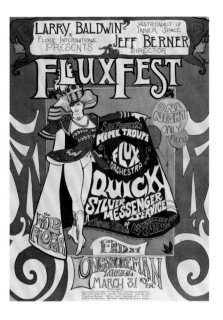

its central tenet: in Maciunas' words, 'anything can be art and anyone can do it'. Fluxus projects aimed not just to push the boundaries of what could be considered art, but to obliterate them altogether, so that art and life were one. Their pieces involved social critique and Maciunas had the aspiration that his message would 'be grasped by all peoples, not only critics, dilettantes and professionals'. To reach a broad audience, works had a 'do-it-yourself' simplicity and involved humour and fun.

Performances and sound pieces were presented at Fluxus festivals, known as Fluxfests or Fluxconcerts, organised in major European and American cities. Many of the actions and compositions were generated randomly, demonstrating the influence of Neo-Dadaist John Cage, who pioneered music that was left to chance. In their belief that art was life and not a commodity, some Fluxus artists refused to sell their works: for example, the Frenchmen Robert Filliou and

Ben Vautier pursued Mail Art, the free exchange of artist-made envelopes, stamps and postcards through the mail.

The collective is hard to categorise under any single ism. Maciunas wrote in the early 1960s of its correlation with Neo-Dadaism, in the way it experimented with a wide range of media. But it blended the earlier movement with emergent Performance Art and Conceptualist practices, in both its anti-commercialism and redefinition of what an artwork could be. This radicalism meant it remained influential throughout and after the 1970s.

KEY WORKS in the Fogg Museum, Harvard Art Museums, Cambridge, Massachusetts

 Fluxfest, 1967, VARIOUS ARTISTS
Fluxfests were the group's most high-profile projects. The artists wished for wide participation and formed alliances outside the world of fine art. In the event advertised here – in a poster designed by Ida Griffin, partner of fellow psychedelic artist Rick Griffin – Fluxus joined forces with members of San Francisco's 1960s counter-culture.

 Flux Year Box 2, c 1968, VARIOUS ARTISTS
The contents of this limited-edition box demonstrate the diversity, playfulness and collaborative nature of Fluxus. Submitted by artists from across the collective, these objects are props for actions, from playing cards and matches to medicine and seeds.

OTHER WORKS in the Fogg Museum, Harvard Art Museums

Fluxkit, 1964, DICK HIGGINS
Bean Rolls, 1964, ALISON KNOWLES
Fluxus 3 newspaper eVenTs for the pRicE of $1 No. 7 February1, 1966, 1964, GEORGE MACIUNAS
Grapefruit, 1964, YOKO ONO
The Postman's Choice, 1964, BEN VAUTIER

Futurism; Dadaism; Neo-Dadaism; Conceptualism; Performance Art

Impressionism; Neo-Impressionism; School of Paris; Abstract Expressionism; Kitchen Sink

Process Art

This term describes artworks that called attention to the processes by which they were made. In the late 1960s and 1970s, especially in America, there was a trend for experimental processes and the behaviour of unconventional materials to become the actual subject matter explored by artists.

BARRY FLANAGAN (1941–2009); **HANS HAACKE** (1936–); **EVA HESSE** (1936–70); **ROBERT MORRIS** (1931–); **RICHARD SERRA** (1939–)

anti-form; gravity; properties; unconventional materials

Bar the saving of plans and sketches for later display, a convention persisted into the modern era that the processes that produced an artwork should be hidden from viewers. As the former pioneer of Minimalism Robert Morris explained in 1968, in an influential article entitled 'Anti-Form' in *Artforum* magazine: 'The well-built form of objects preceded any consideration of means. Materials themselves have been limited to those which efficiently make the general object form.' The finished work was the focus, and the materials and processes that made it were secondary to its successful production.

Process Art subverted this 'anti-entropic and conservative enterprise', in the words of Morris, by making the phenomena of process and materials the work's central themes. The year before he penned his *Artforum* piece, the artist hung thin strips of felt by a single nail on the wall and allowed the fabric to take its own configuration. Abdicating his responsibility to arrange the material, in a move that echoed Dadaism's embrace of chance, Morris left it up to gravity and the properties of the felt to form the artwork.

His compatriot Richard Serra explored gravity in an extended series of works in which lead pipes and plates balanced against one another and gallery walls. In *Splashing* (1968), in a warehouse provided by his art dealer, Serra threw molten lead into the corner where a wall met the floor; the result owed more to the solidification process of the metal than to the calculations of the artist.

The Process Art trend can be traced back to Jackson Pollock's Abstract Expressionist paintings, in which the process of dripping paint was prime. But human expression remained the focus of Pollock's canvases. The drip works of Post-Painterly Abstractionist Morris Louis were closer relatives to Process Art, as Louis avoided any gestural movement, his works testament to the viscosity of paint and absorptive properties of the fabric.

In keeping with Conceptualist practices of the time, the artist's role was often to premeditate the rules for the work. Once these were set and the processes set in motion, the artists would allow the materials to 'do the work' without interference. Practitioners explored the effects of ever-more unconventional materials, from neon (Keith Sonnier) to latex (Lynda Benglis) and sand (Barry Flanagan), and experimented with processes that included condensation (Hans Haacke) and decomposition (Eva Hesse).

Process Art is often included under the broader banner of Post-Minimalism. Although it rejected the sleek forms seen in Minimalism, it shared an interest in the self-evident properties of industrial materials. The movement is also closely related to Land Art, in which natural processes came to the fore, and Arte Povera in Italy.

KEY WORK in the Whitney Museum of American Art, New York

Prop, 1968 (refabricated 2007), RICHARD SERRA
Serra's pared-down Process Art pieces are often seen in the context of Minimalism. The simplicity of this composition – a 5-foot square lead sheet held in place by a lead tube, which is in turn propped up by the wall – helps spotlight the elemental process of gravity that it relies on.

OTHER WORKS in the Whitney Museum of American Art

No title, 1970, EVA HESSE
Tet, 1958, MORRIS LOUIS
Untitled (L-beams), 1965, ROBERT MORRIS
Out-of-Round IX, 1999, RICHARD SERRA
Ba-O-Ba, Number 3, 1969, KEITH SONNIER

 Dadaism; Kineticism; Post-Painterly Abstraction; Arte Povera; Land Art

 Impressionism; Expressionism; Neue Sachlichkeit; Kitchen Sink

Arte Povera ('Poor Art') describes the work of a circle of artists active in Italy from the mid- to late 1960s. 'Poor' has been taken as descriptive of the group's everyday materials, which ranged from vegetables to rags. But its intended meaning was more complex, signifying a lack of adherence to social and cultural conventions.

GIOVANNI ANSELMO (1934–); LUCIANO FABRO (1936–2007); JANNIS KOUNELLIS (1936–); MARIO MERZ (1925–2003); MICHELANGELO PISTOLETTO (1933–)

against convention; everyday materials; juxtapositions; revolutionary; symbolic

Germano Celant was the chief theorist and curator of Arte Povera, and defined the movement in an article for journal *Flash Art* in 1967. He described a group of Italian artists (as well as Greek-born Jannis Kounellis) with whom he had associated since 1963.

Celant's ideas can be seen in the context of Situationism and other revolutionary ideologies of the 1960s that sought to challenge the Western capitalist system. The critic set up a contrast between 'rich' and 'poor' art. The former had a 'kleptomaniac reliance on the system and the use of codified and artificial languages in comfortable dialogue with existing structures'; the latter presented itself 'as something sudden and unforeseen with respect to conventional expectations'.

The group that Celant saw as producing 'poor' art was based in the cities of Northern Italy and predominantly worked in sculpture, installation and performance. In order to challenge social norms they used everyday materials in unexpected juxtapositions with other objects, in an echo of Surrealism. Although they often used humble materials, this was not always the case and many pieces were expensive to fabricate. As Celant explained, 'poor' really meant a stance against convention, not cheap components.

Venus of the Rags (1967) by Michelangelo Pistoletto was a copy of a classical statue of a goddess that propped up a large mound of second-hand clothes. Was the artist suggesting that the contemporary rags were equivalent to a work of antiquity? Such pieces can be seen in the context of Conceptualism, in which an artwork's main ambition was to articulate difficult questions.

Mario Merz built a series of 'Igloo' sculptures from materials such as dirt-filled bags, neon lights, netting and large chunks of wax. The nomadic dwelling was reinterpreted as a symbol of modern society. Milan-based Luciano Fabro looked squarely at the state of the nation in his maps of Italy: a famous example was gilded and suspended upside down, a comment on the country's North/South divide. Process was a concern for Giovanni Anselmo who, like Pistoletto and Merz, came from Turin. The artist produced *Structure that Eats* in 1968, in which a lettuce held in tension two blocks of stone, posing the threat that as the lettuce decomposed, one of the blocks would fall.

Arte Povera's preoccupation with materials and processes had a mirror in Process Art, although the American movement was more interested in physical properties than in symbolic potential. The group can also be related to movements like Fluxus in the way they broadened what could be considered art.

KEY WORK in the Castello di Rivoli Museum of Contemporary Art, Turin

Venus of the Rags, 1967,
MICHELANGELO PISTOLETTO
Perhaps the emblematic work of Arte Povera, Pistoletto's sculpture – of which this is one of several versions – combines Italy's past and present in a provocative form. Some have seen it as primarily a comment on modern consumption, others a satire on how the country perceives its heritage.

OTHER WORKS in the Castello di Rivoli Museum of Contemporary Art

Breathing, 1969, **GIOVANNI ANSELMO**
Italy's Mirror, 1971, **LUCIANO FABRO**
Untitled, 1969, **JANNIS KOUNELLIS**
Igloo: Qaddafi's Tent, 1968–81, **MARIO MERZ**
Girl Walking, 1962–6, **MICHELANGELO PISTOLETTO**

Surrealism; Neo-Dadaism; Conceptualism; Fluxus; Process Art

Impressionism; School of London; Abstract Expressionism; Photorealism

Land Art

From the late 1960s, artists in America and Britain began making large-scale sculptures in, and adaptations of, natural landscapes, often using materials found in those environments. Known as Land Art, these pieces tended to be monumental and explored ecological themes.

CHRISTO (CHRISTO VLADIMIROV JAVACHEFF, 1935–) **AND JEANNE-CLAUDE** (JEANNE-CLAUDE DENAT DE GUILLEBON, 1935–2009); **RICHARD LONG** (1945–); **WALTER DE MARIA** (1935–); **DENNIS OPPENHEIM** (1938–2011); **ROBERT SMITHSON** (1938–73)

environmentally conscious; geometric; monumental; natural forms; remote areas

Land Art (or Earth Art, or Earth Works) had its heyday from the late 1960s to the mid-1970s. Siting sculptures in natural landscapes was nothing new, but forming sculptures *out of* those landscapes was – works involved processes such as the excavation of soil, moulding of mud and rearrangement of rocks.

New Jersey-born Robert Smithson moved more than 6,000 tonnes of rock from the shore of the Great Salt Lake in Utah to form *Spiral Jetty* (1970), a 1,640-foot (500-metre) long coil of basalt and earth that jutted into the water. In its geometric form, heroic scale, isolated location and ecological concerns (the area had been affected by oil prospectors), Smithson's masterpiece epitomised the Land Art movement.

The work was to be submerged and then revealed as the water level dropped, except Smithson miscalculated, and until 2004 it remained under water, only known through photographs and a film. The overall form of *Spiral Jetty* could be best seen from the air, echoing archaic works such as the Nazca Lines in the Peruvian Desert and Stonehenge in Britain; Smithson and others were

conscious of Land Art's association with the mystical practices of ancient cultures. Similarly monumental pieces in remote areas include American artist Michael Heizer's *Double Negative* (1969), a massive trench in Nevada, and the 3-mile (4.8-kilometre) wide Roden Crater in Arizona, which Pasadena-born James Turrell has been trying to transform into a naked-eye observatory since 1977. In *Identity Stretch* (1975), compatriot Dennis Oppenheim reproduced his and his son's overlapped thumbprints in tar – a large-scale but also highly intimate gesture.

Land Art also introduced man-made material into the environment to highlight natural forms and processes. In *Lightning Field* (1977), California-born Walter de Maria installed a grid of 400 steel poles in remote New Mexico to help conduct lightning. Christo and Jeanne-Claude – collaborators born in Bulgaria and Morocco respectively – wrapped coastlines, parks and even a valley in fabric.

Photographs, diagrams and texts about these pieces were shown in galleries; the label 'Earth Works' was originally the title of a show at New York's Dwan Gallery in 1968 that launched the movement. English artists Richard Long and Hamish Fulton made pieces during long hikes in far-flung places, before representing their experiences with a range of works for the gallery space, including sculptures from natural materials such as mud, earth and rock.

Several practitioners of Minimalism and Process Art pursued Land Art, as it revealed the inherent properties of landscape in the same way the other modes disclosed those of industrial materials. It lost visibility during the 1980s, but its example continues to influence an increasingly environmentally conscious contemporary art world.

KEY WORK in the Museum of Modern Art, New York

441 Barrels Structure – 'The Wall' (Project for 53rd between 5th and 6th Avenues), **1968, CHRISTO**
Christo and Jeanne-Claude have installed temporary artworks in urban as well as rural areas, creating monumental site-specific works that intrude on everyday (city) life. One of their unrealised projects – illustrated in this painted photograph by Christo – involved blocking a street outside the Museum of Modern Art with a wall of brightly coloured oil barrels.

OTHER WORKS in the Museum of Modern Art

Over the River, Project for the Arkansas River, State of Colorado, 1996, **CHRISTO**
Walking a Straight 10-Mile Line, Dartmoor, England, 1970, **RICHARD LONG**
Study for TIME POCKET, 1968; *Highway 20*, 1969, **DENNIS OPPENHEIM**
Mirror with Rock Salt (Salt Mine and Museum Proposal), 1968, **ROBERT SMITHSON**

 Minimalism; Conceptualism; Arte Povera; New British Sculpture

 Fauvism; Futurism; Constructivism; Abstract Expressionism; Pop Art

Video Art

Video Art was shown in galleries from the late 1960s. Works were at first projected on single or multiple television screens, before improvements in technology allowed for immersive installations. The medium was used for a variety of aims, from purely aesthetic effect to the exposure of how television misrepresented social groups.

DARA BIRNBAUM (1946–); DAN GRAHAM (1942–); NAM JUNE PAIK (1932–2006); IRA SCHNEIDER (1939–); BILL VIOLA (1951–)

installation; montages; multi-monitor; post-production; television

The first exhibition devoted to Video Art in America was 'TV as a Creative Medium' in 1969, held at the Howard Wise Gallery in New York. Although artists had used the medium earlier in the decade – in particular the Fluxus affiliates Nam June Paik and Wolf Vostell, who included television screens in their installations – it was employed most often in Performance Art to record actions. This seminal show claimed television as an artistic medium in itself, rather than a mode of documentation.

Artworks included Paik and cellist Charlotte Moorman's *TV Bra for Living Sculpture*, a performance in which Moorman wore a 'bra' of two screens as she played, their images varying with the music; *Wipe Cycle* by Ira Schneider and Frank Gillette, a multi-monitor work featuring found and live footage, with one screen at a time blanking out; and *The Archetron* by Thomas Tadlock, which combined three live TV broadcasts into the kind of patterns one sees when looking through a kaleidoscope.

This exploration of aesthetic effects was soon to be accompanied by an interest in video's more formal and theoretical characteristics, such as its ability to represent time. In American artist Dan Graham's installation *Present Continuous Past(s)* (1974), visitors moved in a room that had two mirrored walls and one wall on which a screen and a video camera were mounted. The camera captured the scene and projected it with a time delay of eight seconds on the screen. If the visitor looked in the mirrors, they would simultaneously see themselves in the present and, in the

KEY WORKS in Electronic Arts Intermix, New York

← *Global Groove*, 1973, NAM JUNE PAIK
This 28-minute colour video acted almost as a manifesto for the medium. Claiming in its opening frames that it was 'a glimpse of the video landscape of tomorrow', it exemplified the aesthetic experimentation of early Video Art, collaging diverse sound and images in an anarchic spirit.

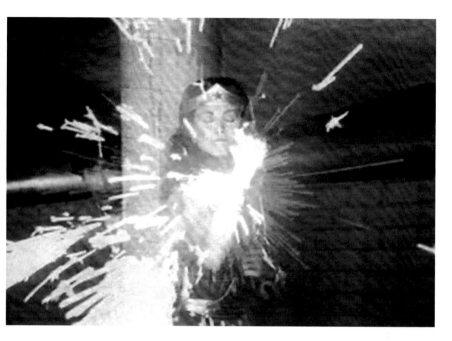

From the late 1970s, artists concentrated more on the content of moving images. New York-born Dara Birnbaum edited together montages from television series in order to question their representations, particularly those of women. Her compatriot Bill Viola developed slow-motion videos of figures in emotional flux, directly examining the human condition.

Viola and others benefited from improvements in technology, both in post-production and presentation. Today the video camera is an integral part of contemporary art, used as readily as a paint brush for a wide spectrum of artistic purposes.

↑ *Technology/Transformation: Wonder Woman,* 1978–9, DARA BIRNBAUM

Video Art has been characterised by a critical stance towards mainstream television. In this groundbreaking work, Birnbaum edited together fragments from the *Wonder Woman* TV series to spotlight that female sexualisation was one of several subtexts of a show supposedly about an empowered woman.

OTHER WORKS in Electronic Arts Intermix

Kiss The Girls: Make Them Cry, 1979, DARA BIRNBAUM
Rock My Religion, 1982–4, DAN GRAHAM
A Tribute to John Cage, 1973, NAM JUNE PAIK
Chott el-Djerid (A Portrait in Light and Heat), 1979;
I Do Not Know What It Is I Am Like, 1986, BILL VIOLA

 Neo-Dadaism; Conceptualism; Fluxus; Performance Art; Sensationalism

 Suprematism; Neo-Plasticism; School of Paris; Concrete Art; Tachism

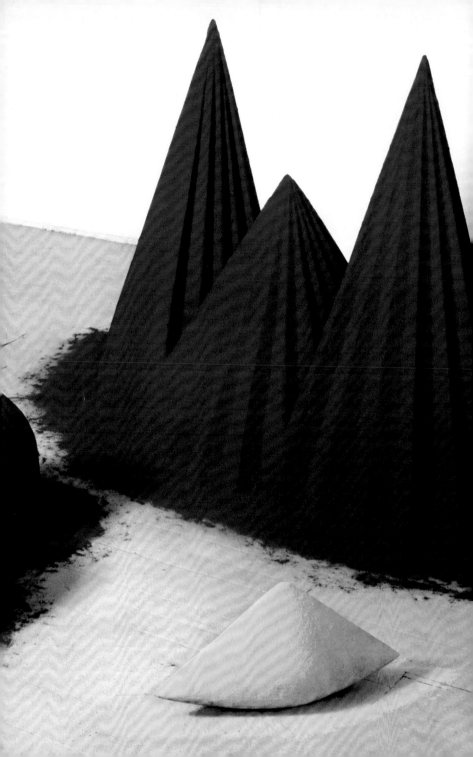

4

LATE
20TH CENTURY

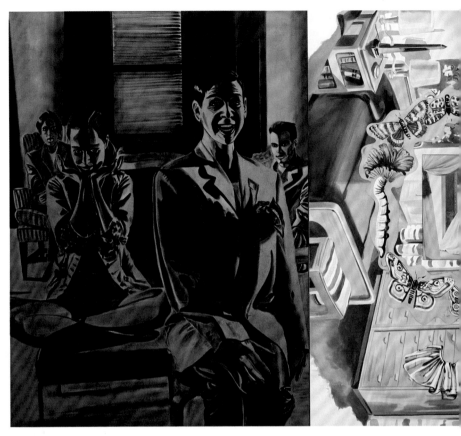

This term describes reactions against the characteristic thought and culture of the modern era, or Modernism. It was not until the 1970s that the phrase Postmodernism came into common use. Underlying its rejection of Modernism is a denial that ideas can claim a fixed or fundamental truth.

SHERRIE LEVINE (1947–); **RICHARD PRINCE** (1949–); **DAVID SALLE** (1952–); **JULIAN SCHNABEL** (1951–); **CINDY SHERMAN** (1954–)

contingency; doubt; irreverence; Deconstruction; subversion

Postmodernism has been used since the 1970s across the arts and academia to describe states or conditions in contrast to that of the modern era. Some critics have argued that these shifts have ushered in a new and still continuing period known as the postmodern age.

Most modern art movements until the late 20th century asserted that, with the right means, an essential truth could be presented and understood for the benefit of humankind, from the truth of our emotional condition (Expressionism) to that of technological potential (Constructivism). Postmodernism's main move has been to

dismiss that such truths exist or are possible. In 1979, Jean-François Lyotard explained the term as an 'incredulity towards metanarratives': the doubt that a single ideology could either accurately define our condition or lead to progress. Jacques Derrida developed Deconstruction from the late 1960s, based on the concept that ideas are unfixed, unstable, inter-reliant and inherently contradictory, and can therefore subvert themselves.

Although Deconstruction was particularly influential in critical theory, its style of subversion can also be seen in visual art. Artists undermined previous practice to call attention to the contingency of ideas and images. American photographer Cindy Sherman, for example, used costumes and makeup to transform herself in her series of staged self-portraits; these works highlight the complex nature of both identity and stereotypes. Her compatriots Richard Prince and Sherrie Levine re-photographed adverts and the works of others respectively, challenging the idea of artistic originality. Neo-Expressionists like American Julian Schnabel and Italian Francesco Clemente interrogated the idea of taste in self-consciously 'bad' works of art.

If no style was better than any other, then why not combine all styles equally? This question was answered by the flamboyant paintings of American artist David Salle, which juxtaposed the widest array of images one could imagine. Kitsch was celebrated as fine art in the Neo-Pop works of New Yorker Jeff Koons, collapsing any remaining distinctions between high and low culture.

These artists would not necessarily define themselves as Postmodernist, as the word describes a tendency towards irreverence and subversion rather than a movement or belief. Many of these attitudes can also be seen in the 1960s, in Conceptualism and Pop Art, or even earlier, for example in Dadaism: one can therefore make a case that Postmodernism is in fact a continuation of the modern era – an assertion of its most complex and self-contradictory aspects.

KEY WORK in the Solomon R Guggenheim Museum, New York

Comedy, 1995, DAVID SALLE

Paintings such as this diptych set Salle in the context of Postmodernism. In a rejection of the coherent styles seen in earlier decades, he juxtaposes images and techniques from across history and culture. The right panel features a copy of a black-and-white fashion photo, surrounded by butterflies, superimposed on an image derived from a 1950s advertisement.

OTHER WORKS in the Solomon R Guggenheim Museum

After Rodchenko: 1-12, 1987/98, **SHERRIE LEVINE**
The Student of Prague, 1983; *Spain*, 1986, **JULIAN SCHNABEL**
Untitled Film Still, #15, 1978; *Untitled, #112, 1982*, **CINDY SHERMAN**

 Modernism; Dadaism; Neo-Pop Conceptualism; Neo-Expressionism

 Impressionism; Expressionism; Neo-Plasticism; Suprematism; Bauhaus

Photorealism

This describes artworks of such realism that they resemble a photograph. It became a distinct trend from the 1970s, particularly in America. It is a term sometimes applied to earlier paintings – even those before the advent of photography – as well as lifelike sculpture.

CHUCK CLOSE (1940–); ROBERT COTTINGHAM (1935–); RICHARD ESTES (1932–); MALCOLM MORLEY (1931–); GERHARD RICHTER (1932–)

detail; illusionism; mass media; painstaking; representations of representations

Highly realistic depiction (or illusionism) was an objective for Renaissance artists. The achievements of 15th-century Flemish painter Jan van Eyck, for example, are such that they bear comparison to a photograph, even though he lived in a time before photography. Illusionism was passed down as an aim through the centuries by academic institutions. It was thought so essential that its rejection by Impressionism represented a seismic shift in the history of art.

Americans Chuck Close, Richard Estes, Audrey Flack, Robert Cottingham and Robert Bechte, as well as Englishman in New York Malcolm Morley, pleased mainstream tastes in the 1970s with similarly realistic works notable for their painstaking attention to detail. The artists worked from photographic material, commonly transferring the image on to the canvas before painting over it. Close gridded his photographic transfers into small squares before attending to each square in turn and applying pigment with an airbrush to avoid visible strokes. The paintings seemed the work of a machine rather than of a human hand.

Some critics thought this illusionism was reactionary, just a perfect execution of an age-old objective. An interpretation that Photorealism was doing something different, something contemporary, can call on the fact that many works made clear they were representations of photographs: representations of representations rather than direct descriptions of the exterior world. In head-and-shoulder portraits painted by Close, the parts of the photograph that are out of focus were replicated just as precisely as those parts in focus. His photographs were also rendered at a large scale – often over 6.5 feet (2 metres) high – allowing camera work to gain the gravitas of traditional portrait paintings.

By putting photography in the context of painting, Close and others called attention to how, instead of being 'real', photographs mediate our experience in certain ways. This can be seen in the context of Pop Art's interest in the mass media, as well as Postmodernist theories that posited that representations and signifiers were just as real as the things they stood for. The Dresden-born artist Gerhard Richter examined the way photographic and film images represent history, in Photorealist paintings of Second World War bombers and a series on the German Baader-Meinhof terrorist group.

The subjects the artists chose, whether intentionally or not, stressed a mood, theme or message, from Existentialist loneliness (Estes' paintings of empty streets) to commercialisation (Cottingham's images of city signs). American Duane Hanson was one of several sculptors to bring Photorealism into three dimensions by producing portraits cast from real people; his disarmingly lifelike figures either satirise their subjects or play with social stereotypes.

KEY WORK in the Hirshhorn Museum and Sculpture Garden, Washington DC

Diner, 1971, RICHARD ESTES
Estes painted depopulated street-level scenes, often working from several photographs so that the entire picture could be in sharp focus. The reflective surfaces he included in his works echo the process of Photorealism itself, in which a painting is a reflection of a photograph that is itself a reflection of reality.

OTHER WORKS in the Hirshhorn Museum and Sculpture Garden

Alex, 1991, **CHUCK CLOSE**
Flagg Bros, 1975, **ROBERT COTTINGHAM**
Waverly Place, 1980, **RICHARD ESTES**
Henley-On-Thames, 1968, **MALCOLM MORLEY**
Waterfall, 1997, **GERHARD RICHTER**

 Neo-Impressionism; Precisionism; Pop Art; Social Realism; Postmodernism

 Fauvism; Rayonism; Suprematism; Tachism; Abstract Expressionism

Coined by artist RB Kitaj in 1976, this term referred to painters active in London who bucked the international trends of Conceptualism and Minimalism by pursuing individual styles of figurative expressionism.

MICHAEL ANDREWS (1928–95); FRANK AUERBACH (1931–); FRANCIS BACON (1909–92); LUCIAN FREUD (1922–2011); RB (RONALD BROOKS) KITAJ (1932–2007)

diverse; expressive; figuration; human bodies; independence

There had been famous Schools of Paris and New York, so RB Kitaj's use of the term can be seen as an attempt to put developments he saw in London on a par with those earlier groups of artists. The painter first mentioned the term in a preface for an exhibition entitled 'The Human Clay'

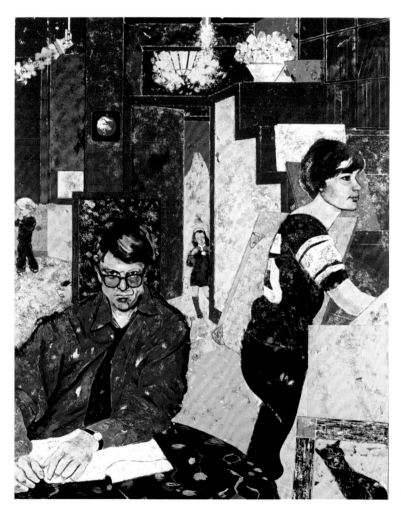

that he curated at the city's Hayward Gallery in 1976. 'There are artistic personalities in the small island [of Britain] more unique and strong and I think numerous than anywhere in the world outside America,' he explained. 'If some of the strange and fascinating personalities you may encounter here were given a fraction of the internationalist attention and encouragement reserved in this barren time for provincial and orthodox vanguardism, a School of London might become even more real than the one I have constructed in my head.'

Kitaj pointedly praised his 'friends of the abstract persuasion' and the show also featured works by Pop Artists like Peter Blake and Eduardo Paolozzi, as well as the non-representational sculpture of Anthony Caro. But the School of London came to denote only figuration, in particular expressive styles pursued by Kitaj, Francis Bacon, Frank Auerbach, Lucien Freud, Leon Kossoff and Michael Andrews. These were the six artists who were included in the 'School of London' exhibition that toured Europe in the next decade.

Examples of works included Bacon's visceral paintings that contorted human bodies inside out; Freud's unsettling portraits, whose sitters' physiology and psychology are vividly rendered; spray-painted acrylics by Andrews that explored people's relationship with place and with each other; Auerbach and Kossoff's semi-figurative landscapes and portraits caked in encrusted layers of thick paint; and Kitaj's own highly complex and symbolic scenes that drew on diverse sources.

Some critics argued that this variety meant the word 'School' was unsuitable, although one can note that the School of Paris included a similarly diverse group of artists. Also like that of Paris, the School of London included artists of different generations and several of foreign birth, from countries that included America (Kitaj) and Germany (Freud and Auerbach).

Although in 1976 representational art was dismissed by international avant-garde circles more attuned to Conceptualism and Minimalism, in retrospect the School of London can be seen as the start of a renewed interest in figuration, anticipating movements such as Neo-Expressionism in the 1980s. The painters' contrariness and independence from short-term fashions gained them respect, and their work now commands large sums from international collectors.

KEY WORK in the Pallant House Gallery, Chichester, UK

The Architects, 1981, RB KITAJ
Artists included in the School of London were inspired by older figurative styles. In this portrait of the husband-and-wife architects Colin St John Wilson and MJ Long, Kitaj uses Post-Impressionist colour and perspective for more contemporary ends.

OTHER WORKS in the Pallant House Gallery

Study of a Head for a Group of Figures (Study of a Head with a Green Turban), 1967, **MICHAEL ANDREWS**
Oxford Street Building Site, c 1960; *Reclining Head of Gerda Boehm*, 1982, **FRANK AUERBACH**
Unripe Tangerine, 1946, **LUCIAN FREUD**
Books and Ex-Patriot, c 1970, **RB KITAJ**

Post-Impressionism; Expressionism; School of Paris; Existentialism; Kitchen Sink

Suprematism; Concrete Art; Minimalism; Conceptualism; Performance Art

Neo-Expressionism

🕐 Neo-Expressionism describes the widespread revival of personal expression in visual art from around 1980. An international trend rather than a shared aesthetic, it was characterised by figurative and gestural paintings. These were often imbued with allegories, ironies or a Postmodernist sense of self-awareness.

⬤ GEORG BASELITZ (1938–); JEAN-MICHEL BASQUIAT (1960–88); PHILIP GUSTON (1913–80); ANSELM KIEFER (1945–); JULIAN SCHNABEL (1951–)

🕐 figuration; grotesque; roughly rendered; self-aware; symbolism

⬤ It had become fashionable during the late 1960s and early 1970s to pronounce painting 'dead', as oil and acrylic paints were replaced by television screens in Video Art, the human body in Performance Art, industrial rectangles in Minimalism, and text works in Conceptualism. But it appeared alive and well in several group exhibitions in the early 1980s, particularly 'A New Spirit in Painting', staged at London's Royal Academy of Arts in 1981. Here work was typified by figuration, expressiveness and symbolism, as well as a newfound self-aware attitude.

An important contingent of the painters came from Germany, making the label Neo-Expressionism particularly apt, as Expressionism in the first decades of the 20th century had been largely a German phenomenon. In aesthetic terms their gestural styles resembled Tachism, although these were practised with a self-consciousness that the earlier movement lacked.

George Baselitz, for example, made deliberately crude marks in an echo of 1950s Art Brut, but he turned convention on its head by painting upside down. This

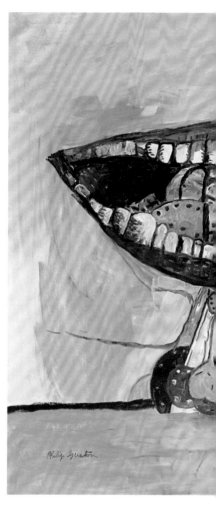

inversion made it harder to make sense of the artist's figurative forms. It led the viewer to appreciate the expressive brush strokes in themselves, as their representational result was unclear, and encouraged a critical distance that, paradoxically, challenged the viewer to consider the meaning of his motifs more carefully.

Other German practitioners included Gerhard Richter, who painted kaleidoscopic

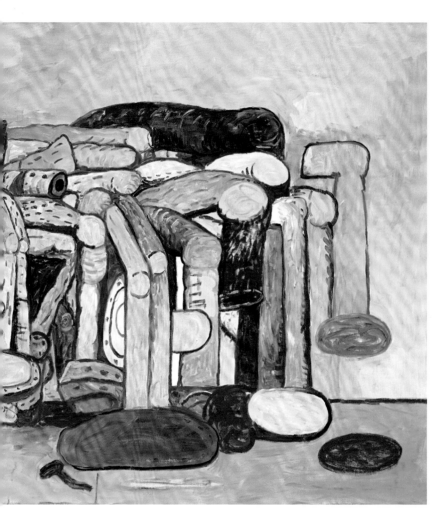

abstracts at the same time as Photorealist pieces, and Anselm Kiefer, who meditated on history in mixed-media works that combined paint with straw, wood and sewn material. Italy was also a hub for the movement, in the form of the Transvanguardia group. Affiliates such as Francesco Clemente and Sandro Chia were responsible for some of Neo-Expressionism's most sensual, eccentric and grotesque images.

KEY WORKS in the Modern Art Museum of Fort Worth, Texas

Painter's Forms II, 1978, PHILIP GUSTON
Guston inspired younger Neo-Expressionist painters by controversially rejecting the pure abstraction he had practised for decades. His idiosyncratic motifs include dismembered limbs, arrangements of which gave his work a grotesqueness characteristic of the movement.

Neo-Expressionism

American art was also overtaken by similar tendencies. Subsets included the 'Bad Painting' of artists like Julian Schnabel, typified by garish colour, roughly rendered figures, obscure references and surfaces collaged with unusual materials such as crockery and animal hides; the graffiti-related art of Jean-Michel Basquiat that chaotically combined symbols of African-American culture, ancient eras and contemporary politics; and New Image Painters such as Susan Rothenberg, whose simple silhouettes and outlines of horses were some of the first works in the 1970s to offer a way forward from Minimalist abstraction. Philip Guston was also influential in the way he had abandoned Abstract Expressionism for a comic-book-inspired figuration, initially to the wrath of the art world.

Although Neo-Expressionism is no longer a buzzword in the contemporary art scene, many of its proponents continue to exhibit to acclaim, pushing forward their practice and influencing younger generations of painters.

Ash Flower, 1983–97, ANSELM KIEFER
Neo-Expressionist works reflected on history as well as contemporary issues. The German artist Kiefer considered both in this semi-sculptural mixed-media painting. Layers of ash evoke the detritus of bomb attacks as well as the horrors of Auschwitz; the dried sunflower symbolises the hope that this past can be understood by modern German society.

OTHER WORKS in the Modern Art Museum of Fort Worth

Elke, 1976, **GEORG BASELITZ**
Untitled, 1982, **JEAN-MICHEL BASQUIAT**
Wharf, 1976, **PHILIP GUSTON**
Quaternity, 1973; *Book with Wings*, 1992–4, **ANSELM KIEFER**

 Post-Impressionism; Fauvism; Expressionism; Tachism; Postmodernism

 Concrete Art; Post-Painterly Abstraction; Minimalism; Conceptualism; Performance Art

Neo-Pop

Taking the Pop Art of the 1950s and 1960s as their point of departure, from the 1980s a number of younger artists produced pieces that commented on society's relationship with popular culture. These works probed the complexities of this relationship with analytical approaches influenced by Conceptualism.

JENNY HOLZER (1950–); JEFF KOONS (1955–); TAKASHI MURAKAMI (1962–); RICHARD PRINCE (1949–); HAIM STEINBACH (1944–)

advertising; ironic; kitsch; materialism; readymades

Neo-Pop (or Post-Pop) refers to a shared artistic tendency rather than a collaborative collective. It was mainly notable in the New York of the 1980s. The themes the artists examined were the same as those of older Pop Art: the attraction of consumer goods, celebrity culture and the mediation of reality through photographs, films, print material and signage. The main difference was one of mindset; Neo-Pop artists had grown up in the context of Minimalism and Conceptualism, and although they rebelled against the aesthetic restraint of these styles, they inherited some of their cerebral concerns and tactics.

New York-based Richard Prince and Jeff Koons are the two most famous exponents of Neo-Pop. While working in the tear-sheet department of Time Life Publications, Prince began to appropriate magazine photos and print advertisements for his own art; he re-photographed these images and then presented them individually or in arrangement as art objects. The only modification the artist tended to make was in terms of their crop. Prince undermined two tenets of earlier art – originality and authorship – and spotlighted the strategies of the advertising and magazine industries.

The borrowing of existing images and objects for artworks had roots beyond Pop Art in the Dadaism of Marcel Duchamp. In his series 'The New' (from 1979), Koons presented vacuum cleaners on the wall or in transparent cases illuminated with fluorescent lights – a Minimalist display treatment for a commonplace domestic item. In later series, rather than presenting actual readymades he replicated them at a larger scale and in immaculate detail. The sources were kitsch or banal objects, often related to childhood: balloon animals, for example, became alluring sculptures in highly polished stainless steel. Critics and the public saw Koons' work as ironic, but he claimed he chose everyday objects in order to relate to his audience so that they felt confident in, and connected to, their own experiences.

Other practitioners included Israel-born New Yorker Haim Steinbach, whose arrangements of pop culture objects on shelves commented on materialism, and Japanese artist Takashi Murakami, inspired by his native animation (anime) and comics (manga). Conceptualist Jenny Holzer interceded with Neo-Pop in her use of the same computer-generated graphics and light displays employed in outdoor signage and adverts.

Neo-Pop influenced the works of Young British Artists (YBAs) in the 1990s such as Damien Hirst and Gavin Turk. It continues to be a strand of contemporary art, evolving in its strategies and sources as popular culture itself changes in the digital age.

KEY WORK in the Museum of Contemporary Art, Chicago, Illinois

Rabbit, 1986, JEFF KOONS
This is an iconic work of Neo-Pop exemplifying how the most kitsch objects were elevated to the status of high art. Its highly reflective surface, copied in many of Koons' subsequent works, was rendered in a spirit of inclusivity: it allowed the viewer's own image to become part of their experience of the work.

OTHER WORKS in the Museum of Contemporary Art

Truisms, 1983, **JENNY HOLZER**
Pink Panther, 1988, **JEFF KOONS**
Jellyfish Eyes, 2002, **TAKASHI MURAKAMI**
Good News, Bad News, 1989, **RICHARD PRINCE**
Untitled (cabbage, pumpkin, pitchers) #1, 1986, **HAIM STEINBACH**

Dadaism; Neo-Dadaism; Pop Art; Conceptualism; Sensationalism

Primitivism; Suprematism; Bauhaus; Concrete Art; Abstract Expressionism

From the first years of the 1980s, in contrast to the Minimalism of the previous decade, a number of young artists from Britain gained critical and commercial success for expressive and symbolic sculptures. The catch-all term New British Sculpture described their diverse styles, which included both figurative and abstract modes.

TONY CRAGG (1949–); **RICHARD DEACON** (1949–); **ANTONY GORMLEY** (1950–); **ANISH KAPOOR** (1954–); **BILL WOODROW** (1948–)

expressive; metaphysical; sensual; symbolic; wit

New British Sculpture can be seen to do in three dimensions what Neo-Expressionist painting did in two: it rebelled against the restrained styles of Minimalism and Conceptualism that had become popular in the 1970s, reintroducing symbolism, emotion and wit into an art scene that had become overly austere. Like Neo-Expressionism, the movement did not have a single aesthetic agenda, but rather encompassed a wide range of practices and interests.

How truly 'new' these were is a matter of debate. Some of New British Sculpture's characteristics can be seen in the innovations of older artists, which had already moved the medium on in Britain from the organic abstraction practised by Barbara Hepworth and Henry Moore. The younger artists' willingness to use colour had a precedent in vibrant works of the early 1960s by Anthony Caro, in particular his bright-red, open-form metal composition *Early One Morning* (1962). Their

unconventional materials echoed the sand and rope pieces produced by Barry Flanagan in the 1960s.

The early works of New British Sculptor Tony Cragg could be seen as a British variant of Arte Povera, as they used junk objects to raise social and cultural questions; in *Britain Seen from the North* (1981), broken pieces of rubbish formed the shape of the country on the wall. Bill Woodrow arranged found objects (for instance, a car door, an ironing board and a washing machine) in mildly comic configurations that gave their everyday components new meanings.

Richard Deacon produced semi-figurative and abstract sculptures in industrial materials, their references ranging from a poem by Rainer Maria Rilke to the human body. The human figure was a preoccupation for Antony Gormley; in his works, faceless bodies were cast in metal in simple, symbolic poses.

Abstraction was also a notable feature of New British Sculpture. Alison Wilding's quietly suggestive small-scale forms explored the sensual properties of materials from beeswax and silk to rubber, plastic and steel, while Iranian-born Shirazeh Houshiary took inspiration from Sufi doctrines and symbolised spiritual transcendence in some of her sculptures.

Indian-born Anish Kapoor also examined mystical and metaphysical ideas in works at first typified by natural materials and coloured pigments (used in everyday Indian rituals), and latterly by highly reflective surfaces, often formed to produce voids. Like the rest of the New British Sculptors, and in particular Gormley, Kapoor has received major public commissions over the last two decades, establishing him as one of the most well-known names in contemporary art.

KEY WORKS in the Tate Collection, UK

↑ *As if to Celebrate, I Discovered a Mountain Blooming with Red Flowers,* 1981, **ANISH KAPOOR**
Kapoor's pigment sculptures epitomise New British Sculpture's renewal of Expressionism and Symbolism. A sense of exuberance is evoked by the colour and shape, as well as the title of the work, which was taken from a haiku poem, a form whose economy the artist thought equated to the sculpture.

← *Bed,* 1980–1, **ANTONY GORMLEY**
This early work by Gormley demonstrates New British Sculpture's use of unexpected materials. The artist ate out in bread two hollows of his recumbent body. The organic material, starting to mould before its preservation in paraffin wax, comes freighted with ideas about consumption and decay.

OTHER WORKS in the Tate Collection

Britain Seen from the North, 1981, **TONY CRAGG**
If The Shoe Fits, 1981, **RICHARD DEACON**
Three Ways: Mould, Hole and Passage, 1981–2, **ANTONY GORMLEY**
Adam, 1988–9, **ANISH KAPOOR**
Twin-tub with Guitar, 1981, **BILL WOODROW**

 Neo-Dadaism; Pop Art; Arte Povera; Neo-Expressionism; Sensationalism

 Impressionism; Neo-Impressionism; Precisionism; Social Realism; Tachism

An exhibition at London's Royal Academy of Arts in 1997, 'Sensation' brought to mainstream attention a loosely affiliated group known as the Young British Artists (YBAs). They produced provocative works that examined both contemporary experience and age-old themes such as morality and mortality.

JAKE (1966–) AND DINOS (1962–) CHAPMAN; TRACEY EMIN (1963–); DAMIEN HIRST (1965–); SARAH LUCAS (1962–); CHRIS OFILI (1968–)

installations; provocative; Saatchi; self-promotional; shock tactics

The works in the 'Sensation' exhibition were all taken from the collection of Charles Saatchi, the advertising executive who since 1985 had presented his pieces in his gallery in London. The show was the point when a group of critically acclaimed artists – such as Damien Hirst, Jake and Dinos Chapman, Chris Ofili, Marc Quinn, Gavin Turk and Tracy Emin – became household names, thanks to massive attendance figures and a media storm about some of the more controversial works on view.

Marcus Harvey's large handprint painting of the child murderess Myra Hindley (*Myra*, 1995) caused an enormous public outcry in England, as did Chris Ofili's *The Holy Virgin Mary* (1996) on the exhibition's showing in New York.

In the years that followed, the shock tactics that these and other works in the group exhibition were accused of came to define the YBAs in the public consciousness. The group managed to convey ideas in a

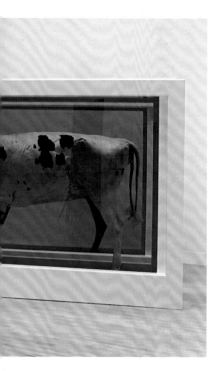

detritus that surrounded it; for visual horror, in works by the Chapman brothers in which bodies were perversely mangled; and for comic irony, when Sarah Lucas arranged melons, oranges and a cucumber in suggestive positions on a mattress.

But painters such as Ofili, Fiona Rae and Gary Hume also came under the YBA banner, and artists like Hirst and Emin worked in painting, drawing and printmaking as well as mixed media and installation. The 'Sensation' generation continues to experiment with different media in order to express ideas in an interesting way, and this interdisciplinary tendency now typifies the practice of young artists coming out of art school.

KEY WORK in the Tate Collection, UK

Mother and Child (Divided), **exhibition copy 2007, (original 1993), DAMIEN HIRST**
The YBA aptitude for condensing complex ideas in bold visual forms is epitomised by Hirst's famous formaldehyde works. In this example, a dead cow and her calf have been bisected and preserved in tanks. This subversion of a religious icon of the Mother and Child leads the viewer to contemplate the permanence and separation of death.

OTHER WORKS in the Tate Collection

Little Death Machine (Castrated), 1993, **JAKE AND DINOS CHAPMAN**
Dad, 1993, **TRACEY EMIN**
Pharmacy, 1992, **DAMIEN HIRST**
Eating a Banana, 1990, **SARAH LUCAS**
No Woman, No Cry, 1998, **CHRIS OFILI**

tone very different to the austere forms of Conceptualism seen in the 1970s. Their works packaged difficult themes in forms that were always aesthetically compelling, using objects and images in unexpected ways to capture the imagination of viewers.

The core of the YBAs graduated from London's Goldsmiths art school in the late 1980s and early 1990s. Hirst organised the 'Freeze' group exhibition of students' works in an empty building in the city's Docklands in 1988, and this set a self-promotional tone that typified the group. Saatchi prized Hirst's installations, the first he bought being *A Thousand Years* (1990), in which maggots and flies fed off a rotting cow's head in a huge glass case.

Works in similarly unusual media were common, and used for self-confession, when Emin exhibited her bed and the

 Conceptualism; Neo-Expressionism; Neo-Pop; Installationism; Internationalism

 Impressionism; Synthetism; Post-Impressionism; Neo-Plasticism; Concrete Art

Installations are assemblages or artist-created environments. These works go beyond the boundaries of sculpture and actively engage with the space in which they are installed. Practised sporadically from the 1960s, installation art had become established as a common genre by the end of the 20th century.

JOSEPH BEUYS (1921–86); **EDWARD** (1927–94) **AND NANCY REDDIN** (1943–) **KIENHOLZ**; **MIKE NELSON** (1967–); **PIPILOTTI RIST** (1962–); **JAMES TURRELL** (1943–)

assemblage; environment; interactivity; narrative; site specific

Installation art started to become popular from the 1960s. The total environment that the viewer experienced was considered an artwork in itself. Examples included the theatrical surroundings created for the 'Happenings' events (see 'Performance Art'), as well as New Realist provocations such as *Fullness* (1960), in which French artist Arman filled a gallery with rubbish. These works were site specific, their form and content inextricably linked with their location.

Early installations tended to be temporary, but from the 1970s and 1980s there was a shift towards producing environments that were in some sense permanent – they could be acquired, stored and presented afresh, either in their original location or another. For example, German artist Joseph Beuys filled rooms with configurations of found and modified objects; these now reside in public collections and are loaned out to other galleries for temporary exhibitions

Some Installationist art is predicated on participation: the way an audience interacts with the environment comprises the actual artwork. Often these pieces immerse viewers in a narrative. The visitor can enter a room that is meticulously constructed as an everyday space, such as an office or bedroom, and the experience is like entering a stage-set, except that the stories are created in the mind of the viewer rather than by a script. In America, this strand of Installationist art is exemplified by the work of Edward and Nancy Reddin Kienholz, as well as Russian-born Ilya and Emilia Kabakov; in Britain, Mike Nelson is a notable practitioner. The installations of American Matthew Barney are opportunities to further explore the highly metaphorical narratives of his series of 'Cremaster' films.

Installationist environments can also appeal to several senses at once, such as touch and smell in the biomorphic fabric worlds of Brazilian artist Ernesto Neto, in which hanging sacks are filled with aromatic spices; and sight and sound in audio-visual installations by Swiss-born Pipilotti Rist and Los Angeles-based Diana Thater. American James Turrell, London-born Anthony McCall and Danish-Icelandic artist Olafur Eliasson produce installations in which our interaction with light is the essential component.

Installation has also become a general default term to classify three-dimensional works for which the word 'sculpture' seems no longer appropriate. Sculptures, traditionally, have a unified form and carry a fixed meaning independent of when or where they are shown. Installations – in this broader sense – are assemblages of objects whose meaning is enriched by their location. The distinction is one for the artist to make: some prefer 'sculpture' and see 'assemblage' and 'interactivity' as part of the term's widening definition.

KEY WORK in the Los Angeles County Museum of Art , California

Back Seat Dodge '38, 1964, **EDWARD KIENHOLZ**
This work by Kienholz, one of Installationism's earliest proponents, exemplifies how the medium can take the public by surprise by constructing realistic environments. As the visitor walks around the car and peers in, they see a couple engaged in sexual activity. The shock was too much for the local Los Angeles authority, which tried to ban the installation.

OTHER WORKS in the Los Angeles County Museum of Art

A Lady Named Zoa, 1960; *The Spirit in the Home is Contentment,* c 1961; *The Illegal Operation,* 1962, **EDWARD KIENHOLZ**
I Want to See How You See, 2003, **PIPILOTTI RIST**
Afrum (White), 1966, **JAMES TURRELL**

 New Realism; Minimalism; Conceptualism; Arte Povera; Sensationalism

Impressionism; Post-Impressionism; Primitivism; Suprematism; Abstract Expressionism

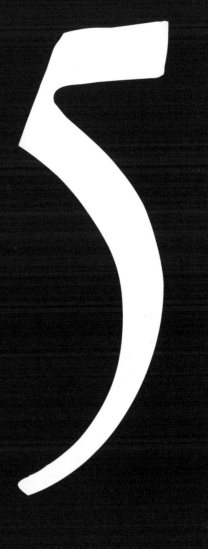

21ST
CENTURY

Artistic interventions are modifications of pre-existing objects, environments and systems. In the context of the art world, they are interactions with artworks, audiences or gallery spaces; in the public realm, they are attempts to reveal or change social conditions.

DANIEL BUREN (1938–); **MAURIZIO CATTELAN** (1960–); **JENNY HOLZER** (1950–); **GORDON MATTA-CLARK** (1943–78); **RIRKRIT TIRAVANIJA** (1961–)

architecture; modifications; protest; relational aesthetics

Interventionism can be traced back to radical practices from the 1960s. The Fluxus group and other Performance Artists blurred the boundaries between art and life, encouraging works in which everyday conventions are exposed and disrupted. The journal *Situationist International* and associated texts such as *The Society of the Spectacle* (1967) by Marxist thinker Guy Debord claimed that aesthetic experimentation could subvert socioeconomic power structures.

While Land Artists refashioned rural landscapes in the 1970s, artists such as

Gordon Matta-Clark modified buildings around New York. A former architecture student, Matta-Clark was known for his 'Splitting' series, in which he sliced structures slated for demolition. Once a house was elegantly splintered in two, it was transformed from a symbol of security into one of instability. Brit Richard Wilson has employed similar tactics in works such as *Turning The Place Over* (2007–8), in which an oval section of the facade of a Liverpool building rotated, so that one could glimpse inside the interior.

Jenny Holzer challenged Manhattanites' expectations of public advertising by pasting up text works on walls declaring 'Abuse of power comes as no surprise' or 'Money creates taste'. Street Artist Banksy intervened on the West Bank barrier that separates Israel and Palestinian territories; his illustrations on the Palestinian side included a girl floating over the wall by holding on to helium balloons.

The social structures of society are subverted in interventions that directly involve the public. In 1992, New Yorker Rirkrit Tiravanija converted a gallery into a kitchen that served Thai curry for free. His works have been championed as an example of what French critic Nicolas Bourriaud calls 'relational aesthetics' – art where the relationships between people are the starting point.

Interventions in the art world often involve institutional critique. An early example was the Guerilla Art Action Group's 1969 action *Blood Bath*, in which members wrestled and then lay in blood in the lobby of New York's Museum of Modern Art (MoMA) – a protest against members of the museum board's involvement in weapons manufacture. Fred Wilson reinstalled artifacts from the collection of the Maryland Historical Society in 1992 to show how their

↑ *Untitled (free/still),* 2011, RIRKRIT TIRAVANIJA
Tiravanija's works in public spaces represent the social side of Interventionism. This photograph shows a recreation of a 1992 work where the artist converted a gallery space into a free restaurant. The intervention reorientates the relationships between artist, institution and visitor.

previous displays ignored African-American slavery.

In the 21st century, institutional critique has been encouraged by institutions themselves: contemporary art museums, fairs and festivals commission artists such as Paris-born Christian Boltanski, his compatriot Daniel Buren and the Italian satirist Maurizio Cattelan to intervene in their buildings, displays and working processes.

OTHER WORKS in the Museum of Modern Art

Framed/Exploded/Defaced, 1978–9, **DANIEL BUREN**
DIE/DIE MORE/DIE BETTER/DIE AGAIN, 2008, **MAURIZIO CATTELAN**
Abuse of Power Comes As No Surprise (from the series 'Truisms T-shirts'), *c* 1980, **JENNY HOLZER**
Bingo, 1974; *Splitting,* 1974, **GORDON MATTA-CLARK**

KEY WORKS in the Museum of Modern Art, New York

◄ *Program Eight: Office Baroque,* 1977–2005, **GORDON MATTA-CLARK**
This video shows Matta-Clark at work on *Office Baroque* (1977), when he chain-sawed tear-shaped holes into the floors of a derelict Antwerp office building. The structure was demolished three years later.

 Conceptualism; Performance Art; Postmodernism; Installationism

 Impressionism; Fauvism; Orphism; Neo-Plasticism; Precisionism

Art created on city streets that has not been commissioned or sanctioned. It has extended beyond freehand spray-painted graffiti to include a wide range of media and styles. Street Art went mainstream in the 21st century, as works by key artists became prized.

BANKSY (c 1974–); **SHEPARD FAIREY** (1970–); **FUTURA 2000** (LEONARD MCGURR) (c 1955–); **KEITH HARING** (1958–90); **SWOON** (CALEDONIA DANCE CURRY) (1978–)

anti-establishment; graffiti; hip-hop culture; pseudonyms; stencils

Twenty-first-century Street Art (or Urban Art) developed from the explosion of graffiti in New York from the 1970s. The practice of 'tagging', where artists spray-painted their pseudonyms, snowballed in scale so that bright cartoon-like lettering covered the entire exterior of subway train carriages.

Prominent graffiti writers from this time, such as DONDI, Zephyr, Futura 2000 and Lady Pink, created individual styles. The most intricate forms of words were known as 'wildstyle', which became the title of a 1983 film that illustrated graffiti's connection with hip-hop culture.

Street Art is vandalism in the eyes of the law. Its removal means that past pieces are only known through photographs. Graffiti writers work hard to evade detection; pieces difficult to execute gain admiration. Neglected areas of New York, such as the South Bronx, became hotbeds for graffiti. The medium allowed artists who were otherwise disenfranchised to reach a broad audience.

From 1980, Street Art also started to receive critical recognition. That year the South Bronx gallery space Fashion Moda opened as a legal space in which graffiti artists could practice. It aided artists such as Keith Haring who, alongside Jean-Michel Basquiat, established graffiti as a force in the Manhattan art world by transferring their aesthetic to canvas.

Street Art had become international by this time and progressed from lettering to figurative works, ranging from complex one-off murals to simple motifs repeated across a city. Spray-paint stencils helped artists premeditate and replicate their works. Blek le Rat pioneered this in the 1980s, for example stencilling an image of a Russian soldier hundreds of times on walls in Paris.

American artist Shepard Fairey developed sticker art; he is famous for 'Obey Giant', his series of stickers and posters of wrestler André the Giant that sprung up worldwide. Swoon specialises in life-size wheatpaste prints of figures, her highly detailed style echoing works of Secessionism.

Although Street Art can be purely decorative, the context in which it appears allows for public social and political comment. In the 1990s, anti-capitalist artists began to subvert outdoor adverts ('adbusting').

Banksy has become known widely for anti-establishment stencil works that satirise society. The English artist's heavily publicised, sell-out show in Los Angeles in 2006 was the moment when the movement crossed over to the mainstream. Fairey's image of Barack Obama, emblazoned with the word 'Hope', became the unofficial icon of the Democrat's presidential campaign in 2008.

The best place to see works by the artists included here is not in a gallery, but on the street; illustrated here are two key examples in London and Los Angeles. These and other works mentioned may have been removed or defaced, although enlightened building owners preserve wall works under Perspex or commission new pieces.

KEY WORKS

Homage to Keith Haring, Southwark, London, 2010, BANKSY

Contemporary Street Art owes a debt to the inventive styles that came out of New York from the 1970s. British artist Banksy wittily acknowledges 1980s art star Keith Haring in this work; a stencilled hooded man walks a South London street not with a pitbull, but a dog painted to resemble one of Haring's characteristically cartoonish forms.

District La Brea Mural, Hollywood, Los Angeles, 2011, SHEPARD FAIREY *(see p132)*

Like many Street Artists who crossed over to the mainstream in the first decade of the 21st century, Shepard Fairey went from being chased by the police to being commissioned by corporations. A Los Angeles property developer paid for this 33-foot (10-metre) high mural by Fairey, which features illustrations that incorporate his famous 'Obey Giant' images.

OTHER WORKS in London and Los Angeles

No Ball Games, Tottenham High Road, London, 2009; *Wallpaper Hanger*, Regent's Canal, London, 2009; *'If graffiti changed anything – it would be illegal'*, Clipstone Street, London, 2011; *Tox Bubble Writer*, Jeffrey's Street, London, 2011, **BANKSY**
West Hollywood Peace Elephant, North San Vicente Boulevard, Los Angeles, 2011, **SHEPARD FAIREY**

 Pop Art; Postmodernism; Neo-Pop; Sensationalism; Interventionism

 Impressionism; Rayonism; School of Paris; Abstract Expressionism; Minimalism

Art in the 21st century is the product of an increasingly globalised world. Galleries, museums, art fairs and festivals present pieces from across the different continents. Successful artists live an itinerant international lifestyle and merge together in their artworks both local and transnational practices, materials, images and ideas.

KUTLUG ATAMAN (1961–); **KADER ATTIA** (1970–); **SUBODH GUPTA** (1964–); **PASCALE MARTHINE TAYOU** (1967–); **AI WEIWEI** (1957–)

interconnectedness; the Internet; migration; travel; translation

As with the trade of other goods and services, the market for art is now international in scope. Commercial galleries are setting up outposts across the globe; the Guggenheim collection, for example, is now shown in New York, Venice, Bilbao and Berlin, with another museum planned for Abu Dhabi.

This geographical expansion illustrates the global appreciation of contemporary art. It also means that in a major gallery in New York, for instance, one is as likely to see the work of a practitioner from Mexico (such as multidisciplinary artist Francis Alÿs), India (sculptor Subodh Gupta), China (Conceptualist Ai Weiwei), Turkey (filmmaker Kutlug Ataman) or South Africa (photographer Santu Mofokeng) as an American artist. A calendar of art fairs and biennials brings these names together again and again throughout the year.

This situation has led to the cross-pollination of ideas and interests, aided by

include French-Algerian artist Kader Attia, who uses installation art to examine themes related to the Middle East, and Cameroon-born Pascale Marthine Tayou, resident in Belgium, whose assemblages comprise European and African materials, referencing multiple traditions.

The conditions of Internationalism are now subjects for young artists. Translation is the theme of Serbia-born Katarina Zdjelar's video installation *Shoum* (2009), in which two of her compatriots attempt to transcribe and sing Tears for Fears' 1985 hit song *Shout*. British-born, Los Angeles-based Walead Beshty presents glass boxes cracked in transit, their pedestals the unpadded Fedex boxes in which they journey from his studio to the international gallery that exhibits them: his sculptures are metaphors for the way contemporary art is shaped by international travel.

KEY WORK in the Tate Collection, UK

Sunflower Seeds, 2010, AI WEIWEI
Chinese artist Ai Weiwei is typical of a large number of high-profile non-Western practitioners who present works throughout the year in venues across the world. Initially displayed as part of a larger installation in Tate Modern, these eight million porcelain pieces were handcrafted in his native country. Their form resembles sunflower seeds, which – like porcelain – are significant in Chinese culture.

OTHER WORKS in the Tate Collection
Women Who Wear Wigs, 1999, **KUTLUG ATAMAN**
Untitled (Concrete Blocks), 2008; *Untitled (Ghardaïa)*, 2009, **KADER ATTIA**
Everyday, 2009, **SUBODH GUPTA**
Table and Pillar, 2002, **AI WEIWEI**

affordable travel, mobile communications and, in particular, the Internet, which transmits still and moving images across the globe with ease. An art student in Cairo can research Asian artists as readily as those from the Middle East or Western countries.

This interconnectedness has been reinforced by migration. Aspirant artists increasingly travel to other cities to study or practise. As with second- and third-generation immigrants, or those who move countries as children, these artists are often bi-cultural, meaning they combine cultural aspects of their heritage with those of their resident country. Less concerned with questions of identity than late-20th-century artists, they are confident in mixing and matching these elements with those that interest them from other cultures. Examples

 Conceptualism; Postmodernism; Neo-Pop; Installationism; Interventionism

 Secessionism; Orphism; Suprematism; Precisionism; Kitchen Sink

REFERENCE
SECTION

A

ABRAMOVIC, Marina (1946–)
Performance Art

ACCONCI, Vito (1940–)
Performance Art

ALBERS, Josef (1888–1976)
Bauhaus

ALŸS, Francis (1959–)
Internationalism

ANDRE, Carl (1935–)
Minimalism

ANDREWS, Michael (1928–95)
School of London

ANQUETIN, Louis (1861–1932)
Synthetism

ANSELMO, Giovanni (1934–)
Arte Povera

ANUSZKIEWICZ, Richard (1930–)
Op Art

APPEL, Karel (1921–2006
Tachism

ARMAN (Armand Fernandez)
(1928–2005)
New Realism; Installationism

ARP, Jean (1886–1966)
Dadaism; Surrealism

ART & LANGUAGE (collective;
active from 1968)
Conceptualism

ATAMAN, Kutlug (1961–)
Internationalism

ATTIA, Kader (1970–)
Internationalism

AUERBACH, Frank (1931–)
School of London

B

BACON, Francis (1909–92)
Existentialism; School of London

BALDACCINI, César (see César)

BALLA, Giacomo (1871–1958)
Futurism

BANKSY (c 1974–)
Interventionism; Street Art

BARNEY, Matthew (1967–)
Installationism

BASELITZ, Georg (1938–)
Neo-Expressionism

BASQUIAT, Jean-Michel
(1960–88)
Neo-Expressionism; Street Art

BAYER, Herbert (1900–85)
Bauhaus

BECHTE, Robert (1932–)
Photorealism

BECKMANN, Max (1884–1950)
Neue Sachlichkeit

BELL, Vanessa (1879–1961)
Vorticism

BELLOWS, George (1882–1925)
Social Realism

BENGLIS, Lynda (1941–)
Process Art

BERNARD, Émile (1868–1941)
Synthetism

BESHTY, Walead (1976–)
Internationalism

BEUYS, Joseph (1921–86)
Conceptualism; Fluxus;
Installationism

BILL, Max (1908–94)
Concrete Art

BIRNBAUM, Dara (1946–)
Video Art

BLAKE, Peter (1932–)
Pop Art

BLEK LE RAT (Xavier Prou)
(1952–)
Street Art

BLEYL, Fritz (1880–1966)
Expressionism

BOCCIONI, Umberto (1882–1916)
Futurism

BOGUSLAVSKAYA, Kseniya
(1892–1972)
Suprematism

BOLTANSKI, Christian (1944–)
Interventionism

BOMBERG, David (1890–1957)
Vorticism

BONNARD, Pierre (1867–1947)
Synthetism

BRANCUSI, Constantin
(1876–1957)
School of Paris

BRAQUE, Georges (1882–1963)
Fauvism; Cubism

BRATBY, John (1928–92)
Kitchen Sink Realism

BRECHT, George (1926–2008)
Fluxus

BREUER, Marcel (1902–81)
Bauhaus

BROODTHAERS, Marcel
(1924–76)
Conceptualism

BURDEN, Chris (1946–)
Performance Art

BUREN, Daniel (1938–)
Conceptualism; Interventionism

BURNE-JONES, Edward
(1833–98)
Symbolism

BURRI, Alberto (1915–95)
Tachism

BURY, Pol (1922–2005)
Kineticism

C

CAGE, John (1912–92)
Neo-Dadaism; Fluxus

CALDER, Alexander (1898–1976)
Kineticism

CAMOIN, Charles (1879–1965)
Fauvism

CARO, Anthony (1924–)
New British Sculpture

CARRÀ, Carlo (1881–1966)
Futurism

CASSATT, Mary (1844–1926)
Impressionism

CATTELAN, Maurizio (1960–)
Interventionism

CÉSAR (César Baldaccini)
(1921–98)
New Realism

CÉZANNE, Paul (1839–1906)
Impressionism; Post-Impressionism

CHAGALL, Marc (1887–1985)
School of Paris

CHAPMAN, Jake (1966–) & Dinos
(1962–)
Sensationalism

CHAVANNES, Pierre Puvis de
(1824–98)
Symbolism

CHIA, Sandro (1946–)
Neo-Expressionism

CHIRICO, Giorgio de (1888–1978)
Surrealism

CHRISTO (Christo Vladimirov
Javacheff) (1935–)
Land Art

CLEMENTE, Francesco (1952–)
Postmodernism; Neo-
Expressionism

CLOSE, Chuck (1940–)
Photorealism

COLDSTREAM, William
(1908–87)
Social Realism

CORINTH, Lovis (1958–1925)
Secessionism

CORNELL, Joseph (1903–72)
Surrealism

COTTINGHAM, Robert (1935–)
Photorealism

COURBET, Gustave (1819–77)
Social Realism

CRAGG, Tony (1949–)
New British Sculpture

CRAWFORD, Ralston (1907–78)
Precisionism

CURRY, Caledonia Dance (see
Swoon)

D

DALÍ, Salvador (1904–89)
Surrealism

DEACON, Richard (1949–)
New British Sculpture

DEGAS, Edgar (1834–1917)
Impressionism

DELAUNAY, Robert (1885–1941)
Orphism

DELAUNAY, Sonia (1885–1979)
Orphism

DEMUTH, Charles (1883–1935)
Precisionism

DENIS, Maurice (1870–1943)
Synthetism

DERAIN, André (1880–1954)
Fauvism; Synthetism

DINE, Jim (1935–)
Neo-Dadaism

DIX, Otto (1891–1969)
Neue Sachlichkeit

DONDI (Donald Joseph White)
(1961–98)
Street Art

DUBUFFET, Jean (1901–85)
Tachism

DUCHAMP, Marcel (1887–1968)
Orphism; Dadaism; Kineticism;
Conceptualism

DUCHAMP-VILLON, Raymond
(1876–1918)
Cubism

DUFRENÉ, François (1930–82)
New Realism

E

EAKINS, Thomas (1844–1916)
Social Realism

ELIASSON, Olafur (1967–)
Installationism

EMIN, Tracey (1963–)
Sensationalism

ENSOR, James (1860–1949)
Symbolism

EPSTEIN, Jacob (1880–1959)
Vorticism

ERNST, Max (1891–1976)
Primitivism; Dadaism; Surrealism

ESTES, Richard (1932–)
Photorealism

F

FABARA, Sandra (see Lady Pink)

FABRO, Luciano (1936–2007)
Arte Povera

FAIREY, Shepard (1970–)
Street Art

FAUTRIER, Jean (1898–1964)
Existentialism; Tachism

FERNANDEZ, Armand (see
Arman)

FILLIOU, Robert (1926–87)
Fluxus

FLACK, Audrey (1931–)
Photorealism

FLANAGAN, Barry (1941–2009)
Process Art; New British Sculpture

FLAVIN, Dan (1933–96)
Minimalism

FRANKENTHALER, Helen
(1928–2011)
Post-Painterly Abstraction

FREUD, Lucian (1922–2011)
Existentialism; School of London

FRY, Roger (1866–1934)
Post-Impressionism; Vorticism

FULTON, Hamish (1946–)
Land Art

FUTURA 2000 (Leonard McGurr)
(c1955–)
Street Art

G

GABO, Naum (1890–1977)
Constructivism; Concrete Art;
Kineticism

GAUDIER-BRZESKA, Henri
(1891–1915)
Vorticism

GAUGUIN, Paul (1848–1903)
Neo-Impressionism; Symbolism;
Synthetism; Post-Impressionism;
Primitivism

GERSTNER, Karl (1930–)
Concrete Art

GIACOMETTI, Alberto (1901–66)
Surrealism; Existentialism

GILBERT & GEORGE (Gilbert
Proesch 1943–, and George
Passmore 1942–)
Performance Art

GILLETTE, Frank (1941–)
Video Art

GLEIZES, Albert (1881–1953)
Orphism

GONCHAROVA, Natalia
(1881–1962)
Rayonism

GONZÁLEZ, Julio (1876–1942)
School of Paris

GORMLEY, Antony (1950–)
New British Sculpture

GOTTLIEB, Adolph (1903–74)
Abstract Expressionism

GRAHAM, Dan (1942–)
Video Art

GRANT, Duncan (1885–1978)
Vorticism

GREAVES, Derrick (1927–)
Kitchen Sink Realism

GRIS, Juan (1887–1927)
Cubism; School of Paris

GROPIUS, Walter (1883–1969)
Bauhaus

GROSZ, George (1893–1959)
Neue Sachlichkeit

GUILLEBON, Jeanne-Claude
Denat de (see Jeanne-Claude)

GUPTA, Subodh (1964–)
Internationalism

GUSTON, Philip (1913–80)
Abstract Expressionism; Neo-
Expressionism

H

HAACKE, Hans (1936–)
Process Art

HAINS, Raymond (1926–2005)
New Realism

HAMILTON, Richard (1922–2011)
Pop Art

HANSON, Duane (1925–96)
Photorealism

HARING, Keith (1958–90)
Street Art

HARTUNG, Hans (1904–89)
Tachism

HARVEY, Marcus (1963–)
Sensationalism

HEARTFIELD, John (1891–1968)
Dadaism

HECKEL, Erich (1883–1970)
Expressionism

HEIZER, Michael (1944–)
Land Art

HÉLION, Jean (1904–87)
Concrete Art

HENRI, Robert (1865–1929)
Social Realism

HEPWORTH, Barbara (1903–75)
Concrete Art; New British
Sculpture

HERON, Patrick (1920–99)
Tachism

HESSE, Eva (1936–70)
Minimalism; Process Art

HIGGINS, Dick (1938–98)
Fluxus

HILTON, Roger (1911–75)
Tachism

HINE, Lewis (1874–1940)
Social Realism

HIRST, Damien (1965–)
Sensationalism

HÖCH, Hannah (1889–1978)
Dadaism

HOCKNEY, David (1937–)
Pop Art

HOLZER, Jenny (1950–)
Conceptualism; Neo-Pop;
Interventionism

HOMER, Winslow (1836–1910)
Impressionism

HOPPER, Edward (1882–1967)
Social Realism

HOUSHIARY, Shirazeh (1955–)
New British Sculpture

HSIEH, Tehching (1950–)
Performance Art

HUME, Gary (1962–)
Sensationalism

I

INDIANA, Robert (1928–)
Precisionism

ITTEN, Johannes (1888–1967)
Bauhaus

J

JAVACHEFF, Christo Vladimirov
(see Christo)

JEANNE-CLAUDE (Jeanne-
Claude Denat de Guillebon)
(1935–2009)
Land Art

JOHNS, Jasper (1930–)
Neo-Dadaism

JONES, Allen (1937–)
Pop Art

JORN, ASGER (1914–73)
Tachism

JUDD, Donald (1928–94)
Precisionism; Minimalism

K

KABAKOV, Emilia (1945–)
Installationism

KABAKOV, Ilya (1933–)
Installationism

KANDINSKY, Wassily
(1866–1944)
Modernism; Expressionism;
Bauhaus

KAPOOR, Anish (1954–)
New British Sculpture

KAPROW, Allan (1927–2006)
Neo-Dadaism

KELLY, Ellsworth (1923–)
Post-Painterly Abstraction

KHNOPFF, Fernand (1858–1921)
Symbolism; Orphism

KIDNER, Michael (1917–2009)
Op Art

KIEFER, Anselm (1945–)
Neo-Expressionism

KIENHOLZ, Edward (1927–94)
Installationism

KIENHOLZ, Nancy Reddin (1943–)
Installationism

KIRCHNER, Ernst Ludwig
(1880–1938)
Expressionism; Primitivism

KITAJ, RB (Ronald Brooks)
(1932–2007)
School of London

KLEE, Paul (1879–1940)
Expressionism; Bauhaus

KLEIN, Yves (1928–62)
New Realism

KLIMT, Gustav (1862–1918)
Secessionism

KLINE, Franz (1910–62)
Abstract Expressionism

KNOWLES, Alison (1933–)
Fluxus

KOKOSCHKA, Oskar
(1886–1980)
Secessionism; Expressionism

KOLLWITZ, Käthe (1867–1945)
Neue Sachlichkeit

KOONING, Willem de (1904–97)
Abstract Expressionism

KOONS, Jeff (1955–)
Conceptualism; Postmodernism;
Neo-Pop

KOSSOFF, Leon (1926–)
School of London

KOSUTH, Joseph (1945–)
Conceptualism

KOUNELLIS, Jannis (1936–)
Arte Povera

KRUGER, Barbara (1945–)
Conceptualism

KUPKA, František (1871–1957)
Orphism

L

LADY PINK (Sandra Fabara)
(1964–)
Street Art

LANYON, Peter (1918–64)
Tachism

LARIONOV, Mikhail (1881–1964)
Rayonism

LÉGER, Fernand (1881–1955)
Cubism; Orphism

LEVINE, Sherrie (1947–)
Postmodernism

LEWIS, Wyndham (1882–1957)
Vorticism

LEWITT, Sol (1928–2007)
Conceptualism

LICHTENSTEIN, Roy (1923–97)
Pop Art

LIEBERMANN, Max (1847–1935)
Secessionism

LIPCHITZ, Jacques (1891–1973)
Cubism; School of Paris

LISSITZKY, EL (Eleazar Markovich
Lisitskii) (1890–1941)
Suprematism; Bauhaus

LOHSE, Richard Paul (1902–88)
Concrete Art

LONG, Richard (1945–)
Land Art

LOUIS, Morris (1912–62)
Post-Painterly Abstraction; Process
Art

LOWRY, LS (1887–1976)
Kitchen Sink Realism

LOZOWICK, Louis (1892–1973)
Precisionism

LUCAS, Sarah (1962–)
Sensationalism

M

MACIUNAS, George (1931–78)
Fluxus

MAGRITTE, René (1898–1967)
Surrealism

MAILLOL, Aristide (1861–1944)
Synthetism

MALEVICH, Kasimir (1878–1935)
Modernism; Suprematism

MANET, Édouard (1832–83)
Impressionism

MANGUIN, Henri-Charles
(1874–1949)
Fauvism

MARC, Franz (1880–1916)
Expressionism

MARIA, Walter de (1935–)
Land Art

MARQUET, Albert (1875–1947)
Fauvism

MARTIN, Agnes (1912–2004)
Post-Painterly Abstraction

MARTIN, Kenneth (1905–84)
Concrete Art

MARTIN, Mary (1907–69)
Concrete Art

MASSON, André (1896–1987)
Surrealism

MATHIEU, Georges (1921–)
Tachism

MATISSE, Henri (1869–1954)
Neo-Impressionism; Modernism;
Fauvism

MATTA-CLARK, Gordon
(1943–78)
Interventionism

MCCALL, Anthony (1946–)
Installationism

MCGURR, Leonard (*see Futura 2000*)

MERZ, Mario (1925–2003)
Arte Povera

METZINGER, Jean (1883–1956)
Orphism

MEYER, Hans (1889–1954)
Bauhaus

MICHAUX, Henri (1899–1984)
Tachism

MIDDLEDITCH, Edward
(1923–87)
Kitchen Sink Realism

MIRÓ, Joan (1893–1983)
Primitivism; Surrealism

MODIGLIANI, Amedeo
(1884–1920)
Primitivism; School of Paris

MOFOKENG, Santu (1954–)
Internationalism

MOHOLY-NAGY, László
(1895–1946)
Modernism; Bauhaus

MONDRIAN, Piet (1872–1944)
Neo-Plasticism

MONET, Claude (1840–1926)
Impressionism

MOORE, Henry (1898–1986)
Primitivism; Surrealism; Concrete
Art

MOORMAN, Charlotte
(1933–91)
Video Art

MOREAU, Gustave (1826–98)
Symbolism

MORISOT, Berthe (1841–95)
Impressionism

MORLEY, Malcolm (1931–)
Photorealism

MORRIS, Robert (1931–)
Minimalism; Process Art

MORRIS, William (1834–96)
Secessionism

MOTHERWELL, Robert (1915–91)
Dadaism; Neo-Dadaism

MUNCH, Edvard (1863–1944)
Symbolism; Expressionism

MÜNTER, Gabriele (1877–1962)
Expressionism

MURAKAMI, Takashi (1962–)
Neo-Pop

N

NASH, Paul (1889–1946)
Surrealism

NAUMAN, Bruce (1941–)
Performance Art

NELSON, Mike (1967–)
Installationism

NETO, Ernesto (1964–)
Installationism

NEVINSON, Christopher Richard
Wynne (1889–1946)
Vorticism

NEWMAN, Barnett (1905–70)
Abstract Expressionism; Post-
Painterly Abstraction

NICHOLSON, Ben (1894–1982)
Concrete Art

NOLAND, Kenneth (1924–2010)
Post-Painterly Abstraction

NOLDE, Emil (1867–1956)
Expressionism

O

OFILI, Chris (1968–)
Sensationalism

O'KEEFFE, Georgia (1887–1986)
Precisionism

OLBRICH, Joseph Maria
(1867–1908)
Secessionism

ONO, Yoko (1933–)
Performance Art; Fluxus

OPPENHEIM, Dennis
(1938–2011)
Land Art

OPPENHEIM, Méret (1913–85)
Surrealism

OROZCO, José Clemente
(1883–1949)
Social Realism

P

PAIK, Nam June (1932–2006)
Fluxus; Video Art

PAOLOZZI, Eduardo
(1924–2005)
Pop Art

PASCIN, Jules (1885–1930)
School of Paris

PASMORE, Victor (1908–98)
Concrete Art

PASSMORE, George (*see Gilbert & George*)

PECHSTEIN, Max (1881–1955)
Expressionism

PEVSNER, Antoine (1886–1962)
Constructivism

PICABIA, Francis (1879–1953)
Orphism; Dadaism

PICASSO, Pablo (1881–1973)
Modernism; Primitivism; Cubism;
School of Paris

PIPER, Adrian (1948–)
Conceptualism

PISSARRO, Camille (1830–1903)
Impressionism; Neo-Impressionism

PISSARRO, Lucien (1863–1944)
Neo-Impressionism

PISTOLETTO, Michelangelo
(1933–)
Arte Povera

POLLOCK, Jackson (1912–56)
Abstract Expressionism

POONS, Larry (1937–)
Op Art

POPOVA, Lyubov (1889–1924)
Constructivism

PRINCE, Richard (1949–)
Conceptualism; Postmodernism;
Neo-Pop

PROESCH, Gilbert (*see Gilbert & George*)

PROU, Xavier (*see Blek le Rat*)

PUNI, Ivan (1894–1956)
Suprematism

Q

QUINN, Marc (1964–)
Sensationalism

R

RAE, Fiona (1963–)
Sensationalism

RAUSCHENBERG, Robert (1925–2008)
Neo-Dadaism

RAY, Man (1890–1976)
Dadaism; Surrealism

REDON, Odilon (1840–1916)
Symbolism

RENOIR, Pierre-Auguste (1841–1919)
Impressionism

RICHIER, Germaine (1902–59)
Existentialism

RICHTER, Gerhard (1932–)
Photorealism

RIETVELD, Gerrit (1888–1964)
Neo-Plasticism

RIIS, Jacob (1849–1914)
Social Realism

RILEY, Bridget (1931–)
Op Art

RIST, Pipilotti (1962–)
Installationism

RIVERA, Diego (1886–1957)
Cubism; Social Realism

RIVERS, Larry (1923–2002)
Neo-Dadaism

RODCHENKO, Alexander (1891–1956)
Constructivism

RODIN, Auguste (1840–1917)
Impressionism

ROPS, Félicien (1833–98)
Symbolism

ROSENQUIST, James (1933–)
Pop Art

ROTELLA, Mimmo (1918–2006)
New Realism

ROTHENBERG, Susan (1945–)
Neo-Expressionism

ROTHKO, Mark (1903–70)
Abstract Expressionism

ROUAULT, Georges (1871–1958)
Fauvism

ROUSSEAU, Henri (1844–1910)
Post-Impressionism

ROZANOVA, Olga (1886–1918)
Suprematism

RUSSOLO, Luigi (1885–1947)
Futurism

RYMAN, Robert (1930–)
Post-Painterly Abstraction

S

SAINT PHALLE, Niki de (1930–2002)
New Realism

SALLE, David (1952–)
Postmodernism

SCHAD, Christian (1894–1982)
Neue Sachlichkeit

SCHAMBERG, Morton Livingston (1881–1918)
Dadaism

SCHIELE, Egon (1880–1918)
Secessionism; Expressionism

SCHMIDT-ROTTLUFF, Karl (1884–1976)
Expressionism

SCHNABEL, Julian (1951–)
Postmodernism; Neo-Expressionism

SCHNEEMANN, Carolee (1939–)
Performance Art

SCHNEIDER, Ira (1939–)
Video Art

SCHULZE, Alfred Otto Wolfgang (*see Wols*)

SCHWITTERS, Kurt (1887–1948)
Dadaism

SERRA, Richard (1939–)
Process Art

SÉRUSIER, Paul (1864–1927)
Synthetism

SEURAT, Georges (1859–91)
Neo-Impressionism; Symbolism;
Synthetism; Post-Impressionism

SEVERINI, Gino (1883–1966)
Futurism

SHAHN, Ben (1898–1969)
Social Realism

SHEELER, Charles (1883–1965)
Precisionism

SHERMAN, Cindy (1954–)
Postmodernism

SHEVCHENKO, Aleksandr (1883–1948)
Rayonism

SICKERT, Walter (1860–1942)
Impressionism

SIGNAC, Paul (1863–1935)
Neo-Impressionism; Fauvism

SIQUEIROS, David Alfaro (1896–1974)
Social Realism

SISLEY, Alfred (1839–99)
Impressionism

SMITH, David (1906–65)
Abstract Expressionism

SMITH, Jack (1928–2011)
Kitchen Sink Realism

SMITHSON, Robert (1938–73)
Land Art

SONNIER, Keith (1941–)
Process Art

SOTO, Jesús (1923–2005)
Kineticism

SOULAGES, Pierre (1919–)
Tachism

SOUTINE, Chaïm (1893–1943)
School of Paris

STEINBACH, Haim (1944–)
Neo-Pop

STELLA, Frank (1936–)
Post-Painterly Abstraction

STEPANOVA, Varvara
(1894–1958)
Constructivism

STIEGLITZ, Alfred (1864–1946)
Precisionism

STILL, Clyfford (1904–80)
Abstract Expressionism

STRAND, Paul (1890–1976)
Precisionism

SWOON (Caledonia Dance Curry)
(1978–)
Street Art

T

TADLOCK, Thomas (unknown)
Video Art

TAKIS, Vassilakis (1925–)
Kineticism

TÀPIES, Antoni (1923–2012)
Tachism

TATLIN, Vladimir (1885–1953)
Constructivism

TAYOU, Pascale Marthine (1967–)
Internationalism

THATER, Diana (1962–)
Installationism

TINGUELY, Jean (1925–91)
Kineticism; New Realism

TIRAVANIJA, Rirkrit (1961–)
Interventionism

TOULOUSE-LAUTREC, Henri de
(1864–1901)
Post-Impressionism

TURK, Gavin (1967–)
Sensationalism

TURRELL, James (1943–)
Land Art; Installationism

V

VALLOTTON, Félix (1865–1925)
Synthetism

VAN DER LECK, Bart
(1876–1958)
Neo-Plasticism

VAN DER ROHE, Ludwig Mies
(1886–1969)
Bauhaus

VAN DOESBURG, Theo
(1883–1931)
Neo-Plasticism; Bauhaus

VAN DONGEN, Kees
(1877–1968)
Fauvism; Expressionism

VAN GOGH, Vincent (1853–90)
Post-Impressionism; Expressionism

VANTONGERLOO, George
(1886–1965)
Neo-Plasticism

VASARELY, Victor (1906–97)
Kineticism; Op Art

VAUTIER, Ben (1935–)
Fluxus

VIENNA ACTIONISTS (collective;
active from 1960)
Performance Art

VILLEGLÉ, Jacques de la (1926–)
New Realism

VIOLA, Bill (1951–)
Video Art

VLAMINCK, Maurice de
(1876–1958)
Fauvism

VOSTELL, Wolf (1932–98)
Video Art

VUILLARD, Édouard (1868–1940)
Synthetism

W

WARHOL, Andy (1928–87)
Pop Art

WEINER, Lawrence (1942–)
Conceptualism

WEIWEI, Ai (1957–)
Internationalism

WHISTLER, James Abbott McNeill
(1834–1903)
Impressionism

WHITE, Donald Joseph (*see
DONDI*)

WILDING, Alison (1948–)
New British Sculpture

WILLIAMS, Emmett (1925–2007)
Fluxus

WILSON, Fred (1954–)
Interventionism

WILSON, Richard (1953–)
Interventionism

WITTEN, Andrew (*see Zephyr*)

WOLS (Alfred Otto Wolfgang
Schulze) (1913–51)
Tachism

WOODROW, Bill (1948–)
New British Sculpture

Z

ZDJELAR, Katarina (1979–)
Internationalism

ZEPHYR (Andrew Witten) (1961–)
Street Art

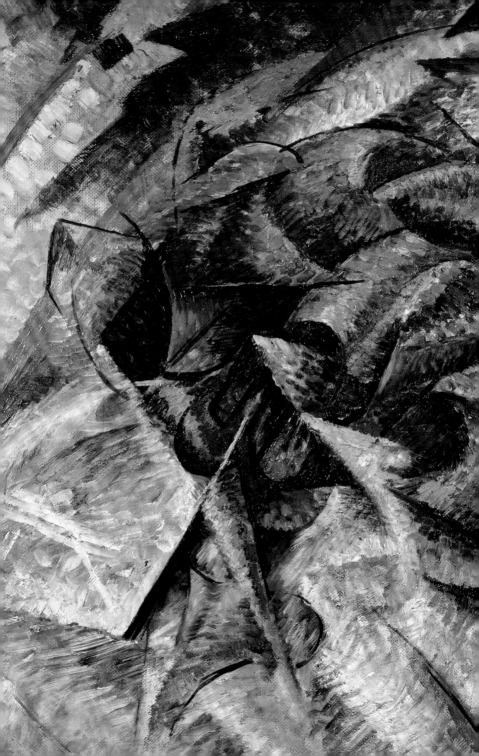

ABSTRACTION
Art that does not imitate or refer to the appearance of objects in the world.

ACTION PAINTING
A form of Abstract Expressionism in which the paint is applied spontaneously – often splashed on the canvas – to emphasise the act of painting itself. The term was coined by American critic Harold Rosenberg in 1952 and is most closely associated with the practice of Jackson Pollock.

ANTI-ART
Works that reject traditional definitions of, and notions associated with, art. These include art's separation from everyday life, elitism and position as a commodity.

APPLIED ART
Objects that are functional as well as artistic, such as ceramics, furniture and textiles.

APPROPRIATON ART
This refers to art that adopts imagery, ideas or materials from pre-existing artworks. Appropriation of commercial art was popular in Pop Art from the mid-1950s. Although appropriation often involves the modification of the chosen works, from the late 1970s original material began to be presented largely unmediated by American artists like Richard Prince and Sherrie Levine – this trend has continued into contemporary art.

ART BRUT
This describes art produced by people outside the mainstream art world. Meaning in French 'Raw Art', it includes art by psychiatric patients, convicted criminals and children. The term was coined by French artist Jean Dubuffet (see 'Tachism') who collected this type of art, which is also called Outsider Art.

ARTS AND CRAFTS
Movement in architecture and applied art that developed in the second half of the 19th century in Britain, Northern Europe and America. It championed the work of individual craftsmen, set apart from the world of industry, and believed in the unity of applied and fine art.

ASSEMBLAGE
Pre-existing materials and objects (often found objects) arranged together to create a new structure. These are three-dimensional equivalents of collage works, and can be classified either as sculptures or installations.

AUTOMATISM
An involuntary artistic process, such as drawing spontaneously without any rational thought or using chance to produce artworks. Closely associated with Surrealism.

BODY ART
Art that uses the body of the artist as its medium. Closely associated with Performance Art.

CLOISONNISM
A painting style that features simple shapes of colour outlined in black, in the manner of cloisonné, the ceramic technique in which metal compartments (*cloisons* in French) separate areas of coloured enamel.

CoBrA
A Tachist artist group whose name was formed by the capital cities of members' nations: Copenhagen, Brussels and Amsterdam. Affiliates included Karel Appel and Asger Jorn, and the group's output was particularly inspired by Art Brut.

COLOURIST
An artist whose use of colour is a particularly significant part of their work.

COLLAGE
A technique that involves applying a range of pre-existing materials and objects – such as cloth, newsprint and paper – to a two-dimensional surface such as a canvas. The method was pioneered in Cubism. Collages in three dimensions are often called 'assemblages'.

COLOUR FIELD PAINTING
Abstract art in which large areas of unbroken colour are applied on canvas. The method is closely associated with Abstract Expressionism and Post-Painterly Abstraction.

DEGENERATE ART
In 1937, the Nazi government in Germany mounted an exhibition entitled 'Degenerate Art' in order to denounce those artists it presented as subversive to the state. Expressionist Ernst Ludwig Kirchner and Neue Sachlichkeit artist Max Beckmann were two of the high-profile practitioners included.

DEMATERIALISATION
When an artwork does not take physical form. This term, popularised by American critic Lucy Lippard in her book *Six Years: The Dematerialisation of*

the Art Object from 1966 to 1972, refers to the rise of Conceptualism, in which artworks are ideas rather than material works.

DESIGN ART

The 21st-century phenomenon that has seen pieces of applied art – such as furniture or light fittings – raised to the elite status of fine art objects by their makers, dealers and collectors. These one-off works are often produced by artists not normally working in the realm of design, which makes the pieces even more unique and desirable.

DIVISIONISM

(See *Pointillism*)

DOCUMENTATION

Photographs, films, publications and texts that record the creation of artworks. Documentation is an important element of Performance Art, as it remains behind after the event as a representation of the work; as such, it can have value both aesthetically and as a commodity.

EARTH WORKS

Alternative term for Land Art (see chapter) and Earth Art.

ENVIRONMENTAL ART

When a distinct environment such as an architectural space is part of the artwork. Closely related to Installationism, this term was used commonly from the 1960s. Not to be confused with Environmentalism, which is art that has ecological concerns.

EPHEMERA

Source material for artworks that is insubstantial and normally produced for short-term use before disposal. Examples include advertisements, posters and product packaging. Ephemera became an important inspiration for Pop Artists. 'Artists' ephemera' specifically refers to ephemeral items – notes, tickets, private view invitations – that are related to an artist's working life.

FIGURATION

Art that represents forms as they appear in the world, in particular the human figure. Used in opposition to abstraction.

FINE ART

Art produced for aesthetic reasons rather than for any functional use.

FORESHORTENING

This is a method used to depict objects so that they appear with a similar spatial depth as they do in real life (known as linear perspective). One dimension of an object is relatively shortened at an angle so that it appears to recede into the distance.

FOUND OBJECT

Non-art objects of either natural or manufactured origin that are incorporated into artworks. The French form of the term, *Objet Trouvé*, is commonly used in English.

GEOMETRIC ABSTRACTION

Abstract art that features geometric shapes. It was a mode popular in the first half of 20th century and was practised in movements including Suprematism and Neo-Plasticism.

GESTURAL ART

Art in which the spontaneous physical gestures of the artist are visible in the finished work. It is related to Tachism and Abstract Expressionism, specifically Action Painting. Gestural art is underpinned by the idea that a physical act – whether spreading paint or handling plaster – can express thought or emotion in a powerful way.

GOLDEN RATIO

A set ratio for arranging one geometric plane to another in a particularly harmonious way. Developed by ancient mathematicians, architects and artists, the ratio was rediscovered in the Renaissance. It continues to influence modern artists and designers. Its linear expression is known as the Golden Section.

GRAFFITI ART

In contrast to graffiti and Street Art, this is art that incorporates the styles or methods of graffiti but is presented in galleries rather than on the street. The term is associated with the works of Jean-Michel Basquiat and Keith Haring.

HAPPENING

An art event characterised by unorthodox content and the participation of visitors. Happenings became common in artistic circles from the late 1950s and led to the Performance Art of the 1960s.

HARD-EDGED PAINTING

Hard-edged is an adjective used to describe paintings characterised by sharp transitions between their different spaces. It refers in particular to a group of Post-Painterly Abstractionists working from the 1960s whose works featured abrupt changes in colour.

ICONOGRAPHY

An artist's iconography is the images they include in their

artworks. The term is also used in this history of art to refer to the general study and classification of art images, with particular attention given to their symbolic meaning.

ILLUSIONISM
A type of art that renders objects in the world particularly realistically, so that there is 'an illusion' that the representation could actually be real.

IMPASTO
A technique in which paint is so thickly applied to a canvas or panel that it stands in relief. Artists commonly use a palette knife for this process.

INSTITUTIONAL CRITIQUE
The criticism by artists of the workings of art institutions such as museums and commercial galleries.

INTIMISM
A style of art characterised by intimate, domestic subject matter, such as the depiction of daily chores like preparing meals. It is associated with French painters Pierre Bonnard and Édouard Vuillard, members of the Nabis who at first followed Synthetism.

JUNK ART
Art made out of objects salvaged from rubbish dumps. It was a key feature of New Realism in the late 1950s and early 1960s.

LINEAR PERSPECTIVE
The arrangement of a subject in a two-dimensional picture so that it gives the illusion of three-dimensional depth. Renaissance artists developed rules, such as the use of a vanishing point and foreshortening, in order to realise linear perspective.

LIVE ART
Synonym for Performance Art.

MAGIC REALISM
The combination of fantastical and realistic elements in a work of art. Coined by German critic Franz Roh in 1925, it commonly refers in visual art to paintings in which dream-like scenes are rendered in a realistic way.

METAPHYSICAL PAINTING
A mode of painting developed by Italian painter Giorgio de Chirico from about 1913. It was characterised by odd perspectives and the strange juxtaposition of objects, which often included classical sculpture and architecture. Known in Italian as Pittura Metafisica, the style influenced Surrealism.

MIMETIC
An adjective for art that mimics or refers to objects or structures found in the real world.

MULTI-PERSPECTIVISM
The arrangement of objects in one work from different perspectives so that they appear at different angles to the viewer. The technique was pioneered by the French Post-Impressionist Paul Cézanne.

MULTIPLE
An artwork that is produced in a number of identical editions. These works can be produced according to the artist's instructions, but without their direct involvement. The term is commonly used in relation to sculpture, although a print is a type of multiple.

MURALISM
A movement in Mexican art during the 1920s and 1930s that saw artists produce large-scale Social Realist mural works. The key artists were Diego Rivera, David Alfaro Siqueiros and José Clemente Orozco. Their works were often commissioned by the country's post-revolutionary government to emphasise its social ideals. The movement spread to America before the Second World War.

NABIS
A group of Parisian artists influenced by the Synthetism of Paul Gauguin. Members included Pierre Bonnard, Maurice Denis, Aristide Maillol, Paul Sérusier, Félix Vallotton and Édouard Vuillard. The name Nabis meant 'prophets' in Hebrew.

NATURALISM
Art that attempts to represent objects as they appear in nature. It is often used interchangeably with the word 'realism'.

NON-OBJECTIVE ART
An alternative term for abstract art – or art that does not represent objects as they appear in the world. It was first used by Russian Constructivist Alexander Rodchenko and was popularised by his compatriot, the Expressionist Wassily Kandinsky.

OBJECT TROUVÉ
(See *Found Object*)

OUTSIDER ART
(See *Art Brut*)

PAPIER COLLÉ
Meaning 'pasted paper' in French, this is a type of collage that consists of glued paper elements, normally applied to a paper support.

PERSPECTIVE
The angle of appearance to the viewer of an object in a painting. Renaissance artists developed linear perspective, which arranged objects so they appeared to have realistic three-dimensional depth. But from the late 19th century artists painted objects so that they appeared at odd angles to the viewer, so that their perspective was not realistic. If an object is said to be 'in perspective' it means that it is rendered in linear perspective.

PITTURA METAFISICA
(See *Metaphysical Painting*)

POINTILLISM
A painting technique in which the picture is built up by distinct, individual dots of pigment. The method was developed by Neo-Impressionist Georges Seurat. The theories that underpin Pointillism are known as Divisionism, although the two words are often used interchangeably.

POST-MINIMALISM
A broad term for practices that responded to Minimalism during and after the late 1960s. Some Post-Minimalists continued to create objects in a relatively pared-down Minimalism style, but incorporated an interest in process and fabrication (Process Art), or connections to personal and social narratives.

READYMADE
A found object presented on its own without significant modification. Readymades were pioneered by Dadaist Marcel Duchamp. (See *Found Object*)

REPRESENTATIONAL ART
Art that depicts or refers to recognisable objects and environments. Representational art is not necessarily realistic.

SALON
Exhibitions organised by the French Royal Academy of Painting and Sculpture in Paris from the 17th century. From the late 19th century other shows rivalled the main Salon, such as the Salon des Indépendants and the Salon d'Automne.

SELF-SUFFICIENCY
When an artwork does not represent or relate to anything other than itself. Closely associated with Minimalism.

SEMI-FIGURATIVE
Art that is on the cusp between figuration and abstraction – between depicting things as they appear in the real world and avoiding the representation of objects entirely. Some objects are suggested and may be recognised, but their appearance is notably ambiguous and unrealistic.

SERIAL ART
Artworks that consist of a series of usually identical objects. Closely associated with Minimalism.

SITE-SPECIFIC ART
Art that has been devised for installation in a particular location, often an unusual space indoors or outside. The form and content of the work are linked with that location, and for this reason artists sometimes stipulate that temporary site-specific works should not be installed elsewhere after their removal.

SYNAESTHESIA
A neurological condition in which two usually separate senses are combined. The most famous synaesthesiac in modern art was Russian Expressionist Wassily Kandinsky, who heard sounds when he saw colours, and vice-versa.

TROMP L'OEIL
This French word means 'trick the eye'. It refers to two-dimensional pieces – commonly paintings – that trick the viewer into sincerely believing they are not artworks, but real objects or environments with three-dimensional depth.

VANISHING POINT
An imaginary point in a painting towards which all of its objects recede. A vanishing point is necessary for realistic linear perspective and its use was encouraged by art academies after the Renaissance. It was rejected by modern artists as they turned away from realistic depictions of the world.

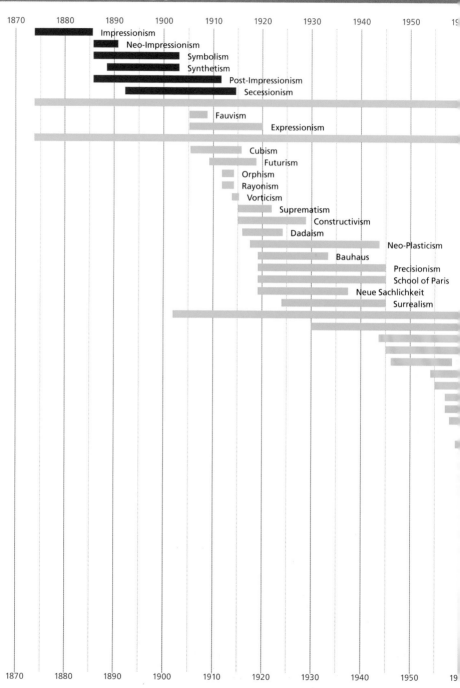

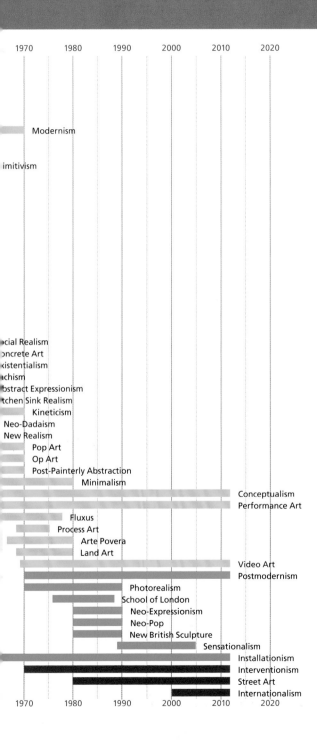

1970	1980	1990	2000	2010	2020

Modernism

imitivism

cial Realism
oncrete Art
xistentialism
chism
bstract Expressionism
tchen Sink Realism
Kineticism
Neo-Dadaism
New Realism
Pop Art
Op Art
Post-Painterly Abstraction
Minimalism
Conceptualism
Performance Art
Fluxus
Process Art
Arte Povera
Land Art
Video Art
Postmodernism
Photorealism
School of London
Neo-Expressionism
Neo-Pop
New British Sculpture
Sensationalism
Installationism
Interventionism
Street Art
Internationalism

1970	1980	1990	2000	2010	2020

France

PARIS
Centre Pompidou, Modernism
Musée d'Orsay, Impressionism

Germany

BERLIN
Hamburger Bahnhof, Museum
for Contemporary Art,
Conceptualism

HAMBURG
Hamburger Kunsthalle, Tachism

STUTTGART
Staatsgalerie, Neue Sachlichkeit

Italy

TURIN
Castello Di Rivoli Museum of
Contemporary Art, Arte Povera

VENICE
Gianni Mattioli Collection at
the Peggy Guggenheim
Museum, Futurism

The Netherlands

AMSTERDAM
Stedelijk Museum, Suprematism

THE HAGUE
Gemeentemuseum,
Neo-Plasticism

Portugal

LISBON
Centro de Arte Moderna, Op Art

Spain

MADRID
Museo Centro De Arte Reina
Sofía, Surrealism
Thyssen-Bornemisza Museum,
Cubism

Sweden

STOCKHOLM
Moderna Museet, Neo-Dadaism

Switzerland

BASLE
Fondation Beyeler, Existentialism

UK

CHICHESTER
Pallant House Gallery,
School of London

EDINBURGH
Scottish National Gallery,
Synthetism

LONDON
Courtauld Gallery,
Post-Impressionism
Tate Collection
(Tate Britain and Tate Modern,
London; Tate Liverpool, Tate St Ives)
Vorticism; Dadaism; Kitchen Sink
Realism; Pop Art; New British
Sculpture; Sensationalism;
Internationalism
Victoria and Albert Museum
(V&A), Bauhaus

USA

BUFFALO
Albright-Knox Art Gallery,
School Of Paris

CAMBRIDGE
Fogg Museum, Harvard Art
Museums, Fluxus

CHICAGO
Museum of Contemporary Art,
Neo-Pop

CLEVELAND
Cleveland Museum of Art,
Symbolism

FORT WORTH
Modern Art Museum of Fort
Worth, Neo-Expressionism

INDIANAPOLIS
Indianapolis Museum of Art,
Neo-Impressionism

LOS ANGELES
Los Angeles County Museum
of Art (LACMA), Post-Painterly
Abstraction; Installationism
Museum of Contemporary Art
(MOCA), Abstract Expressionism

MINNEAPOLIS
Walker Art Center, New Realism

NEW YORK
Electronic Arts Intermix,
Performance Art; Video Art
Metropolitan Museum Of Art,
Primitivism
Museum of Modern Art (MOMA)
Expressionism, Rayonism;
Constructivism; Kineticism;
Land Art; Interventionism
Neue Galerie, Secessionism
Solomon R Guggenheim
Museum, Minimalism;
Postmodernism
Whitney Museum of American
Art, Precisionism; Process Art

PHILADELPHIA
Philadelphia Museum of Art,
Orphism

SAN FRANCISCO
San Francisco Museum of
Modern Art (SFMOMA), Fauvism

WASHINGTON DC
Hirshhorn Museum and
Sculpture Garden, Concrete Art;
Photorealism
National Gallery of Art,
Social Realism

Important note for readers

This list is not, of course, exhaustive
– it is a simple summary of those
museums and isms mentioned in
this book. The collections in each
museum and gallery above will also
include examples of other isms.

AN IQON BOOK
This book was designed
and produced by
Iqon Editions Limited
Sheridan House
112–116a Western Road
Hove BN3 1DD

Publisher, concept and direction:
David Breuer

Designer: Isambard Thomas

Editor and Picture Researcher:
Caroline Ellerby

Printed in China

First published in Great Britain
in 2012 by
Bloomsbury Publishing Plc
50 Bedford Square
London WC1B 3DP

www.bloomsbury.com

ISBN 978-1-4081-7178-3

Copyright © 2012
Iqon Editions Limited

A CIP record for this book is
available from the British Library

Cover illustration details
(left to right, from top)

Umberto Boccioni, *Dynamism of a Cyclist*, 1913 (p 41)

Kasimir Malevich, *Suprematist Composition (With Eight Red Rectangles)*, 1915 (p 48)

Jeff Koons, *Rabbit*, 1986 (p 125)

Paul Gauguin, *Vision of the Sermon (Jacob Wrestling with the Angel)*, 1888 (p 21)

Marcel Duchamp, *Fountain*, 1917 (replica 1964) (p 53)

Juan Gris, *The Smoker (Frank Haviland)*, 1913 (p 39)

Gustav Klimt, *Adele Bloch-Bauer I*, 1907 (p 10)

Ai Weiwei, *Sunflower Seeds*, 2010 (pp 138–9)

Édouard Vuillard, *Two Seamstresses in the Workroom*, 1893 (p 21)

Anish Kapoor, *As if to Celebrate, I Discovered a Mountain Blooming with Red Flowers*, 1981 (p 127)

Dara Birnbaum, *Technology/ Transformation: WonderWoman*, 1978–9 (p 111)

Theo Van Doesburg, *Contra-Composition of Dissonances XVI*, 1925 (pp 54–5)

Michelangelo Pistoletto, *Venus of the Rags*, 1967 (p 106)

Bridget Riley, *Metamorphosis*, 1964 (p 93)

Shepard Fairey, *District La Brea Mural, Hollywood*, 2011 (p 132)